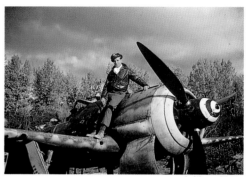

via Wayne Watts

There Once Was A War

*The Collected Color Photography
of World War II*

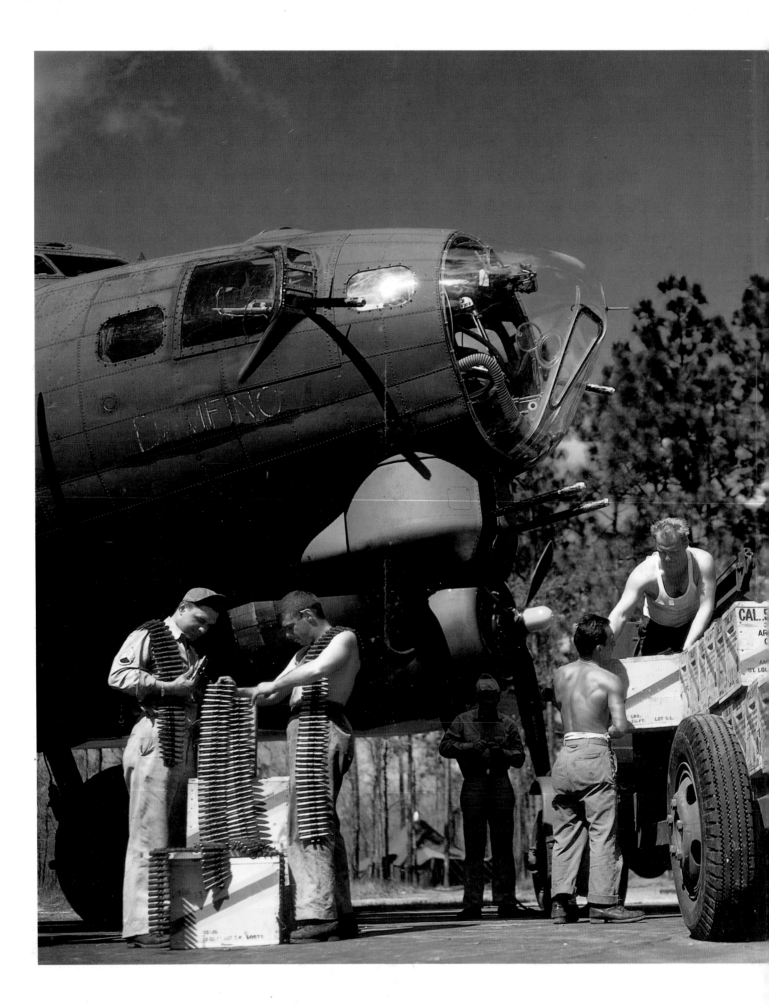

A bomber crew loads .50 caliber bullets on a B-17 at a Florida training base. The name of the plane, "Damifino," was thought by Air Force brass to be the title of an Italian song. Most enlisted men got the message right away. (USAF)

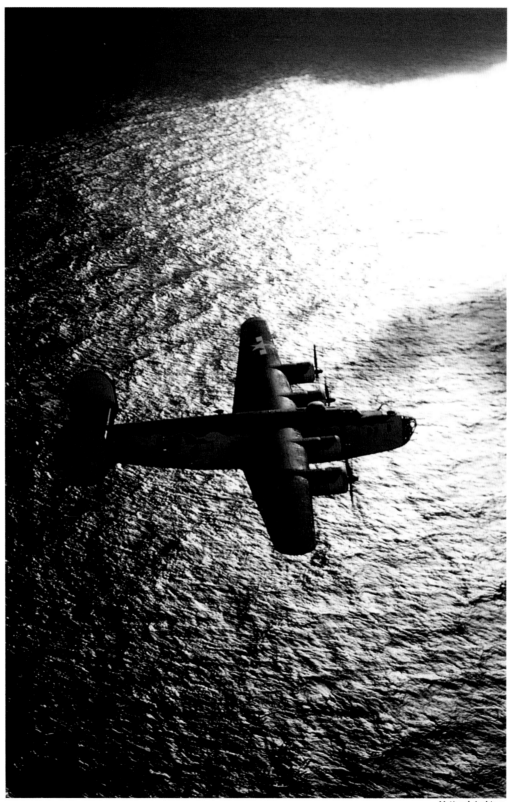

THERE ONCE WAS A WAR

*The Collected Color Photography
of World War II*

VIKING
STUDIO
BOOKS

*Featuring the Jeffrey Ethell Collection
of World War II Color Photography*

Jeffrey Ethell, Editor

Text by

**General Charles E. "Chuck" Yeager
and Colonel Clarence E. "Bud" Anderson**

This book is dedicated to the men and women who fought and won World War II both on the front lines and on the home front. Without the American miracles of production and training, victory may have been far more elusive. There will never again be a generation quite like the one that came out of the Great Depression with a fierce determination to get an unwanted war over with and come home.

VIKING STUDIO BOOKS
Published by the Penguin Group
Penguin Books USA Inc., 375 Hudson Street,
New York, New York 10014 U.S.A.

Penguin Books Ltd, 27 Wrights Lane,
London W8 5TZ, England

Penguin Books Australia Ltd, Ringwood,
Victoria, Australia

Penguin Books Canada Ltd, 2801 John Street,
Markham, Ontario, Canada L3R 1B4

Penguin Books (N.Z.) Ltd, 182-90 Wairau Road,
Auckland 10, New Zealand

Penguin Books Ltd, Registered Offices:
Harmondsworth, Middlesex, England

First published by Viking Studio Books, an imprint of Penguin Books USA Inc.

First printing September 1995
10 9 8 7 6 5 4 3 2 1

Library of Congress Catalog Card Number: 95-60128

Book design and production by Butler+Keeney+Farmer, Louisville, KY
Printed and bound by Dai Nippon Printing Co., Hong Kong, Ltd.

ISBN: 0-670-86044-1

CONTENTS

ix Foreword

xv Introduction

26 SOLDIERS: *The War on the Ground*

68 AIRMEN: *The War in the Air*

136 SAILORS: *The War at Sea*

166 BEHIND THE LINES: *People, Places, and Events*

224 Glossary

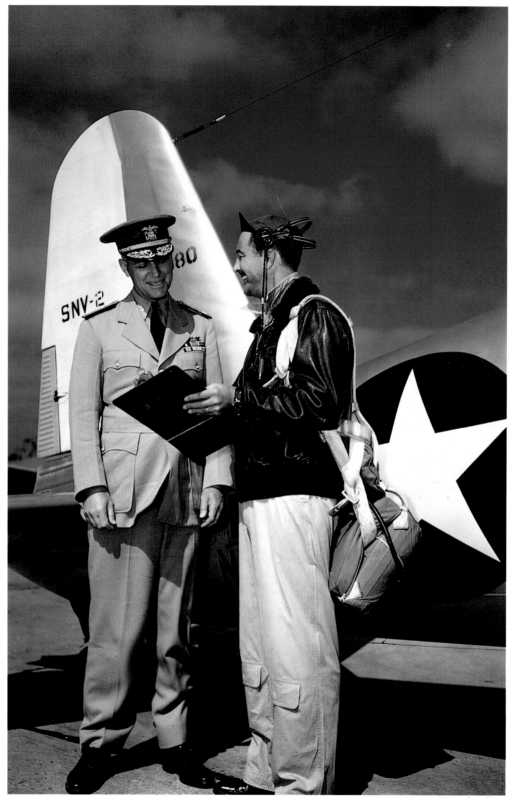

Actor Robert Taylor, an accomplished pilot before the war, became a talented Navy flight instructor. Although he kept trying to get transfered to combat duty, his superiors, like Admiral Hardison here, thought he was better utilized by training others to fly. In the process, he made a number of excellent training films.

Foreword

My early memories of World War II were formed by my dad's scrapbook, a collection of black-and-white snapshots taken in North Africa in 1942-43, and during gunnery instruction in California through 1945. I spent hours trying to understand what it must have been like for young, twenty-two-year-old Lt. Erv Ethell to fly P-38 Lightnings in combat over the

"Jumpin' Jacques" was the personal P-51D Mustang of Jacques Young, 3rd Air Commando Group, Luzon, Philippines, June 1945. (National Archives)

bare Tunisian wastes, living in tents, and surviving on minimal rations. The pictures were devoid of color, and their dim gray shades left only a guess as to how that world really must have looked.

Those of us born after the war, and even those who fought in World War II, have come to accept black-and-white images as the norm for experiencing what took place at that time. Veterans have had their own memories washed of color by viewing their own scrapbooks countless times. Wartime and post-war newsreels, documentaries, and books have been produced in black-and-white with only rare bits of color film to punctuate the pauses.

When I was hired by the Smithsonian Institution's National Air and Space Museum in 1968 for my first research grant between my sophomore and junior years at King College, I saw that their vast holdings contained only a few Army Air Forces color images from the war. Curators on the whole said that color did not exist and that it must have been used experimentally by a few chosen units in the field.

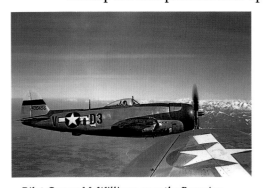

Pilot George McWilliams over the Bavarian Alps in his 397th Squadron, 368th Fighter Group P-47D. His wingman, Arthur Houston, shot the photo.

I accepted this professional opinion as my own. After all, who was I to argue with established curators who had been doing research long before I was born? In the back of my mind, however, there was a nagging doubt, brought on principally by the existence of one slide my dad had of himself with a P-51, and also by a small number of color shots I obtained from military photographers. Slowly, driven probably by my restlessness for research, I began to look for more 1940s color. Without being able to pinpoint an exact starting time, I was set on a course of discovery.

Much to my surprise, I found that curators and museum professionals were not even asking veterans if they had shot color. (If it didn't exist, why ask?) Unfortunately, that kind of stupidity dominates much of academia, leaving future generations to be all the poorer in their understanding of the past. In a very

short time I found veterans who said yes, they had shot color slides, and was I really interested in them? Before long a slow trickle of early Kodachrome came across my desk, including slides shot by Army pilots Jacques Young and Arthur Houston. The clarity and definition were astounding to someone who had never seen the war in color.

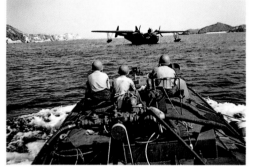

On the way to refueling a PBM-5 Mariner in Tanapag Harbor, Saipan, April 1945. (National Archives)

Soon the trickle widened into a stream, then into a flood. It seemed that every other veteran I approached had color or knew someone who did. I now have over 20,000 World War II color slides in my collection, making it arguably the largest of its kind in the world. Every week I hear about someone who has vintage color and I diligently follow up the lead. Where did this rich, near-flawless color come from, when the world was dominated by black-and-white technology?

Women riveters at the Consolidated-Vultee plant, San Diego, California, July 1943. (National Archives)

I called Kodak in Rochester, New York, to find out. I was referred to Phil Condax, Senior Curator, Technology Collections, at the George Eastman House, one of the finest museums of photography in the world. He was delighted I had found such a treasure trove of Kodak's early color, since no one was making much of an effort to collect and archive it. He proceeded to tell me how it happened.

In 1935, the Eastman Kodak Company announced an entirely new 16 mm color movie film called Kodachrome. Inspired by the theories of Rudolph Fisher published early in the century, and the work of Leopold Mannes and Leopold Godowsky, the Kodak Research Laboratories perfected a single color-film process previously thought impossible. Until then, the most successful professional motion picture film had been devised by Technicolor. Their technique required film that was shot simultaneously on three different reels of black-and-white film in a very complex camera, to be processed by color-dyeing each reel individually, then mating the result into a single reel. (No wonder it was called Technicolor.)

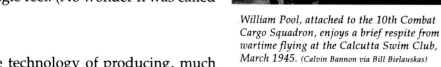

William Pool, attached to the 10th Combat Cargo Squadron, enjoys a brief respite from wartime flying at the Calcutta Swim Club, March 1945. (Calvin Bannon via Bill Bielauskas)

The technology of producing, much

less buying, a still camera to shoot three different rolls of film at once, and then paying for developing, would make it prohibitively expensive for ordinary consumers, and this technology would never have caught on. Kodak's breakthrough changed all that. Kodachrome was a single film,

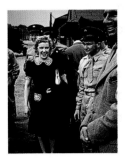

composed of a number of layers of emulsion, sensitive respectively to the red, green, and blue portions of the spectrum.

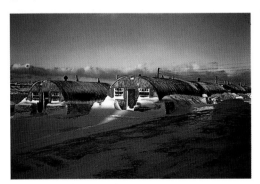

The USS Pennsylvania *at the Pacific Advanced Base Sectional Docks, 1944. (National Archives)*

By means of a number of chemical processes, a single, high-quality natural-color transparency resulted.

Local English citizens visit Debden, home of the 4th Fighter Group, 1944. (Edward Richie)

In September 1936, Kodachrome was made available in 35mm (eighteen exposures) and 828 (eight exposures, 28mm wide) with the idea of attracting amateur camera enthusiasts to color. The professional photographers and newspaper editors of the day, who used and required 4 x 5 or larger sheet film, took virtually no notice, considering the 35mm format a toy for the family snapshot taker.

Nissen huts at a U.S. Navy station in Iceland, 1943. (National Archives)

Not that there weren't some excellent cameras around to take the new film. The Leica 35mm camera had been introduced in 1924, but it stumbled along through the Great Depression until the arrival of Kodachrome. The two went together as if made for each other, and the new film caused a substantial increase in Leica sales. There were enough affluent amateurs to keep this very tenuous marriage intact, but not everyone could afford an expensive German camera.

In 1934, Kodak introduced the Retina 35mm camera manufactured in their German plant, and a rangefinder-equipped American-made camera in 1939. Prices varied according to the lens selected, but they were well over $50, which was expensive at that time. According to Kodak's Phil Condax it was the Argus C-3 made by a small firm in Ann Arbor, Michigan in 1939 that was to become the most popular with the buying public. With only modest changes in its basic design it remained on the market until 1966, a remarkable production run. During this period more Kodachrome film was used in the Argus C-3

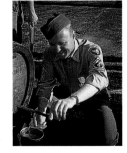

Sgt. Lawrence Hanratty of the 55th Fighter Group has a farewell toddy at the unit's going-home party at Wormingford, England, June 18, 1945. (Robert T. Sand)

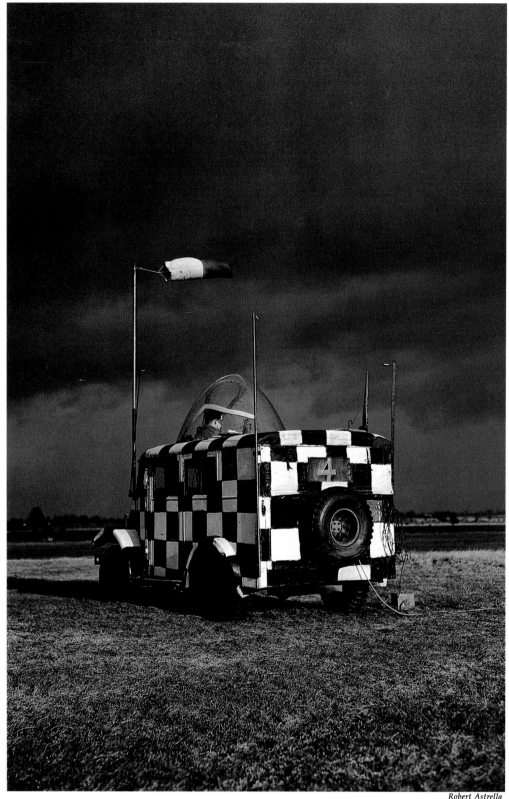

Robert Astrella

The 7th Photo Group mobile control trailer at Mt. Farm, England. The custom plexiglass dome on top of the truck was made from the nose of a B-17 Flying Fortress. Being right next to the runway, the auxiliary tower gave controllers a bit more latitude in helping pilots get back on the ground.

than in any other camera.

This put the film into the hands of enthusiastic amateurs and some professionals who, although not affluent, would soon be at war around the world with their "toy" cameras and a remarkable new color-slide film to go with them. Without knowing it at the time, they would become the small band of historians who would ultimately rescue World War II from its black-and-white restraints.

The first batches of Kodachrome tended to color-fade, but by 1939 a second, more refined process resulted in stable film images which, the Kodak researchers guessed, would last fifteen years. They were wrong. On the whole, Kodachrome images have remained unchanged for fifty years, the only exceptions being those subjected to intense humidity or heat. Its film speed of ten was considerably slower than its black-and-white counterparts, making it hard to shoot moving subjects, but its grainless clarity was breathtaking, and it still is when compared to modern color film.

Since amateurs tended to use their film at a very slow rate, shooting up to eighteen exposures took too long. As a result, Kodachrome 828 roll film for use in the smaller Kodak Bantam series of cameras was very popular throughout the 1940s. The only major obstacle to it all was the problem of projection, where a fifty-pound cast-iron slide projector was required, along with a light bulb the size of one's head. The bulb put out enough heat to cook the slides if they stayed in the viewer too long. But the color-print film Kodacolor came along in 1942, and ever since the public has continually opted for the convenience of prints over slides. Ironically, Kodachrome, designed for amateur use in the beginning, is now used almost exclusively by professionals.

According to Condax, by the time World War II started, Kodachrome was available in a number of professional sheet-film sizes, but the problem was in the processing. Eastman Kodak had been approached during the war with a request from the military that field-processing stations for Kodachrome be set up for aerial reconnaissance work. This simply could not be worked out; the process was too complex. During many of the processing steps the temperature could not vary more than plus-or-minus one tenth of a degree. Combat conditions, which included varying temperatures, local water, and darkened tents, made this impossible.

Some photographers shot it anyway, but it had to be sent back to Rochester, New York, for processing. What's more, Kodachrome expired much more rapidly than black-and-white film, was very sensitive to heat, and could not be carted around in the field without concern. Wartime professionals could not live with

these restrictions, so shooting color remained, for the most part, a hobby of ordinary soldiers, sailors, and airmen who were simply documenting their small corner of the war. No one knew just how much they had shot until I started my research.

Without meaning to, I have ended up with not only a library-length look at World War II as it was genuinely experienced but also with a watershed history of early color photography. What a fitting tribute to a brave generation of soldiers, sailors, airmen, WAVES, and WACS who washed the black-and-white shroud from one of civilization's most cataclysmic events, and filled our imaginations with this brilliant glimpse into a world at war.

Jeffrey Ethell

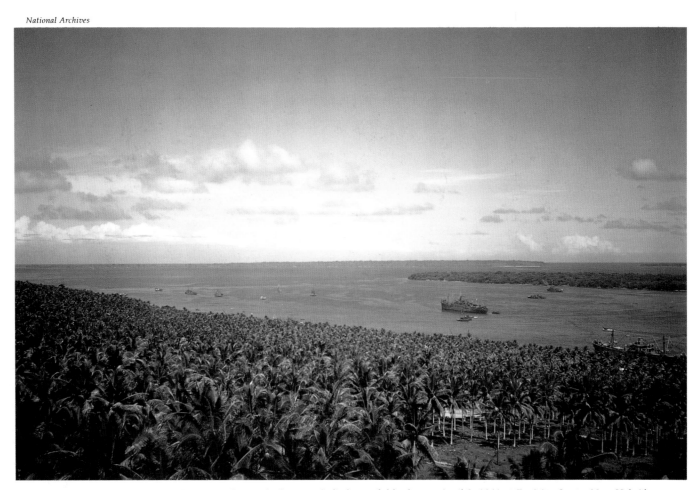

The Navy cargo ship Segond Channel *and several other vessels find peaceful harbor on April 3, 1941 at Espiritu Santo, New Hebrides, one of many Pacific islands that became Allied staging points. Espiritu was known in particular as a liberty port in the middle of a very big ocean.*

A GOOD MISSION TO FLY

A World War II Reminiscence

Brig. Gen. Charles E. "Chuck" Yeager
and Col. Clarence E. "Bud" Anderson

Chuck Yeager and Bud Anderson are brothers in arms and brothers in spirit, having first met in 1943 as members of the famous 357th Fighter Group, flying and fighting in the skies over Europe. They have remained close friends for over 50 years. They are among the elite of American aviation, held in high esteem by the flying community—indeed by a worldwide community of friends and fans who admire their accomplishments from World War II (Anderson had 16.25 kills, Yeager 11.5) and from the golden age of test flying at Edwards Air Force Base. Although very young during the War, both men recall it as the most satisfying, exciting time of their lives.

Before the War; a simpler time, with America emerging from the Great Depression and realizing that the events of Europe may engulf it in a world war.

Gen. Yeager: Historians talk about the Great Depression that preceded World War II. There wasn't any Depression back in West Virginia; it was *always* Depression. My memory doesn't go much further back than about 1931, but as I remember there was absolutely no change in the economic situation around home. We ate well, we worked the farms, and life didn't depend on any industry or business.

My dad raised a family by working six days a week away from home, so Mom raised the kids. We were tied up in school work from eight in the morning until five in the afternoon, five days a week, and the rest of the time we worked in the garden, milked the cows, did chores after school. But the outside world—politics, world events, war in Europe—didn't enter my life at all. When you were from a small town in West Virginia, you didn't have a newspaper, and you didn't pay much attention to things outside your immediate surroundings. It was a simple lifestyle. You had work to do and you did it.

In 1940, when mobilizing began in the country, we did find out in a hurry that the move was on to get guys into the military service. There were only two recruiters who came through town; one was Army Air Corps, one was Navy. It wasn't that I was eager to get out of Hamlin, but joining up was the thing to do in those days. We were mobilizing and most of the guys had just finished high school and had nothing else to do except go in the military, and that's just what happened to me. Of the nineteen boys in my graduating class, every one of them went into some branch of the service—Army, Army Air Corps, or Navy. It was just the thing to do.

Col. Anderson: I grew up on a farm in northern California, and I can remember the Great Depression from newspapers, radio, and my mom and dad talking. I got an idea that times were hard. But, we grew up in hard times and didn't have anything to compare it with. My parents really kept the kids free from any sort of worry. They didn't come around and tell you that things were rough. But my mom went to work, and that was unusual, I thought, in those days especially.

I can remember hearing about the Battle of Britain and the war going on

in Poland. I was aware of European events, and had the feeling the war was going to come our way. I was particularly interested in the Battle of Britain because, from an early age, I was always interested in aviation. And, being from California, I went to school with a lot of Japanese kids, and there was a lot of news from the Pacific, too. I can remember the Japanese kids bringing Japanese comic books to school. They were very war-like, with flags and soldiers and fighting in them. I was quite aware of what was going on around the world.

Gen. Yeager: I was in the service at that time, and had been since September, 1941. I went through boot training at Ellington Field, Texas, then on to Mather Field in Sacramento, California, and finally to Moffett Field, where I was a crew chief on T-6's. On December 7, 1941, I was down at Tracy, California, on a Saturday night, running around with some nurse. The next day we were all in civilian clothes because you didn't have to wear a uniform at that time, and all of a sudden the radios were blaring and MP's were running up and down the street, saying if you were in the military, get the hell back to your base. So I went back to Moffett Field and reported in, and the first thing they did was start issuing rifles and .45 automatics.

I was transferred to Victorville, in Southern California, soon after that, and there was a lot of activity in air defense and a lot of anxiety. The whole West Coast was very jittery after Pearl Harbor. In January 1942 we had to build revetments for all our planes. It was a very tense time.

Col. Anderson: I wanted to fly, and had in mind joining the Army Air Corps. But you had to be twenty years old, have two years of college, be unmarried, and physically fit. I was only nineteen when I graduated from junior college, but I had taken an aeronautics course which qualified me to be an aircraft mechanic. The Sacramento Air Depot, which is now McClellan Field, was hiring as many mechanics as they could get, so I took a job there, and was just waiting until I was twenty, when I would join the Army Air Corps. At the Air Depot, I could really see the government building up its military capability. We were bringing in P-40's, crating them up and shipping them to the Pacific. We changed the fuel tanks to the self-sealing types on the B-17's as they stopped enroute to Hawaii.

Being single and young, they put me on the graveyard shift. After a full summer I had just gotten to the day shift in December 1941. On December 7, I had been to work for a few hours when the foreman rushed over and said, "Hey Anderson, go home and come back on the graveyard shift; the Japs have just attacked Pearl Harbor!"

You talk about hysteria. Everybody thought the West Coast was about to be attacked. I remember one night there was a real air raid warning. They thought there were Japanese planes coming in. They sounded alarms over the PA system, the lights went out all over the base, and all the employees had to walk out in the middle of the airfield to get away from the buildings. There were planes scrambled up and down the West Coast. Nothing happened, but the fear was real.

December 7, 1941: Pearl Harbor. The decision to go to war is made for us. Mobilization, which had started already, swings into high gear as the West Coast fears an invasion.

All the military services begin fast training of millions of American boys in the specific art and science of war. For flyers that meant intense hours in the cockpit.

Gen. Yeager: What flying is all about is learning how to fly your airplane without thinking. Basically the practice that we got, dogfighting, made you learn to fly that way. You learn how to cut a guy off in a turn, how to watch what he's going to do. We were being trained to be just fighter pilots. Gunnery, dive bombing, skip bombing, dogfighting—we sure got a lot of that. It was good training, starting with P-39's at Tonopah, Nevada, then advanced training in Santa Rosa, Oroville, and Casper. We were very lucky to get that kind of training. If you look at the history of the 357th Fighter Group, and how effective it was, you can see that the training paid off. Now, look at what it cost us. There were a lot of guys who got clobbered because, as Andy and I put it, those guys just weren't very good. They didn't have the ability. I watched a fellow in our squadron dogfighting, and he would over-rotate a P-39 at high speed and just snap it out. Later, he pulled the wings off a P-51 in a dive and killed himself. Somebody should have been real careful with him, maybe they should have washed him out. But that didn't happen during training. We were moving fast, and once you pin your wings on, you're supposed to know how to fly.

Our training was very intense. There was no "mickey mouse" discipline. You could go cut the tops off trees with your wings, run cars off the road, anything you thought you were good enough to do. A lot of guys weren't good enough to do it, and they creamed themselves.

When I went through flying school, the instructors could identify guys who probably would make better fighter pilots than others. They would assign guys to single-engine fighter school. Others would go to twin-engine school, and those were the guys who went on to fly bombers, B-25's, and P-38's. All instructors had five students, and I was the only one of my five who went into fighters when we got our wings. If they had told me to be a bomber pilot, I would have. Flying was flying to me. It didn't make any difference. After I flew fighters for a while, though, there was no way I was going to fly anything else.

Col. Anderson: Back before Pearl Harbor the government knew it was going to get in the war, and they knew it would need a lot of pilots. So they put a civilian flying program in many of the colleges to train pilots—the Civilian Pilot Training Course. For $7 in insurance you could get free training in Piper Cub-type airplanes and get your private pilot's license. Then when they built up the Army Air Corps, they needed pilots and planes as fast as possible. When you got into a tactical fighter unit, the training got very intense.

I can remember specifically wanting to be a fighter pilot, and when it came to the point of deciding where I was going to advanced flying school, the instructor asked each fellow what they really wanted to do. I said fighters, and he agreed.

With training, the subtleties of air combat become second nature. America's war machinery is honed to a fine edge, ready to be unleashed on the enemy in Europe.

Gen. Yeager: I don't think tactics have changed since World War I. For every situation you find yourself in, there are a million things that could happen. A guy can fly a million different ways and you have to follow him or cut him off. You just try to get behind him and shoot him down. It's different now because of advanced technology.

When we first started flying the P-51B, you really had to get into a narrow cone behind your opponent to shoot him down. 90-degree deflection shots were just pure luck. Then, when they came with the K-14 gunsight, that gave you the capability for 90-degree deflection hits. That made it easier to do your job. Today's technology has made it even easier for the pilots to do their job. When we were flying 51's against Germany, there was a lot of instinct involved. Today, a pilot launches a missile on somebody, there's a 99.9% probability of a kill. In P-51's in World War II, there were guys shooting up all their ammunition and never hitting anything.

Col. Anderson: The basic tactics remain the same. New weapons, air-to-air missiles, might cause a slight deviation from the basics, or require a new countermeasure, but the basic air-combat tactics are the same.

Both Chuck and I were blessed with good eyesight, and that is a great advantage in air combat. If you saw your opponent before he saw you, the odds swung heavily in your favor.

Gen. Yeager: You set yourself up to come out of the sun, kind of maneuver around so he couldn't see you, behind him and low. If he doesn't see you, he's dead. Ninety per cent of the guys who got shot down never saw the airplane that got them. They got sneaked up on.

A good element leader doesn't think just about himself, but about his wingman. You have to be very careful in a dogfight. If you're following somebody, you're depending on your wingman to keep you clear. You don't over-G your plane to the point where your wingman blacks out and you black out, because that wingman will never get back to you and you'll lose him. That happened a lot, though. I remember the day we got those German 190's. That was some high-G stuff. There were so many airplanes, and you were maneuvering so violently to keep from running into somebody, and guys were trying to shoot you down—we all lost our wingmen. They got home, but we all flew alone for awhile.

You can clear an area visually, and you know nobody's going to move into that area for a minute or two. That's where good eyesight pays off. It gives you situation awareness—knowing what's going on around you. If you see a guy coming way off, you know you've got a few minutes before he gets there, and you can maneuver against him.

Col. Anderson: It goes back to basic tactics. You've got a leader and a wingman. That is the basic fighting formation. The front guy is offensive-minded, looking for targets. The wingman is looking the other way, in a defensive role, for both himself and the leader.

Gen. Yeager: As a pilot you were gone five or six hours a day from Leiston, England, and you weren't all that cognizant of the day-to-day life on the base. But the mail came in and the food was good. The problem we had with food was

The training over, millions of men enter the combat zones of Europe and the Pacific. They learn to live in a combat environment— eating, sleeping, and breathing the war, doing their jobs with efficiency and dedication.

that our timing was bad. We'd take off at eight o'clock in the morning and land at three or four o'clock in the afternoon. The mess hall would be closed until five or five-thirty, so we would have to go into town to get some fish and chips and a couple of beers. Then you would be so tired you would just sack out. The next morning you wouldn't go to the mess hall, you'd go straight to your briefing because you'd sleep until the last minute. Then you'd go to your ops and have coffee with peanut butter and marmalade on toast, which was as good as anything the mess hall had for breakfast.

It was a well-regimented structure we had on the base, no half-baked kind of thing. You had a chain of command, a maintenance officer in each squadron, a line chief, a supply sergeant, a crew chief—it was all very disciplined. The guys all did their jobs. In fact, it was amazing how good the maintenance was in our P-51s. When you have a maximum effort like we got, the crew kicks out seventy-five airplanes, seventy-five airplanes go, do their mission, and come back.

Every day was just another day and another mission. You never looked at any holidays. I'd fly eleven straight days, then Doc Tramp, the flight surgeon, would look at me and say, "Chuck, go to London, relax, then come back in a few days." I'd do it and come back in worse shape than when I left! They expected you to stay in your hotel, or walk around a little bit. Bull. But I'd rather have been flying, because I might run into some Germans.

Col. Anderson: We can't say enough about the kind of support we got from everybody—maintenance, supply, gasoline. We were never short of gasoline, oil, or parts. If we needed an engine, it was there. We had them in supply. We nearly always put up every plane we had.

The crew chiefs did a great job with all the airplanes. The pilots always had the same crew chief. He was there for the duration. When we'd finish our tour, a replacement pilot would come in and take over the airplane and its crew chief. As a pilot you could go down and help him if you wanted, but, really, the pilots were too tired. If you flew a deep penetration mission, that's a long day—a couple of hours of pre-mission group and squadron briefings, four to five hours of flying, and the intelligence debriefing after the mission. The debriefing could take a long time if you had had an encounter, or shot somebody down. You had to write up the encounter, or tell them about it, sign it, and your wingman had to write up a confirmation. If you didn't get that, and you didn't have your gun camera film confirmation, you didn't get credit for the kill. Even if nothing much happened, the intelligence officers would want to know what you saw and any small thing that went on. We had two intel guys and sixteen mission pilots, so it took some time.

The P-51 fighter pilots flew an important mission: escorting Allied bombers from England to their targets and back.

Gen Yeager: We would circle above and below the bombers on their runs. Our job was to protect them. But you would not protect them by staying close; you had to get out and hit the guys who were going to hit them.

When we first got over there, I remember our first mission. I'm flying around and around this box of bombers, and German 109's are flying right through us, and I'm thinking, "Jeez, this is really neat; these guys are flying just like they told us

they'd be doing."

You'd have to admire those bomber pilots. The bomb runs had to be straight and level, with everybody boxed in. They knew where and when the flak would come, and they had to hold their course. We fighter guys got the hell away from there. We'd see B-17's get shot down on a bomb run, with ten guys aboard each of them, and we'd just sit there watching; we couldn't do a thing about ground fire.

Col. Anderson: In World War II the high command of the Eighth Air Force was run by bomber-oriented people. The orders for us were to stay close to the bombers. They almost wanted you to fly in formation with them. The bomber pilots wanted to see you outside their windows. But that really wasn't the smart way to do it. When Gen. Doolittle got over there in January 1944, we had more fighters and more relacements coming in, and he turned the rules around. Before, we couldn't chase German fighters below 18,000 feet. Doolittle said we could take them all the way to the ground and kill them. Our job became to destroy German fighters, and that made a tremendous difference.

From the ground today you can occasionally see the persistent, white contrails of a jet going by. Can you imagine the contrails from a thousand B-17's and a thousand P-51's and P-47's in the sky? To see and be part of a thousand-bomber raid was an incredible experience and an unbelievable sight. We'd create our own overcast some days.

I went back to Leiston a few years ago. It has almost all been reverted to farm land. But there is still a piece of the runway there, and some of the taxiway is still there. I got onto the base with the help of an Englishman, and we actually ended up right in our squadron area. Once I got out on the taxiway I got oriented, and I knew right where the North Sea was and I felt right at home. I pointed out where the tower was, where the runways were. Where our squadron parked is now a vacation spot for caravaners, and they have a little park there with a clubhouse with a P-51 model mounted out front, in our Fighter Group colors. I walked around a little bit and soon found my old hardstand. I found the very place I parked my P-51, *Old Crow*. It was a very nostalgic feeling for me at that moment.

Gen. Yeager: Toward the end of 1944, the German pilots who came up for us were very inexperienced. I'm told the average number of missions a German fighter pilot flew before he was killed was three. We, on the other hand, were very experienced guys with very good airplanes. We were decimating them very badly.

But I always felt, from the first airplane I shot down, that I could hack anything I ran up against in my P-51.

By the end of 1944 we had air superiority. We had the leeway to begin strafing runs on ground targets. Sounds easy, but it could be dangerous, depending on what you were doing and how you did it. Trains and convoys were one thing. But strafing a defended airfield, that was something different. Hit in

Relentless aircraft production and pilot skill and numbers eventually wear down the once-mighty Luftwaffe. Air superiority allows pilots to seek out ground targets of opportunity.

the right spot, like in the radiator, a rifle shot will bring down a P-51. Hell, a .22 shot in the radiator would bring you down. There's no armor under there. The only armor plate in a P-51 was in front of you and behind you. Here again, situation awareness would save your life. Doesn't make any difference—on the ground, landing, taking off, flying combat, strafing—it's knowing what is going on around you that is important.

I flew 270 hours of combat time on fifty-eight missions. I only saw Germans on six of those missions. But a German pilot saw enemy airplanes every time he went up. That's the reason why some of those guys shot down two-or-three hundred airplanes. They flew thousands of missions. But if you look at the number of missions we flew and the number of airplanes we shot down, it's basically about the same ratio German pilots were getting.

Col. Anderson: People have asked me many times, "Of all the airplanes you fought against, which one did you fear the most?" I didn't fear any of them. We all felt that if we saw anything with twin-engines up there, the first guy to get there got the most of them. And the type of single-engine planes didn't make any difference to us. They were no problem. It made no difference if they were Messerschmitt 109's or Focke-Wulf 190's.

But sometimes they wouldn't *let* us shoot them down. One time I was chasing three Germans in a formation, and I jumped this guy from behind. I surprised the hell out of him. He knew I had him dead, cold meat, so he just bailed out. He sacrificed his airplane, but he knew he could bail out and fly again tomorrow. The Germans had plenty of airplanes, but a shortage of pilots. They were over their own country, and some of these guys were bailing out a couple of times a day.

Out of 480 hours of combat flying, two tours of combat, 116 missions, I got hit only one time, and it must have been a rifle shot from somebody on the ground. We were strafing a railroad yard, and when I came back I reported no damage. The next morning the crew chief says he wants to show me something. We went underneath the left wing, and there was a hit. One tiny little hole. The chief used an English shilling coin to cover the hole as a patch.

We weren't scared of a thing in the air, and we were an awfully good fighter squadron. The beauty of our fighter group was being able to train in the United States as a complete unit, then go overseas together. You knew what everybody was going to do. I would always be able to recognize Chuck's voice; as a matter of fact, in our squadron you could tell who was who by the way they flew the traffic pattern.

War takes its physical and emotional toll. For many, the moral questions are simplified by the overriding dictum: Do your duty.

Gen. Yeager: World War II was part of my long career in the military. Basically, there are lots of things I don't remember, and if I do remember, I remember it wrong. Fifty-four years is a long time. But I do remember that in World War II we had to have fun. That's the one thing that went on in our squadron. When we were in the war, you had a lot of fun because you *had* to. If you went around moping and crying, it would get to you. There were a lot of guys getting killed. You'd see them get shot down and they wouldn't come home. If you didn't have a little fun in that

atmosphere, it would get to you. It was the same way in Vietnam. We had a lot of fun there. And we had a lot of fun at Edwards in the flight-test days. We had a lot of fun in Okinawa, and in Thailand. You have to, to keep your morale up and not let the bad parts get to you.

And believe me, there were bad parts. In 1944, we were very young and very dedicated. If we were assigned an area like three or four hundred square miles, the order might be, and often was, "Strafe anything that moves." You didn't think anything about it, because there is no morality in war. That's a thing that is hard to realize. But when you're fighting a war, there is no such thing as morality. War is *complete*. You can say later you shouldn't have done this or you shouldn't have done that, but you have to look at the time that it happened. Look at Dresden. We wiped it off the face of the earth, killed 38,000 people, as many as with a nuclear weapon. But to try to impose our morality now, fifty years later, on that event is just infuriating.

When we would go down and strafe people, civilian or military, it was just a mission. It was assigned to you, and you didn't give any thought to it. You had no emotion whatsoever, and I cannot emphasize enough that there is no morality in war. You can say now that that was bad. Well, *war* is bad. That's just the way it is. Look at us, 21-year-old fighter pilots, flying around shooting at people. There's really not that much difference between us and the Germans. They were out to win a war; we were out to win a war. But here's the important part—don't lose. Don't lose the war. If you lose, your atrocities will get you hanged. The winner's atrocities will get overlooked or forgotten.

To me, duty is duty, either side. It's like in research flying. People would ask, "Why do you strap yourself in an airplane that you don't know can fly?" Simple—because they tell you to do it.

Col. Anderson: Following orders in the German army led to the deaths of millions of innocent people. But there were many cases in the German army where if you didn't follow orders, it would get you killed, such as at the Remagen Bridge. The guy who didn't get that bridge blown up was executed. That is pretty tough. I can see why German soldiers would follow orders. You think the soldiers would have uprisen and prevented that sort of thing, but that's not the way war is. The Germans had an especially disciplined grip on their soldiers and officers. Disciplined by fear.

Col. Anderson: I remember coming back to the U.S. on leave between tours and the big question from everybody was, "Well, it's almost over with, isn't it?" That was the big concern, when the war was going to be over. In the summer of 1944, everybody had the feeling the Germans were going to crumble now that the invasion had started. But it wasn't to be. The war lasted almost another year.

A grateful and generous nation greets its returning heroes.

Gen. Yeager: When Andy and I came home from the war on the first of February, 1945, it was really, really neat. We took a train ride across the United States, and people would give us their sugar and all sorts of stuff. We'd be in our uni-

forms in the dining car, and they could tell we were just back from the war because we had lots of ribbons on our uniforms. They'd come up and offer us sugar, butter, bread, like we hadn't had any in years. They were all so generous.

It was the same way before we went to Europe. When I pinned my wings on and was sent to Tonopah—Andy was already there—I had to go through Reno, then wait a few days because the train only went to Tonopah three times a week. If you went into a restaurant to eat, you couldn't spend a penny. Some old rancher would say, "Gimme that ticket, son," or tell the waitress, "Give him anything he wants and send me the bill." They were really patriotic people.

The nation returns to civilian life. There are opportunities for some to remain in the military, but for most, private life beckons. Reliving the War is confined to the occasional unit reunion.

Gen. Yeager: Very few of our guys stayed in the service after the war. For many of them, there was no choice. You were separated. You couldn't stay in even if you wanted to. You were very lucky to get into a flying job. I was lucky in that I was an evadee [shot down and evaded capture], and I got the right to select a base. I picked Wright Field. I was just at the right place at the right time. I got to fly.

Since the war has been over, I've been to functions with German fighter pilots, but, you know, there is no such thing as recognizing your opponents, going up and waving at each other in combat. I've been hunting with some of them, and I've known some of them socially. I don't exactly love them, but I never hated them either. In combat you don't have a hate for your opponent. You've got a job to shoot his airplane down, and that's all there is to it. You either shoot him down or he shoots you down. When I see Gunther Rall [German fighter ace] at the Oshkosh Fly-In, we don't talk about combat. That was just a part of our duties. He'd tell a story about how he got his thumb shot off, then I'd tell a story about something that happened to me, but it's all told as ancient history, not as the brotherhood of flying.

Not that there isn't some honor in combat. For example, you don't shoot another pilot who is using a parachute. I personally don't know of a time it has ever been done. Now, when he gets on the ground and starts running, then he's fair game!

Col. Anderson: Of the original pilots in our squadron, ten are with us today. That's all; ten out of the twenty-eight original pilots who went overseas together. We try to get together every couple of years. Out of that twenty-eight, we lost exactly 50% in combat, either killed or POW's. The rest made it back, but some have died of natural causes since then.

We don't dwell on the events of World War II; we've all had busy lives since then. But we have been to a few reunion functions, sometimes with German pilots. They haven't been memorable. But somebody once got some of our fighter aces, myself included, to a party with some Japanese fighter pilots. The Japanese are very reserved people, more reticent in social situations. So they introduced the Japanese pilots and lined them up, and we're on the other side of the room, and the Master of Ceremonies says, "OK, now you guys get together and talk about those great air battles that you were in!" And it was the most embarrassing, quiet moment you can imagine. We just stared at each other and rolled our eyes.

But sometimes nostalgia does happen. For example, there are two airplanes out there now, painted up like Chuck's and mine; P-51's, exactly like the ones we flew in World War II, only prettier. But they're quite representative and very accurate. In January 1995, on the fiftieth anniversary of our last World War II combat mission, where Chuck and I flew together, freewheeling across Europe, sightseeing and missing one of the greatest air battles of World War II, we got these two airplanes together in Troy, Alabama. Chuck and I flew them several times on the exact fiftieth anniversary date. So you could say we've never really stopped flying P-51's.

Gen. Yeager: I believe that today there has been no change in the dedication to duty, capability, and skills of U.S. fighter pilots. In Vietnam, guys flew their missions, and the camaraderie was the same as ours in World War II.

There is a misconception in a lot of people's minds that guys in Vietnam were affected by the antiwar attitudes of Jane Fonda and others. I know I wasn't, and none of the guys in my wing were, and none of the guys in Andy's wing were. You see, you don't pick the wars you're going to fight in, where you're going to fight, or how you're going to fight. You do what you're told.

Col. Anderson: When I was in the Pentagon, they came around and said they needed a wing commander in Vietnam, and that my name had come up...did I want to go? I went, but I had a lot of misgivings about it. My peers said I was crazy. I was within two years of mandatory retirement. For one thing, I might get killed, and it was a lousy war, the morale was down, there were drugs in the service, and I didn't need that at that time in my life. But I did my duty as a military guy, and I made a conscious decision to go. First, because that's what I'm in the service to do, to fly and fight. But I went over there with a certain degree of bad feeling. I thought, I'm going to retire in two years, and I'm going to leave the service with this bad experience as the last thing I do. But I went to Vietnam, and I am so glad I did. I got over there and I found out that we've still got the fighter jocks I dream about and remember. All our guys need is a good mission to fly. Just like in Desert Storm. Let the pros plan it, let them execute it, with good ground rules, and it is still there. That old patriotism is still there.

In World War II, we were young. When I finished over there I had just turned twenty-three, and Chuck was just twenty-one, about to turn twenty-two—and we were *done*. And all the rest of the guys were about the same age. If you saw a guy twenty-five, twenty-six, twenty-seven years old, my God, the guy was over the hill. We were worried about those "old" guys. We'd say, "You've got to watch that guy—he's over thirty." In Vietnam the average age of pilots had to be in the thirties. I was forty-eight years old. We'd get these brand-new lieutenants, twenty-six or twenty-seven years old, and it was a whole different attitude. We'd say, "You've got to watch out for those young guys!" But they were really well trained and did a great job.

I found out in Vietnam that gung-ho guys were still around, and they didn't let all that antiwar crap bother them. Now, we knew that we were fight-

For professional military men, there were other wars in which to serve the nation. To their surprise, their old-fashioned dedication is matched by a new generation of patriotic combat pilots.

ing a dumb war, the way we were fighting it, with lots of political constraints, with our hands tied behind our back. Compare it to Desert Storm. President Bush, a World War II veteran who knew a little about fighting a war, said, "I want this over as soon as possible, here's the broad guidelines, now you military guys plan it and you execute it." What a difference!

Gen. Yeager: The rules of engagement in Desert Storm were told in one word: *win*. The rules of engagement in Vietnam would fill this room. Air rules were very strict. SAM missiles in a village? Can't hit it. MiG-21's taking off from a base? You can't hit the base.

But the military guys didn't let it bother them. You didn't pay any attention to it. That attitude was entirely different from what a civilian thought or, God knows, what the media thought. The antiwar stuff made any military man thoroughly disgusted. But it did not affect the morale of the unit at all. As a matter of fact, it strengthened it.

For World War II veterans, the residual memory of the War is one of solidarity, pride, and patriotism, the likes of which we may never see again.

Gen. Yeager: When I came back from Vietnam, I didn't find any antiwar feeling. I went to Chico State and gave talks, in uniform, and all I got from the students was, "Hey, man, we're all proud of you!" I believe all that antimilitary feeling was a function of the press. The media only shows the controversial things. I believe they gave a false reading on the mood of the country.

Col. Anderson: In World War II, once the decision to go to war was made, everybody got behind the war. We were young guys then, but as far as we could tell, one hundred per cent of the people in the United States were behind the government and the war effort. There was no dissension from that attitude. You'd go into a town and mostly you would see people in uniform. If a guy wasn't in a uniform, he was either physically unfit or he worked in the defense industry. The whole attitude of the country was that they couldn't do enough for their boys in the service. Everybody supported the war effort. The women went to work in factories. That was an absolute necessity because there weren't enough men to do the work. And patriotism was rampant. Flags were everywhere. The houses had stars in the windows—gold stars if a son had been killed in the war. And think about rationing. Tires, cigarettes, coffee, and sugar, all rationed. There were real sacrifices made so these things could go to the men in the service. I can remember my mom and dad turning in their aluminum pots and pans to help make airplanes.

It's gone a bit downhill since then. Patriotism isn't what it once was, like a lot of things in this country. You saw some patriotism in Desert Storm. Just think of that multiplied by one hundred. That's what patriotism was from 1941 to 1945. I can't think of anybody in those years that was antiwar or antiAmerican.

It was a tremendous feeling, and it made servicemen feel good to know that the country was behind them one hundred per cent. It may be the last time we as a nation will ever know that level of commitment and common purpose.

SOLDIERS

The War on the Ground

Although the Armed Forces had looked into the tactical advantage of color photography at least ten years before the start of the war, the disadvantages of Kodachrome's slow film speed, temperamental and fragile processing requirements, the scarcity and cost of 35 millimeter cameras and film, and iffy results on overcast days all combined to outweigh its one, colorful, obvious advantage. So, despite stateside magazines' hunger for good color combat pictures, not many were forthcoming from the professionals.

But some Army photographers and many GIs carried 35 mm color cameras—German Leicas, American Kodaks, and Argus C-3s—for personal snapshots. Most of their successful pictures were shot with slow-moving or stationary subjects, with plenty of sunlight, since early color film was very slow and yielded color brilliance only with flat, bright daylight. Usually they only found time for pictures during lulls in combat or movement, which explains the absence of much "action" photography in color.

From the perspective of the 1990s, these limitations seem providential, because they forced photographers to plan, compose, and await the correct lighting for their pictures, giving us a uniformly high-quality photographic yield. And, as you will see, the rich pigments of the Kodachrome dyes give these pictures a depth, warmth, and detail that has not faded in fifty years.

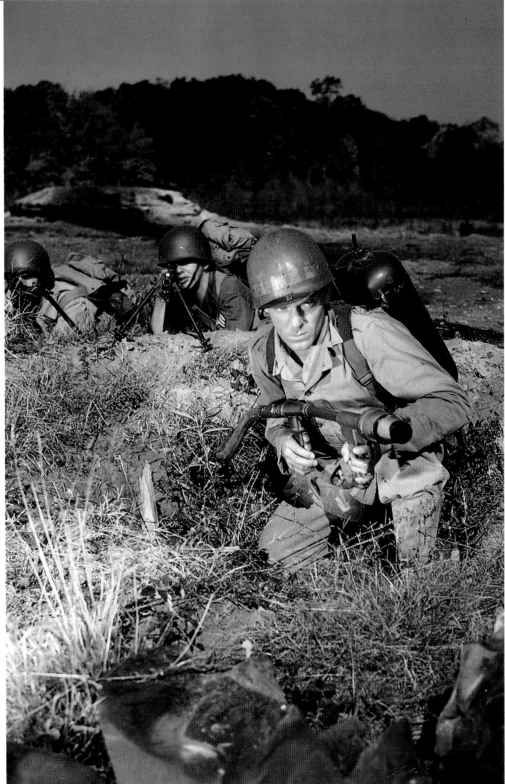

National Archives

A small infantry unit trains with the M2-2 flame thrower at the Edgewood Arsenal near Baltimore, Maryland. This particular weapon found its usefulness in fighting an entrenched, hard-to-reach, but immobile enemy.

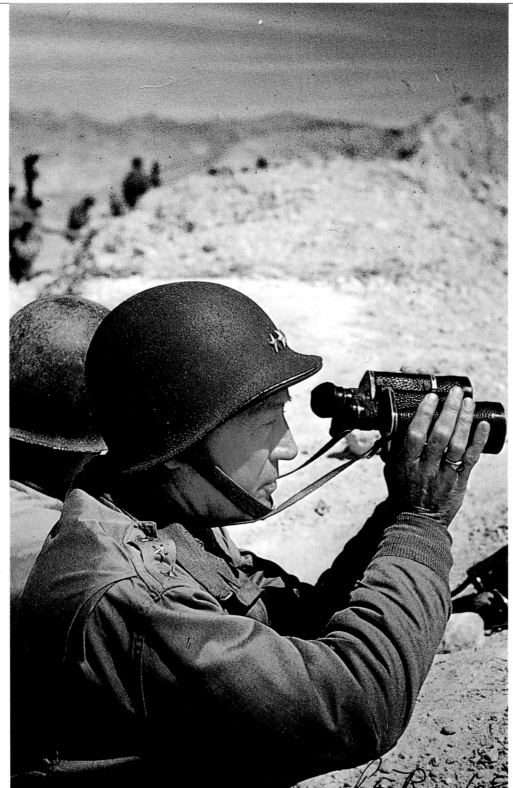

National Archives

Gen. George Patton takes a look at the battlefield while commanding the U.S. Seventh Army during the Sicilian Campaign of 1943. Impulsive and tactless, Patton was nonetheless one of the finest field commanders of the war. He was an armor tactician whose creed was, "Attack rapidly, ruthlessly, viciously, and without rest."

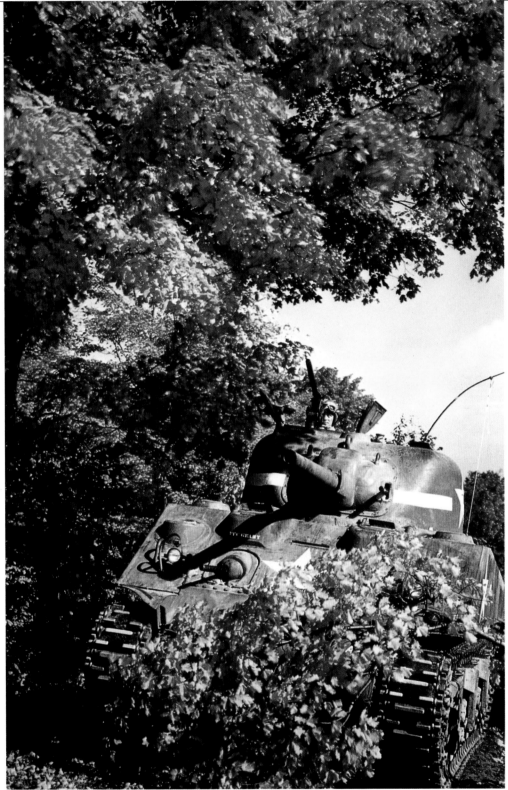

The M-4 Sherman tank was the workhorse in America's armored force. It wasn't the prettiest vehicle ever built. It was nonetheless a rugged, versatile, reliable machine upon which many an American soldier rode across Europe.

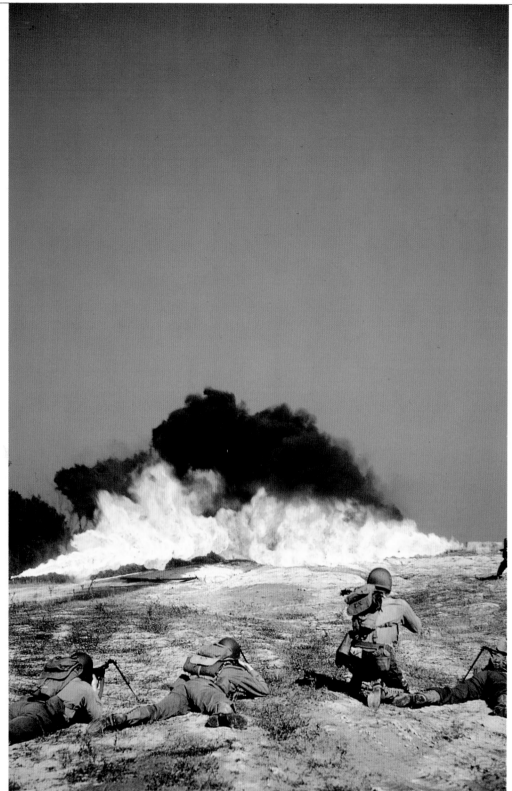

National Archives

In late 1944, the U.S. Army was fighting against the Japanese in the jungles of Leyte, and against the Germans in the hedgerows of Bastogne. The flame thrower became an effective weapon in those close-quarters situations. Thorough training in the proper use of the flame thrower preceded the arrival of troops in the Pacific and Europe.

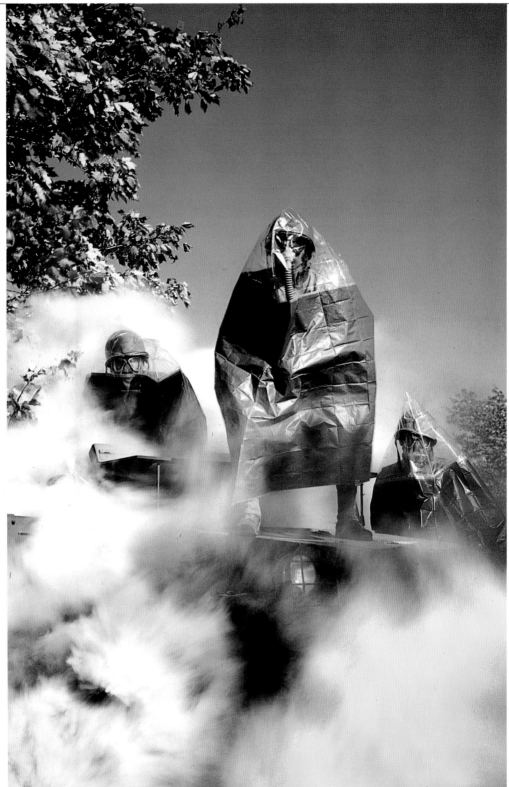

National Archives

Both the Allied and Axis forces had the ability to deploy chemical and bacterial agents on the field of battle at any time during the war. Luckily, these weapons were never used by either side. To be safe, though, U.S. troops were trained in the use of gas masks.

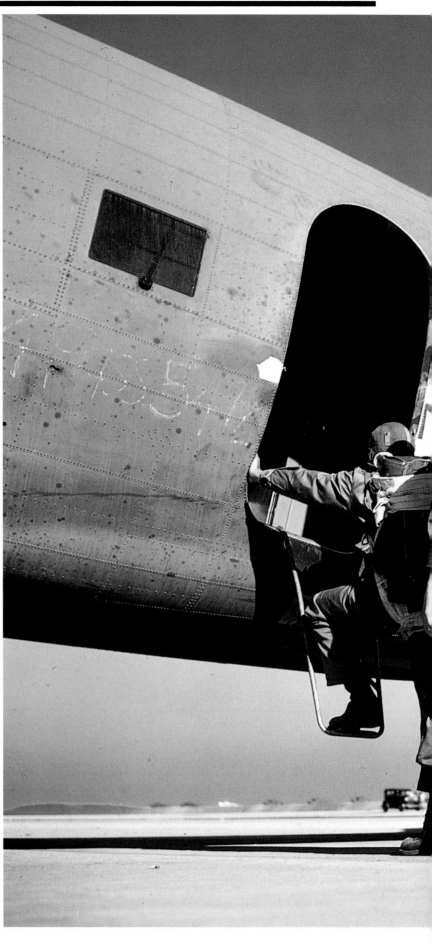

Young paratroopers load into a Douglas C-53, a version of the better-known C-47. The C-47, also called the Skytrain, Skytrooper or Dakota, was a critically important aircraft for the Combat Cargo Command, for it carried troops, supplies, and equipment into far-flung, inaccessible spots around the world. Gen. Dwight D. Eisenhower called it one of the four weapons that won World War II. (National Archives)

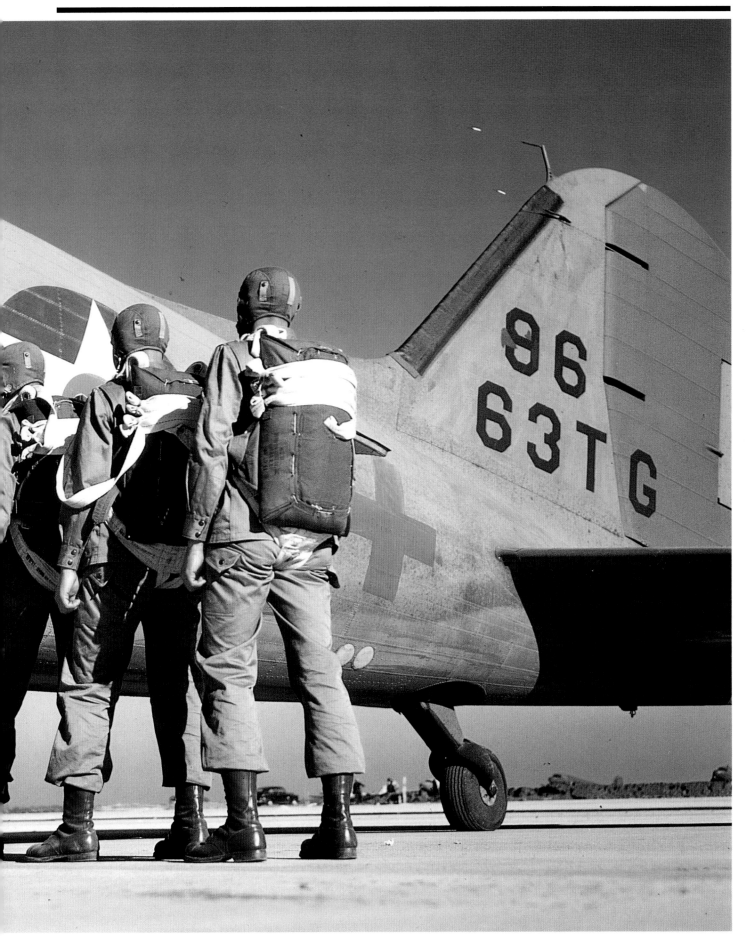

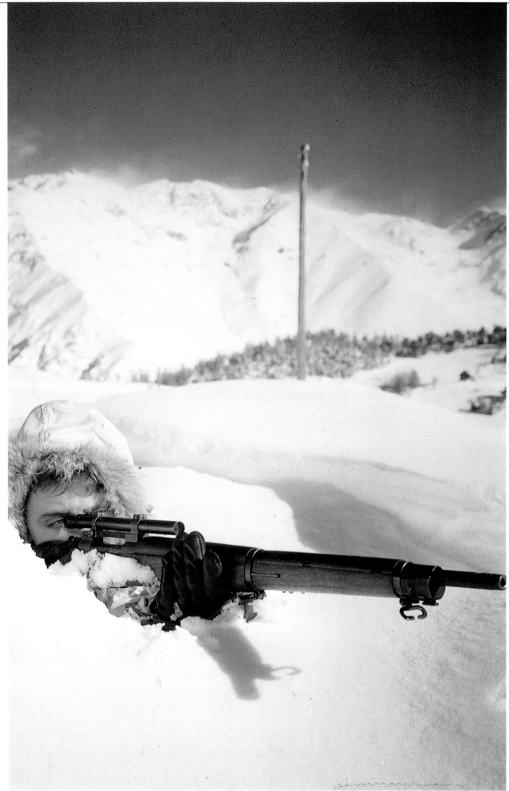

Sgt. Douglas Dillard, a sniper with the Parachute Infantry Battalion, sights a target from his hidden position in the snow of the French Alps. Winter camouflage clothing was available for some units; most fought in olive drab.

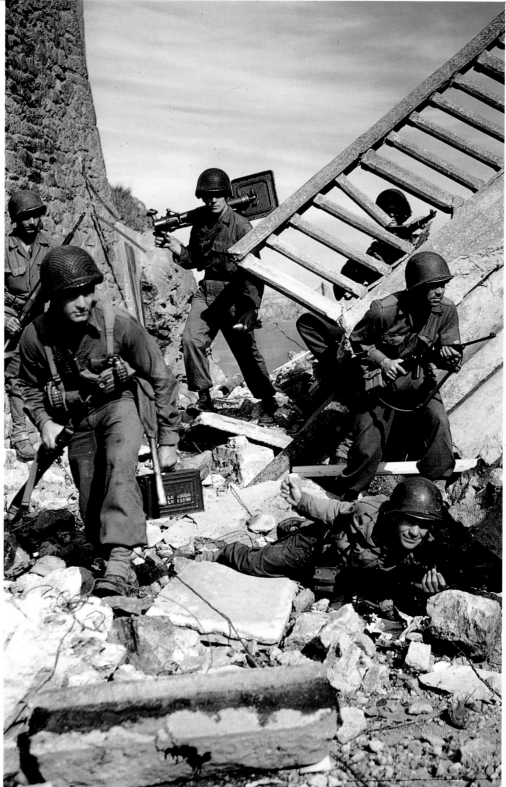

National Archives

A mortar squad moves to a new position amid the
ruins of St. Malo, France, 1944. Town-clearing duty
was a nerve-wracking job, with retreating Germans
putting up the occasional stubborn resistance, and
booby-trapping vehicles, equipment, and even dead
bodies left behind.

A Navy PBY pilot takes a break in his quarters at Samarol, New Guinea. These Black Cat Catalina crews attacked Japanese shipping and installations at night, a necessity for survival in the slow-flying PBYs, then tried to sleep during the daytime. The mosquito netting was a deterrant to malaria, and kept insects from robbing pilots of much-needed sleep.

In November, 1943, Marines moved on Bougainville, at the top of the Solomon Islands. Like every island battleground before it, Bougainville was a misery of jungles and snipers and hidden enemy. The airstrip won there became a staging point for air strikes on Rabaul, New Britain, the Japanese stronghold.

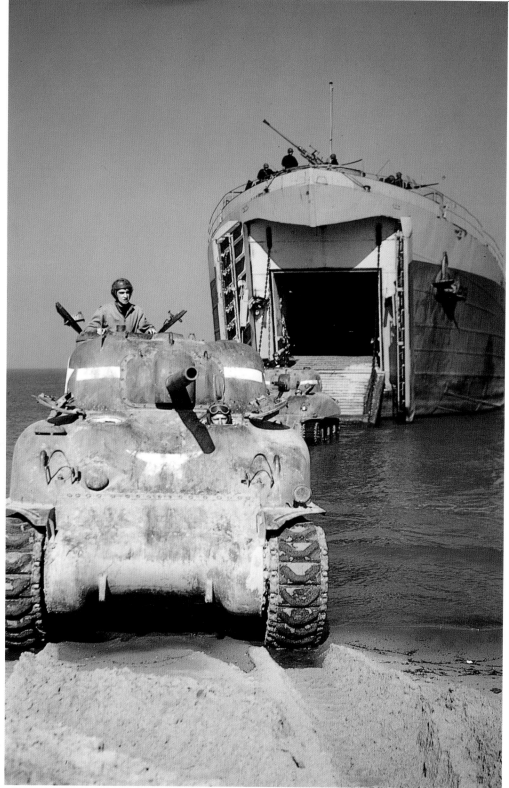

A line of M-4 Sherman tanks debark from an LST. Although this landing was entirely peaceful, the massive LST (landing ship, tank) was capable of fire support, both forward to the beach and skyward to attacking planes. Such amphibious landing ships were not developed until 1941, when a few far-sighted individuals saw the coming need for them.

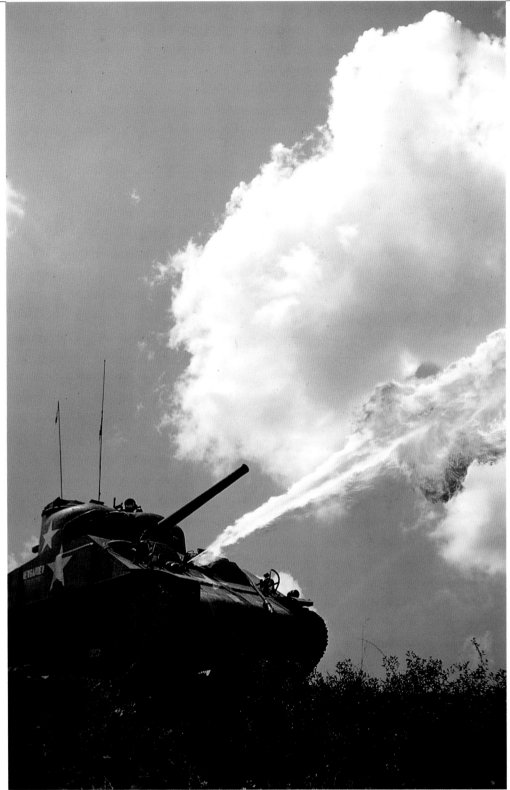

National Archives

An M-4 Sherman tank, fitted out with the E-4 Series flame gun. This tank was the most durable armored vehicle in the history of American armor. Despite the development of new tanks like the M26 Pershing and the M48 and M60 Pattons in the 1950s and 1960s, the Sherman was used on many battlefields for three more decades, including the Vietnam War.

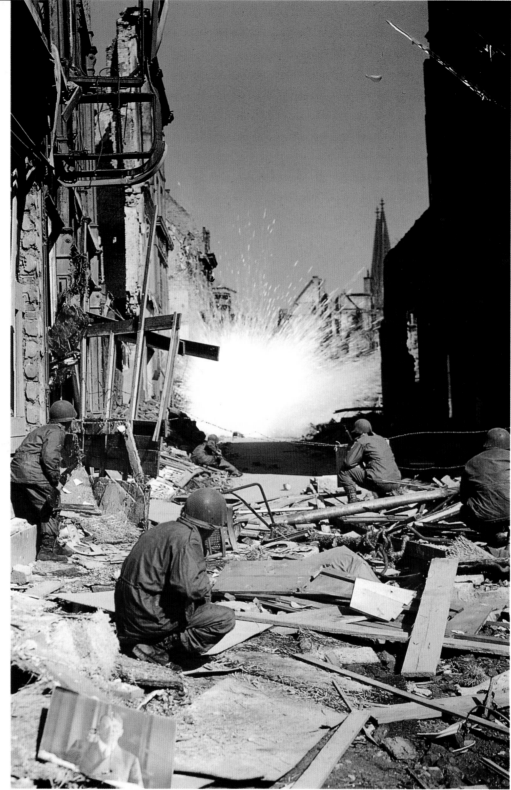

National Archives

Elements of Company F, 325th Glider Infantry, advance in a street-sweep operation through the rubble of a German village. The pockets of resistance in this theater were sporadic but often fierce, and grenade explosions, like the one in the background, came out of nowhere.

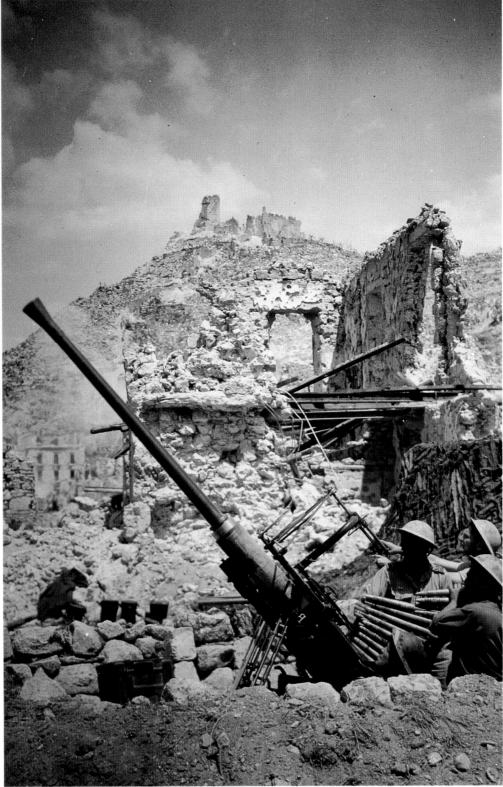

National Archives

A British 8th Army artillery crew mans a 40mm Bofors AA gun near Cassino, Italy. The legendary action around Cassino was a microcosm of the war: fierce, heroic, and tragic, with American bombers reducing the ancient abbey town to rubble in an attempt to pry crack German troops from their mountain-top positions.

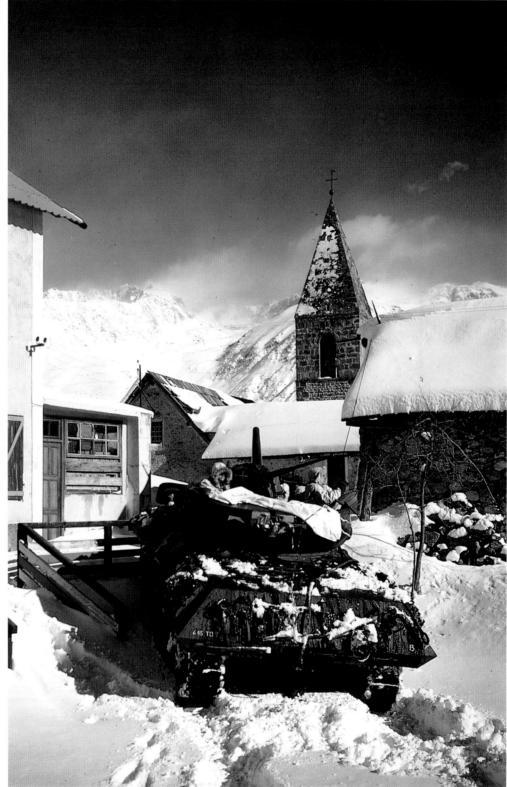

It's five days before Christmas, 1944. In the beautiful French Alps, there is no time to enjoy the view, as an American tank destroyer is about to begin shelling German positions. The M-10 Wolverine shown here mounted a 76mm gun on a Sherman tank chassis. A newer model, the M36, which arrived about this time in Europe, had a 90mm gun.

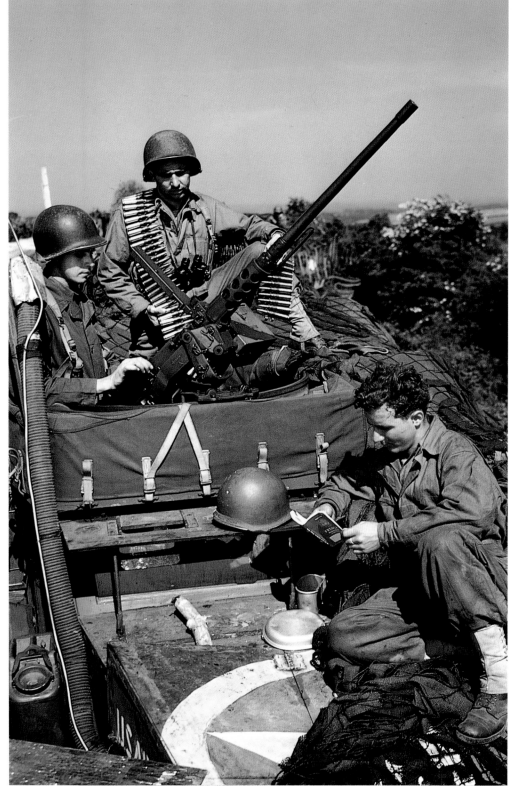

National Archives

The Allied invasion force was assembled in England over a long period of time prior to D-Day (June 6, 1944). Specialty units, such as tank crews, mortar teams, and so on, practiced their roles for months, never knowing when the invasion orders would come. This is a halftrack crew in the south of England, spring 1944.

George J. Fleury

Battlefield conditions, but you've got to shave once in a while. The "steel pot" helmet was used by GI's for all kinds of purposes—as stove, sink, and bucket—as well as the one for which it was intended. Here Lt. Col. William N. Darwin, executive officer of the 345th Bomb Group (Air Apaches) makes good use of his at Dulag, Philippines, 1944.

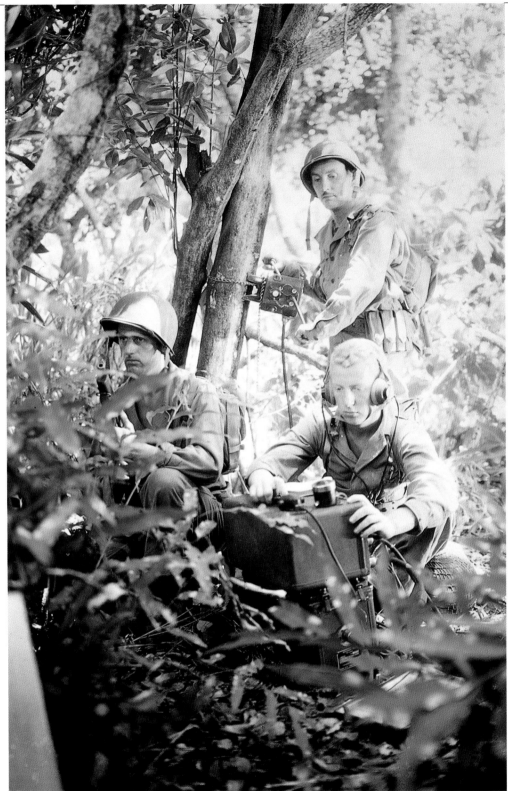

National Archives

Pfc.'s Harvey Tilley and Robert Dalton make up a Marine communications unit on Guadalcanal, December 1943. Cpl. Ashton Howard stands guard. The jungle canopy of the 'Canal hid a variety of dangers; wariness and quiet was always a good policy.

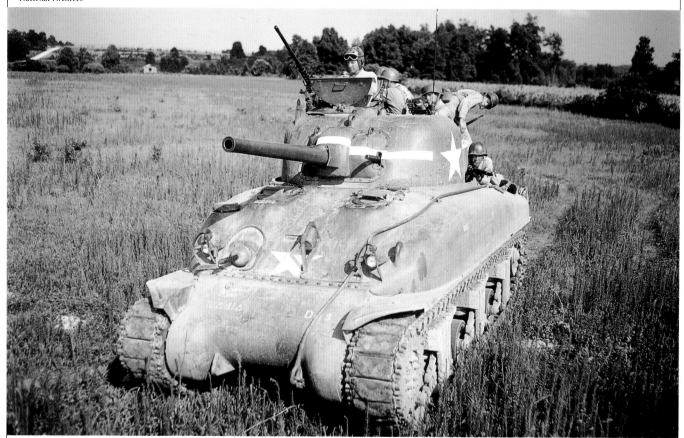

An M4 Sherman tank fitted with a 105mm gun. This armament gave the M4 much bigger punch, something long needed since the early Shermans were lightly armed and armored compared to their German opponents. The M4's strong point was maneuverability, a trait its crews relied on for survival and victory in a fight.

National Archives

America's armor capability in 1941 was minuscule, especially compared to Germany's mighty hardware and experience. America went to war with outmoded equipment, such as this M2A3 Light Tank. Hurry-up training took place at armor centers like Fort Knox, Kentucky, and in armor exercises as shown above in rural Tennessee and South Carolina.

Company 7, 129th Infantry Regiment, 37th Division, opens up on a Japanese position with its 37mm gun. This action was typical of the house-to-house fighting that took place near Manila, Philippines, in January 1945. Gen. MacArthur's early priority upon invading the island was to rescue the 3500 American prisoners held at Santo Tomas.

National Archives

U.S. armor rolls across the Italian countryside in late spring, 1944. The drive to Rome was completed on June 4, 1944, when Gen. Mark Clark led the 5th Army into the city. This was not the culmination of the invasion of Italy, however; fighting northward was to continue through the end of the war.

Clyde H. Barnett, Jr.

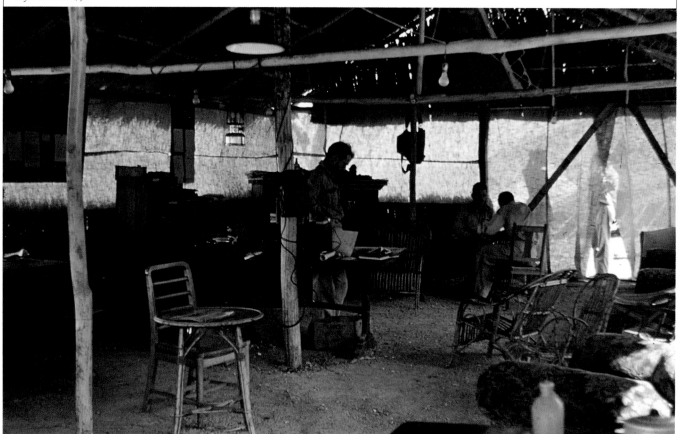

The 49th Pursuit Group Officer's Club at Strauss Field, 27 miles north of Darwin, Australia. American P-40 pilots were stationed there in April 1942 to help defend Australia against the anticipated first waves of Japanese bombing.

Frederick Hill

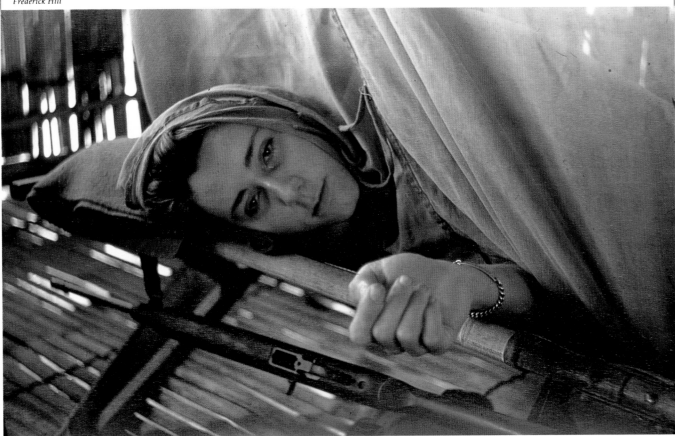

Sgt. Van Reimer of the 17th Reconnaissance (Bomb) Squadron climbs into his bunk at Binmale, Philippines. This island nation was the scene of both defeat and triumph for U.S. forces over a three-year period. Gen. Douglas MacArthur's return in January 1945 was a strategic and symbolic victory for the Allies.

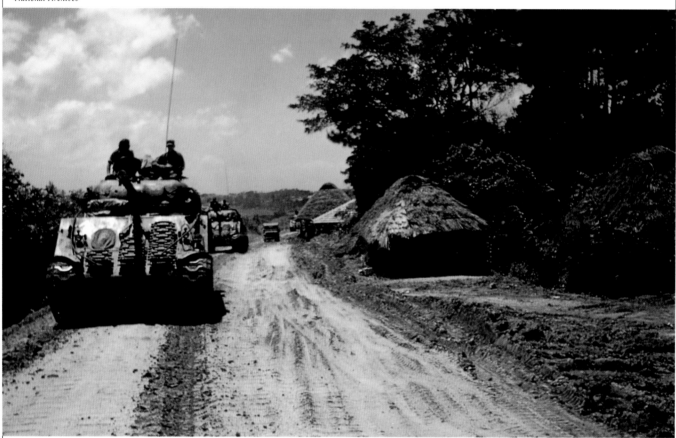

May 6, 1945. U.S. Marine Corps tanks are moving
on Okinawa. This 700-square-mile chunk of land
was the site of the war's last and largest amphibi-
ous assault. By the time it was over 110,000 Japa-
nese soldiers were dead, and the Allies had a ma-
jor staging area 350 miles from the Japanese main-
land.

James G. Weir

A group of the 19th Fighter Squadron, 318th Fighter Group P-47 Thunderbolt pilots on Saipan, 1944. The Marianas was the scene of the fiercest fighting of the Pacific War, involving Marines, Navy, and Air Force assets. When the dust cleared, 23,000 Japanese troops were dead, including their commander, who committed hara-kiri, the Japanese ritual suicide.

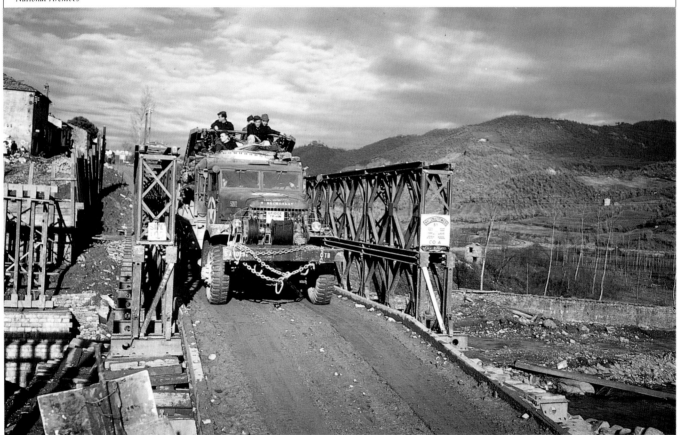

American half-ton trucks cross a Bailey bridge in the Italian mountains near Ponetta, December 1944. The Army Corps of Engineers built thousands of these sturdy but temporary bridges to keep supply lines moving to the front. At this point in the war, combat action had shifted out of Italy toward Belgium, where the Battle of the Bulge was forming.

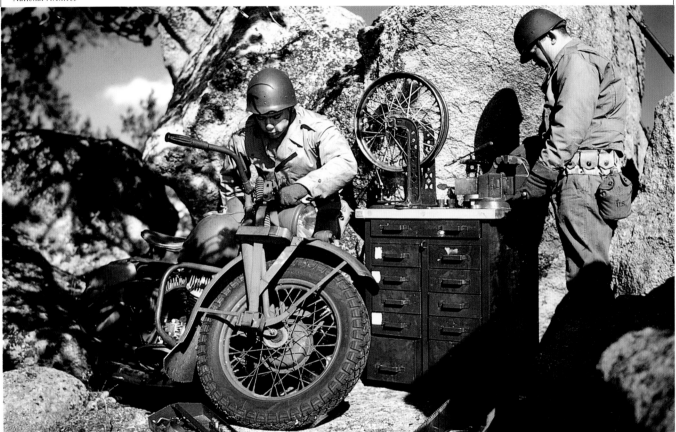

Motorcycle dispatch riders had a role in the European war, navigating some terrain easier than Jeeps and halftracks. These vehicles were the precursors of the Harleys and Indians that became popular with returning veterans and other free-spirited Americans in the 1950s.

William Skinner

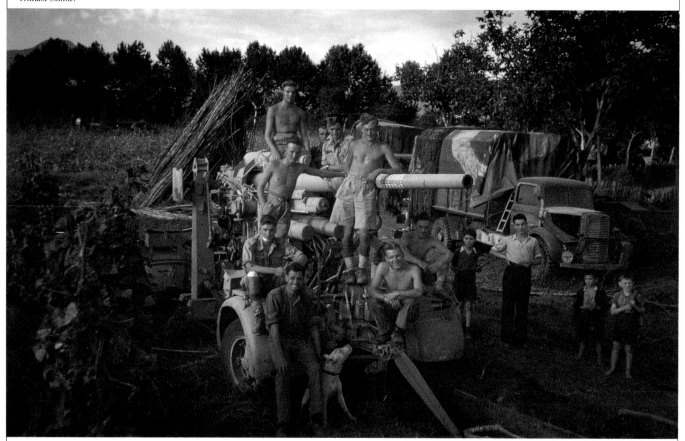

American and British soldiers pose with a captured German 88mm flak gun in Italy. Note the kill markings on the barrel. The "88" was the most feared of all German anti-aircraft weapons. Luftwaffe gun crews were able to place large sections of simultaneous fire at a specific altitude, leading to the expression, "flak so thick you could walk on it."

Ted Sedvert

After the Normandy invasion in June 1944, American fighter pilots relax on the beachead. The Ninth Air Force moved its close air support outfits from England to France as soon as the first makeshift airstrip could be put in place. Living in tents with very little assistance, these pilots flew in support of ground troops until the end of the war.

John A. Franz

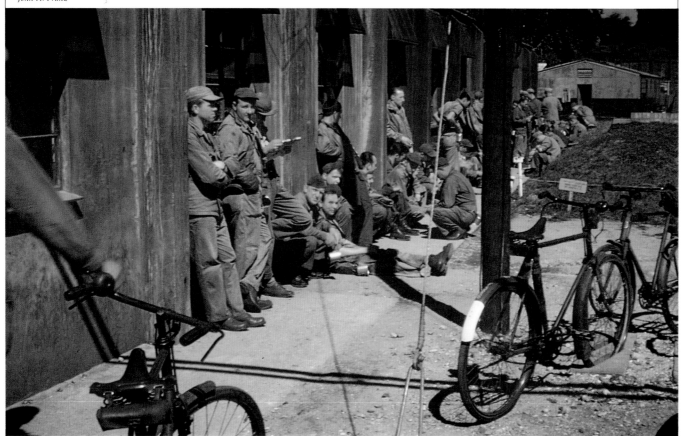

The enlisted-men's mess hall at Fowlmere, England, home of the 339th Fighter Group. Every Army Air Forces unit depended on its enlisted troops to keep aircraft operational. Since most of the flying was done during the day, maintenance personnel had to stay up late and get up early, even in the worst weather.

Stanley Wyglendowski

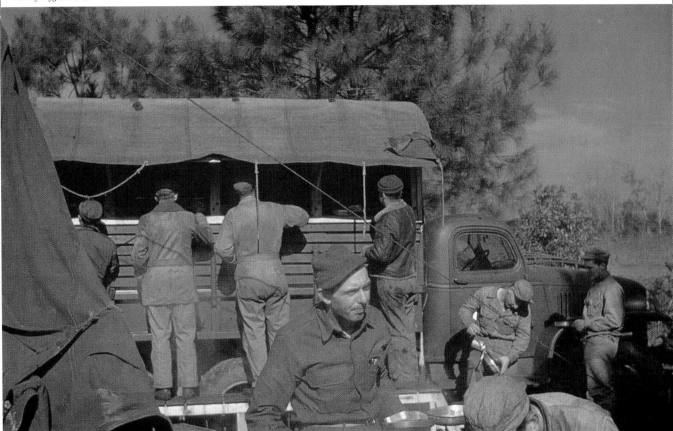

The 406th Fighter Group on maneuvers at Wampee Strip, near Myrtle Beach, South Carolina, in January 1944. They are getting ready to support the Normandy invasion, and part of their training includes how to live outside like ground troops, since no formal quarters will be available to them.

Richard H. Perley

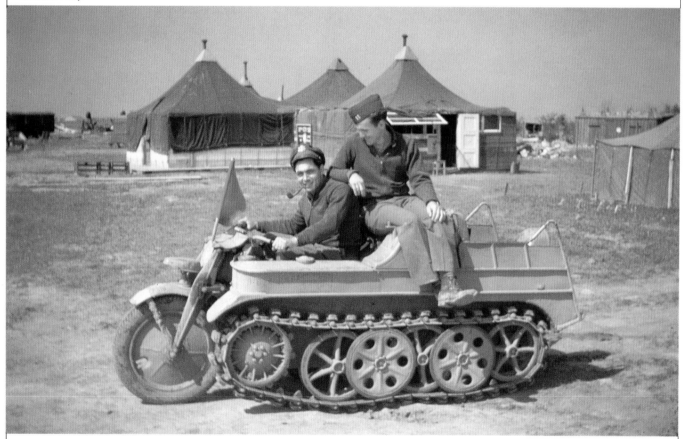

Pilot Phil Savides drives a captured German Kettenkraftrad with fellow pilot Dick Perley as a passenger at Toul-Ochey, their 50th Fighter Group base in France, November 1944. Essentially a motorcycle tractor with treads for rear wheels, the vehicle was used to move through semi-rough terrain, often towing light guns and equipment.

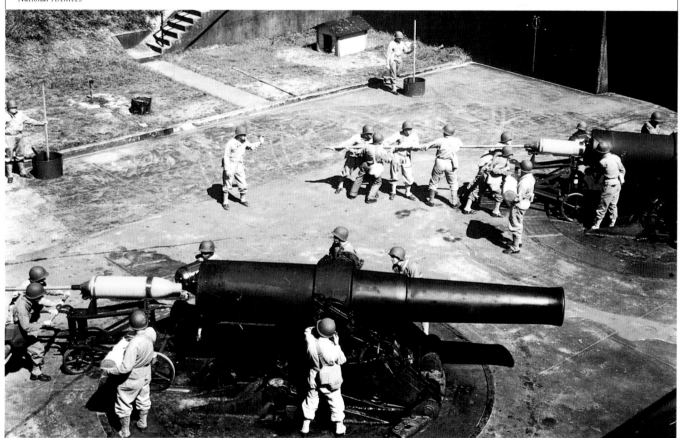

The Army's shore-defense plan before the advent of long-range bombers centered on massive coastal artillery like these 14-inch guns in California. They were already obsolete by the time this photo was taken in 1942. Ironically, the only way a prewar isolationist Congress could be convinced to develop the B-17 was as a new form of coastal defense.

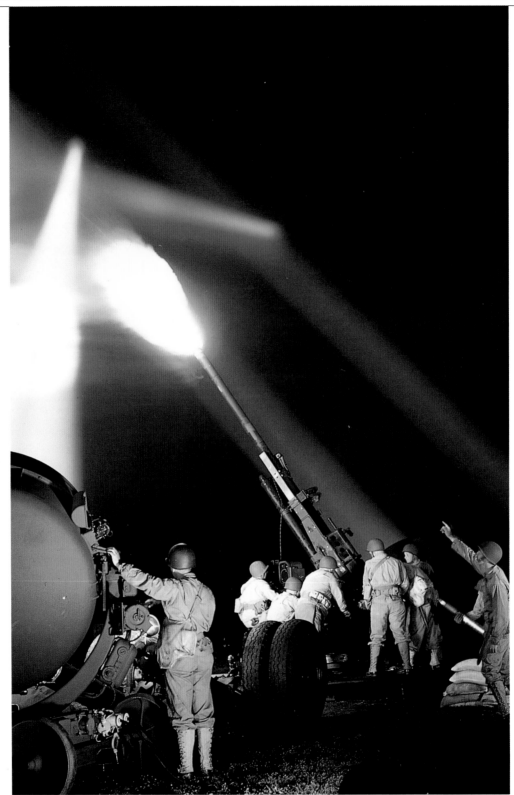

As searchlights probe the sky, a U.S. 90mm gun crew fires a round in a practice session in California, 1944. Training exercises such as these were largely held at night, the time when they suspected real attacks from Japan would probably come.

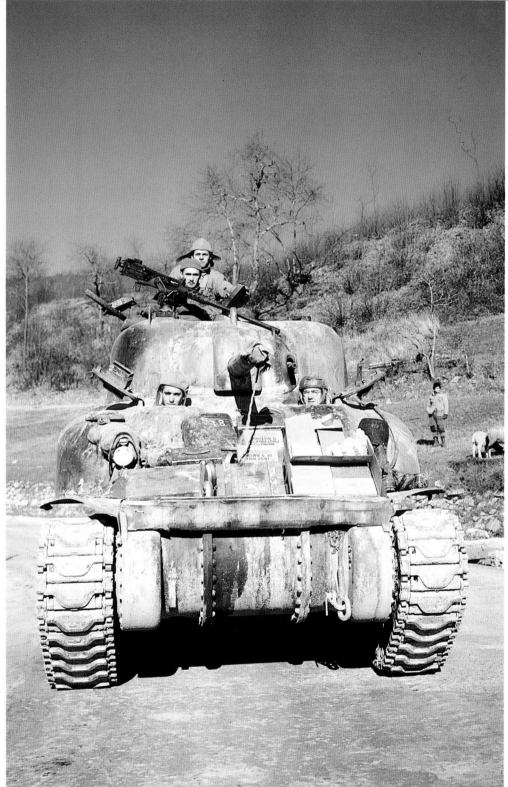

National Archives

As sheep graze in the Italian sunshine, a well-worn Sherman tank from the 1st Armored Division conducts its business near Lucca, Italy, 1945. The Italian theater of operations was quiet at this time, but thousands of other Sherman tank crews to the north were racing toward Germany in the breakout after crossing the Rhine at Remagen in March.

National Archives

American paratroopers trained in 1944 for the amphibious assault on France that began in earnest in mid-August in the skies over the Riviera. These troops were among the Seventh Army assets that sent the Germans on a 30-day retreat,removing them completely from French soil.

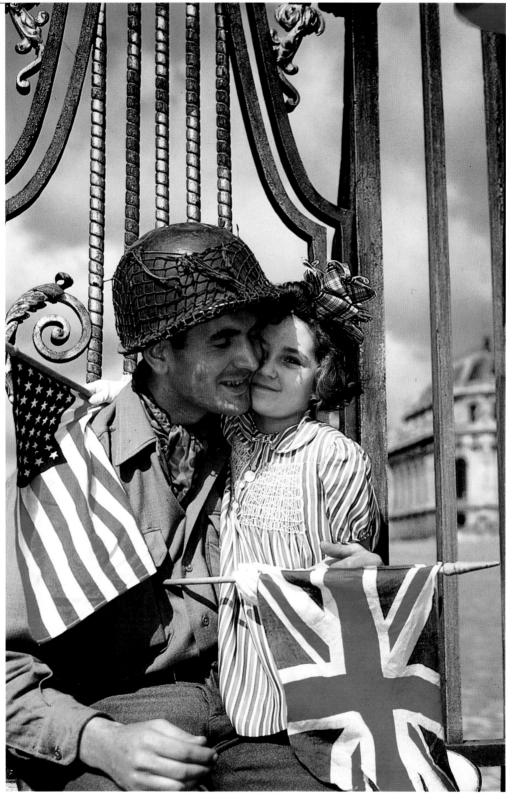

National Archives

When the shooting stopped in Europe, American GI's were instant heroes to entire nations of grateful people. American soldiers overseas have always had a soft spot for children, and here a GI, who is as happy as anyone that the war is nearly over, makes a young English friend.

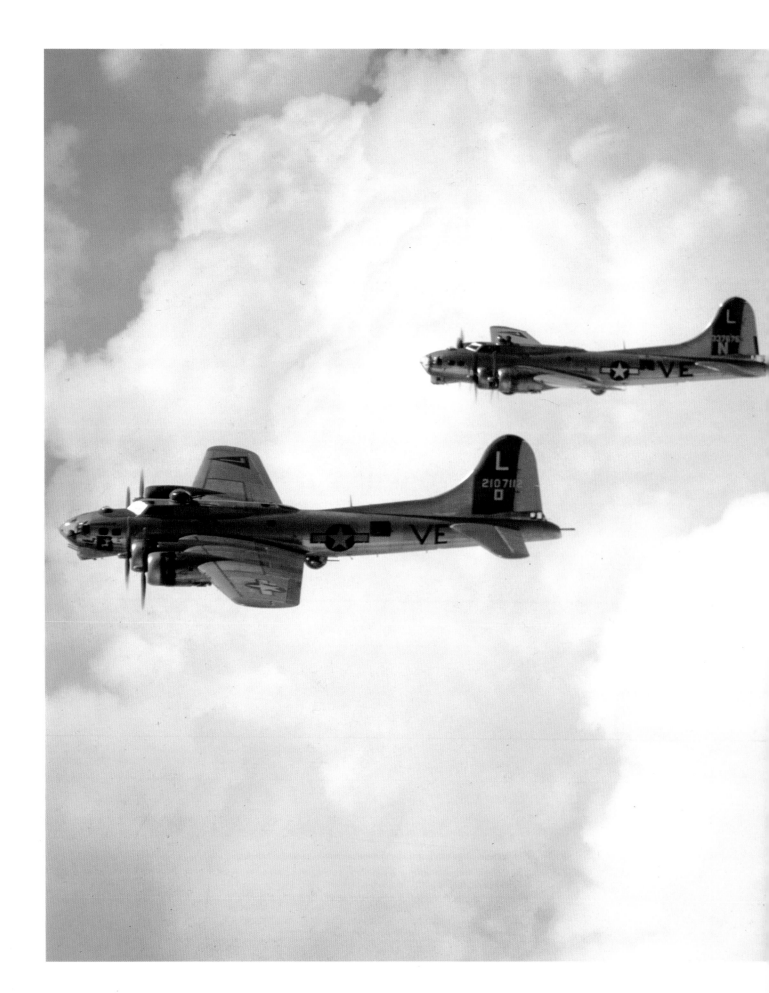

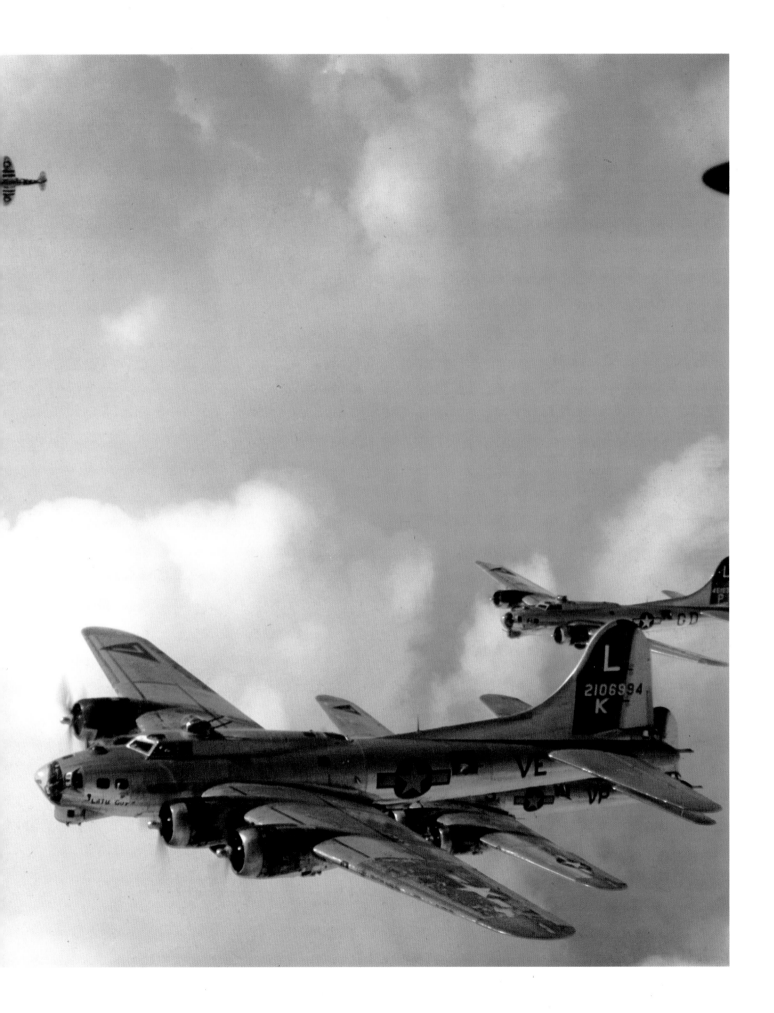

AIRMEN

The War in the Air

The biggest portion of extant color photography of World War II was taken by personnel involved in the air services, or by professional photographers who chose planes, pilots, and flying as the most photogenic subjects for the magazines, posters, and ad art that kept morale high at home.

It seems that among pilots, navigators, gunners, or crew—in the States or overseas—somebody always had color film. Perhaps it was because air bases, in general, provided a comparatively stable, clean, safe rear-guard environment for picture-taking. Or perhaps it was simply because the blue skies and silver planes were too beautiful, and the flyers too dashing, not to photograph.

Previous page: The majestic sight of 381st Bomb Group B-17 Flying Fortresses in the skies above Europe. This formation is escorted in the background by a P-47 Thunderbolt. The B-17 was ubiquitous in the war, and survived by flying at high altitudes, though it was still vulnerable to anti-aircraft fire and enemy fighters. (USAF)

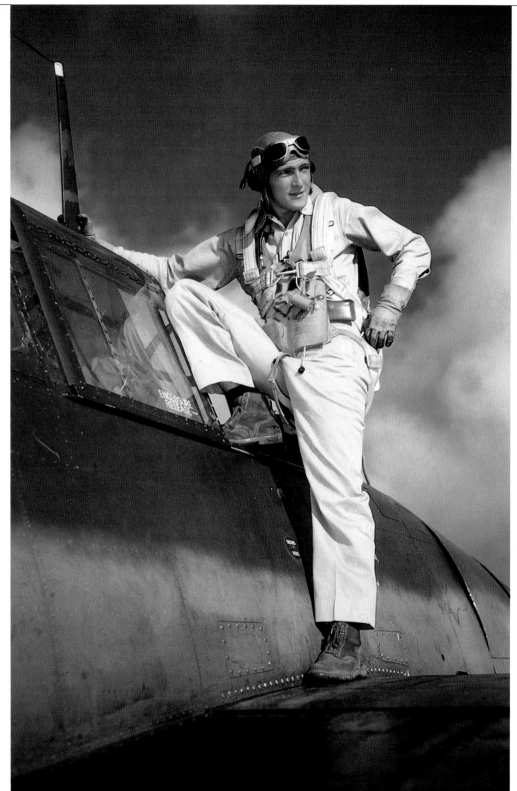

National Archives

This TBM Avenger pilot is about to fly a mission from his aircraft carrier. By mid-1943 the Navy had caught up with and surpassed the enemy in quality of aircraft and pilots. Newer aircraft like the Avenger, Hellcat, and Corsair were flown by pilots with superb training, often at the hands of combat veterans who were rotated home to pass on their expertise.

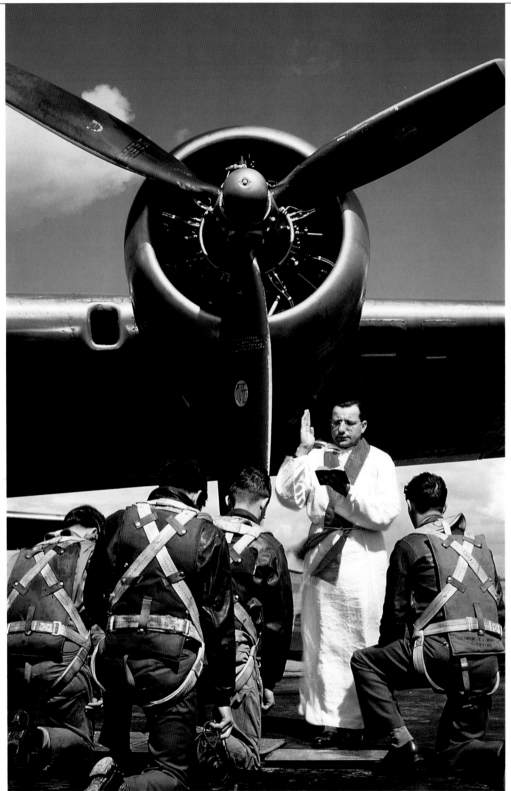

National Archives

Before a mission, a B-17 bomber crew from the 91st
Bomb Group out of Bassingbourn, England, attends
a short flightline service and receives a blessing from
Padre Captain M.S. Ragan, a former pastor of St.
Paul's in Cleveland, Ohio.

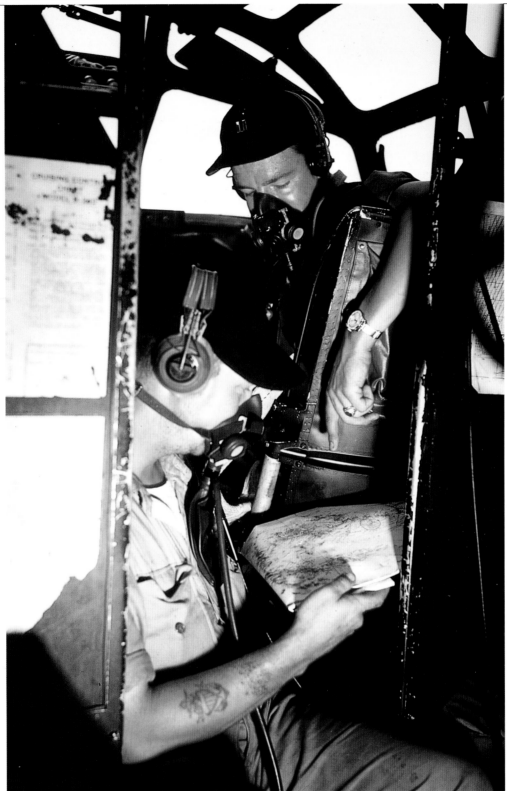

USAF

A Marine PB4Y-1 Liberator crew uses a well-worn map to fly the corridor between Guadalcanal and New Georgia, December 1942. The PB4Y was the Navy's version of the B-24 bomber, and was used to good effect in patrolling the vast expanse of the Pacific Ocean for enemy shipping or other targets of opportunity.

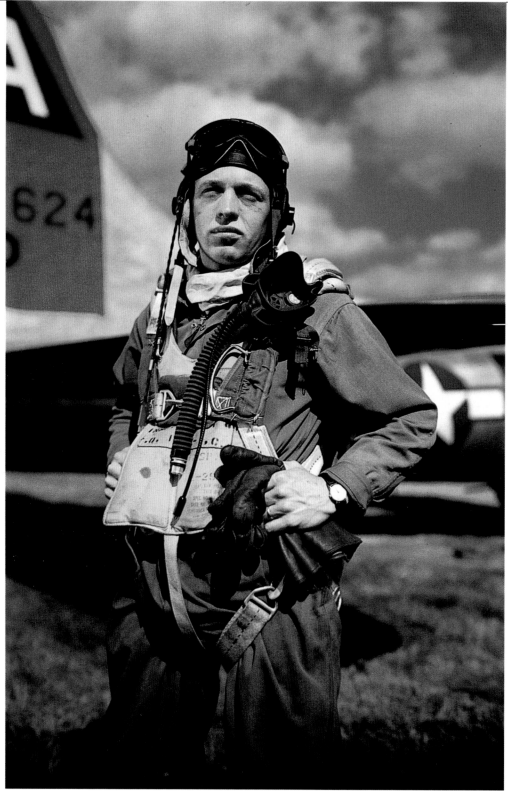

USAF

1st Lt. Willis H. Kennedy, Jr. stands in front of his
91st Bomb Group B-17G at Bassingbourn, England,
in the summer of 1944. He wears standard-issue
flight equipment—gabardine flight suit, Mae West,
leather gloves, helmet with earphones, oxygen mask,
goggles, and parachute. With cockpit temperatures
as low as -60°F, warm clothing was essential.

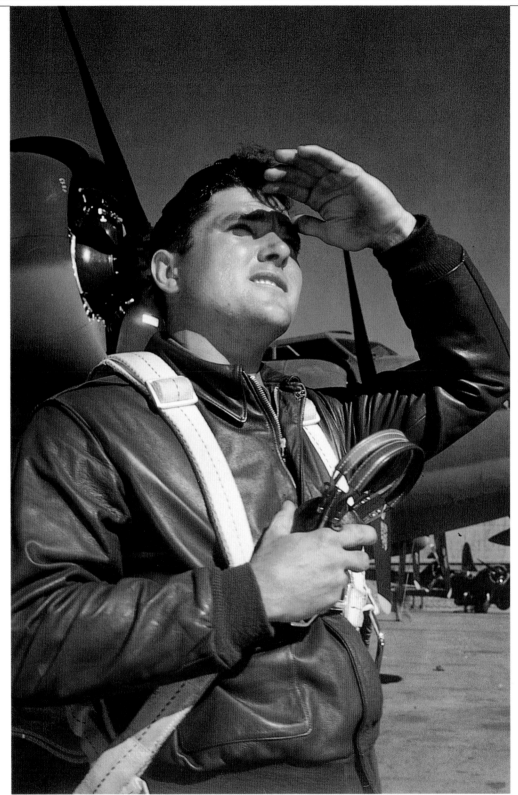

USAF

Bombardiers like this one got trained stateside before being shipped to forward air bases in England, India, and New Guinea, among others. The Norden bombsight they used was a vast improvement over previous methods of putting ordnance on target, but being able to put a bomb in a pickle barrel from 30,000 feet, as was boasted, was an impossibility.

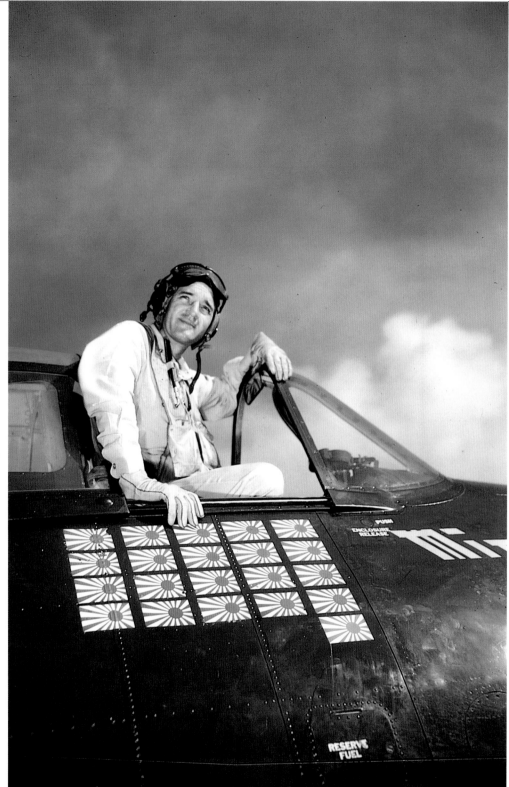

National Archives

Lt.Cdr. David McCampbell, commander of Air Group 15, sits in his F6F Hellcat "Minsi III" aboard the USS Essex, November 4, 1944. He won the Medal of Honor when he downed nine Japanese aircraft in a single mission. Before the war was over he had a total of 34 kills, making him the leading Navy ace of all time.

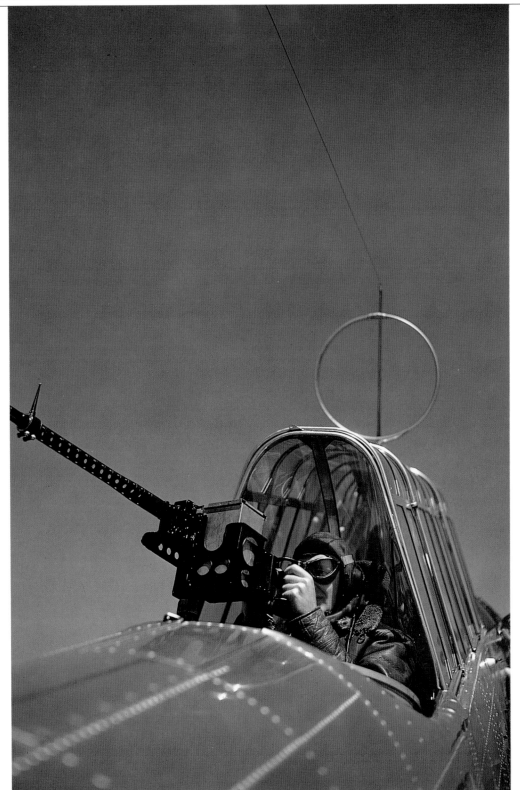

The O-47, like other single-engine, multiple-seat aircraft, had a rear-facing position for a machine-gunner to protect the pilot's blind side. Most had .50 caliber armament, unlike the .30 caliber in this photograph. One of Japan's leading aces, Saburo Sakai, was almost killed by rear-seat gunners in a clash over Guadalcanal in August 1942.

Fred E. Bamberger, Jr.

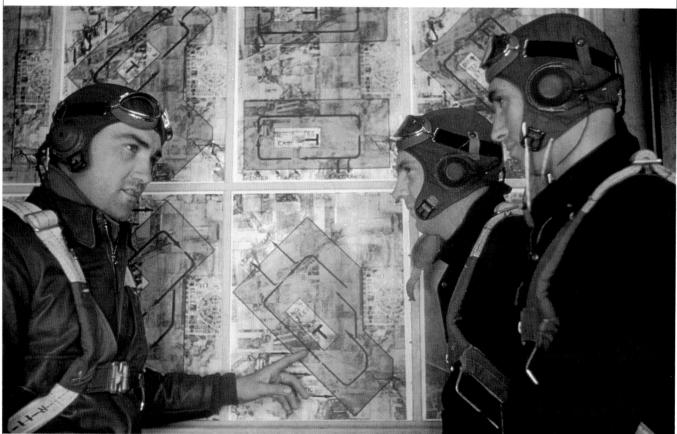

An Army instructor and two trainee cadets go over one of the landing-pattern maps at Randolph Field, Texas, the West Point of the Air, in November 1941. The pre-war Army Air Corps was woefully underfunded, but one of the miracles of World War II was the speed with which over 80,000 American pilots were trained by 1943, fifteen times Japan's output.

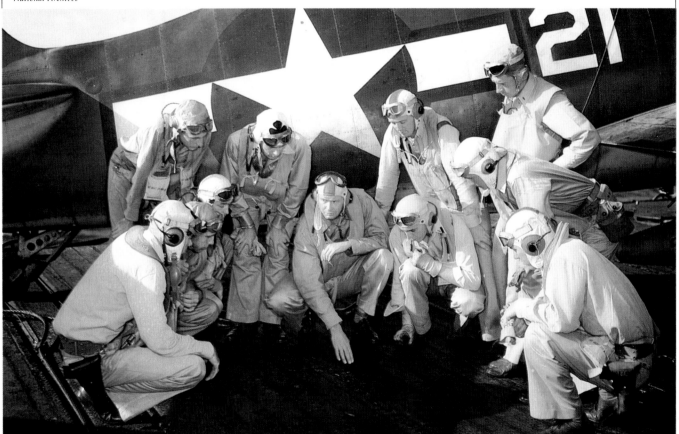

Grumman F6F Hellcat pilots hold an impromptu briefing on the deck of the USS Lexington before flying a mission in late 1943. Navy Hellcats dominated Japanese carrier and land-based aviation across the Pacific, shooting down more than 5,000 enemy aircraft in two years. Pilots found the airplane easy to fly, rugged, and with a good gun platform.

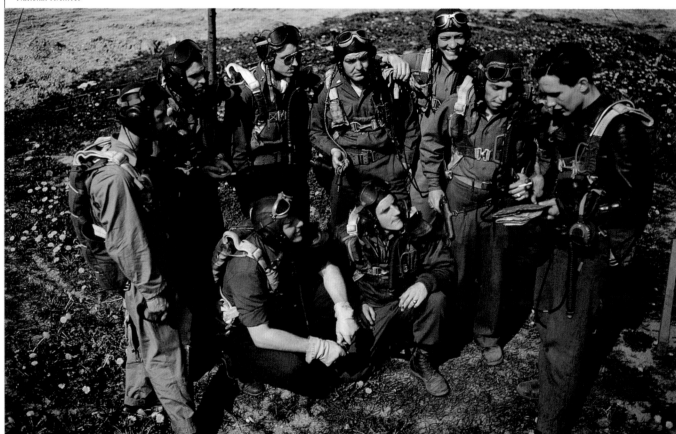

The commanding officer of the 355th Fighter Squadron, 354th Fighter Group, conducts an outdoor pilot briefing at Ober Olm, Germany, April 1945. In the last month of the European war, U.S. fighters were staging against German targets from inside German borders.

F.M. Grove

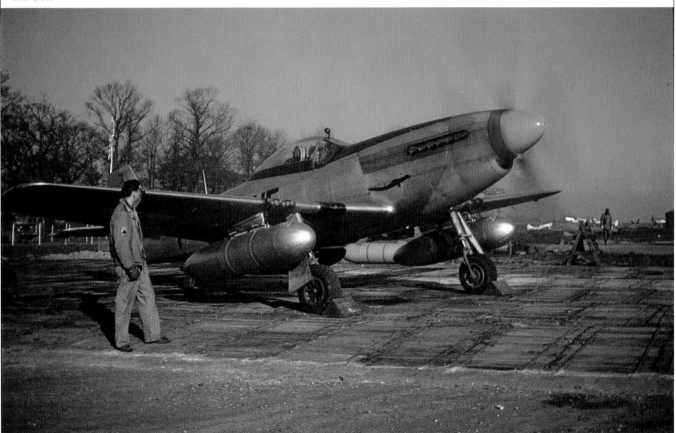

The North American P-51 Mustang was the "little friend" of American and British bombers on their runs to Germany, blunting the Luftwaffe fighter attacks that had nearly destroyed the Allied bomber fleet earlier in the war. This 4th Fighter Group P-51D of Lefty Grove is being run up by its crew chief at Debden, England, winter 1944.

National Archives

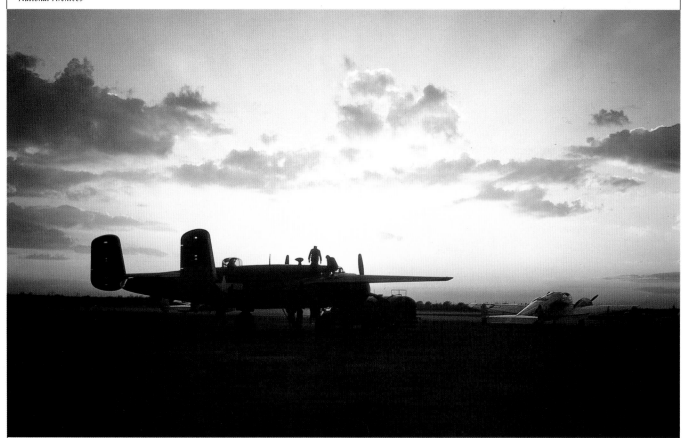

The sun sets on a North American PBJ at Naval Air Station New Orleans in 1944. The PBJ was the Navy version of the B-25 Mitchell medium bomber. Flown mostly by Marine Corps pilots, PBJs roamed the Pacific, harassing Japanese shipping and island installations, often under the most severe combat conditions.

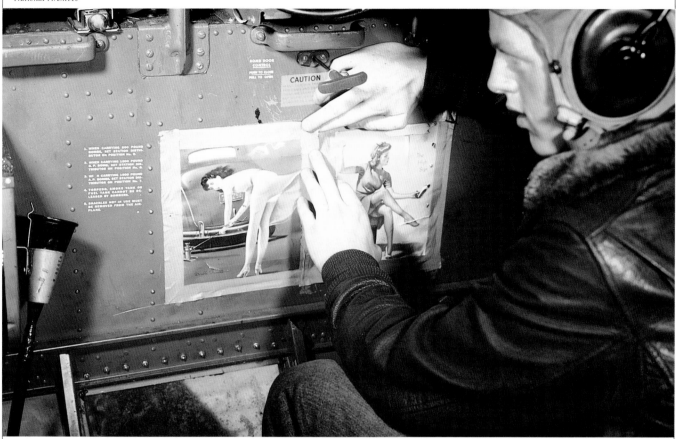

Aviation Machinist's Mate K.A. Meredith carefully places his new pin-ups in his crew station on a TBF Avenger. Pin-ups were a fact of life for overseas GI's, and many stars, such as Betty Grable, will be remembered, among veterans at least, more for a single photo than for a lifetime of film performances.

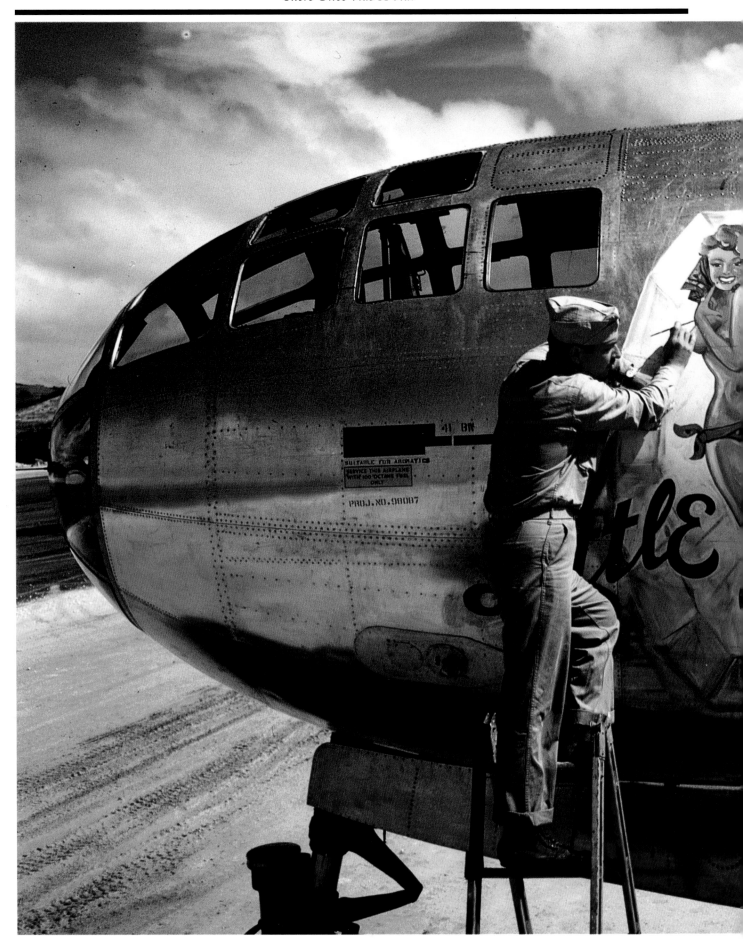

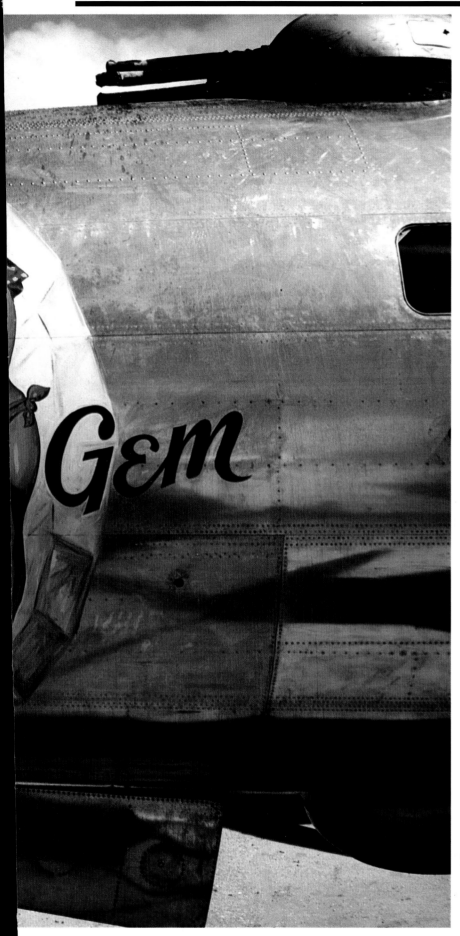

Nose art on all manner of aircraft was popular during the war. It was all unofficial, with amateur artists sometimes staying up all night in the cold with runny paints in order to personalize and decorate the airplanes. Here on Saipan, Marine Pfc. Randall Sprenger creates his magic on the B-29 "Little Gem." (National Archives)

John L. Lowden

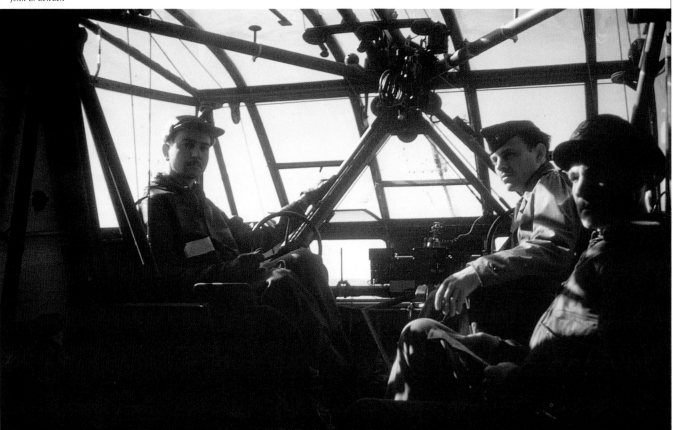

The flight deck of a CG-4A glider, just before Operation Varsity, the invasion of Germany, March 1945. These big gliders were a silent way to insert troops close to enemy lines. They were expendable airplanes, meant for one-way use only, with an expected 50% casualty rate for both crews and glider-borne troops.

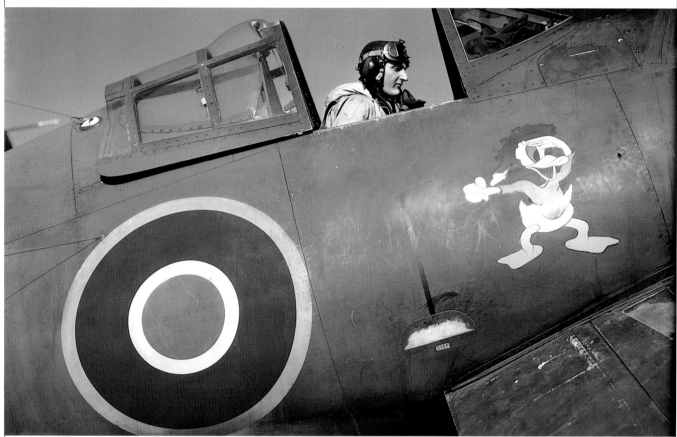

A British F4U-1 pilot at Naval Air Station Quonset Point, Rhode Island, September 1943.The U.S. supplied airplanes and training to the RAF when their resources were severely stressed by the air war over England. Disney characters like Donald Duck were popular with all pilots, showing up even on German aircraft.

Walter E. Zurney

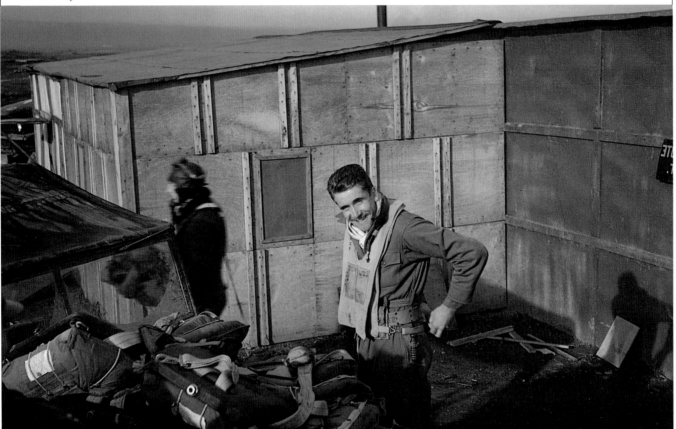

Ist Lt. Al Durell of the 82nd Fighter Group prepares
for another mission in his P-38 Lightning out of
Foggia, Italy. The operations shack behind him was
made from discarded drop-tank crates, which was
the only wood available in war-torn Italy. Officers
and enlisted men also lived in shacks like these.

Robert T. Sand

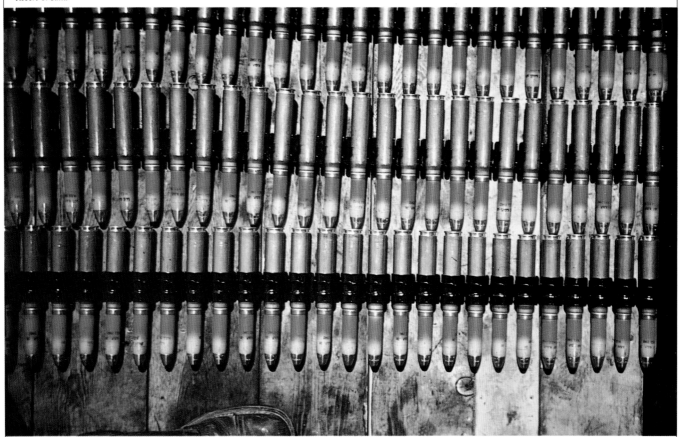

These are color-coded 20mm cannon shells for a 55th Fighter Group P-38 Lightning. Color-coding enabled the armorer to identify and load different rounds—high explosive, tracer, or armor piercing—to correspond to mission requirements.

George E. Miltz, Jr.

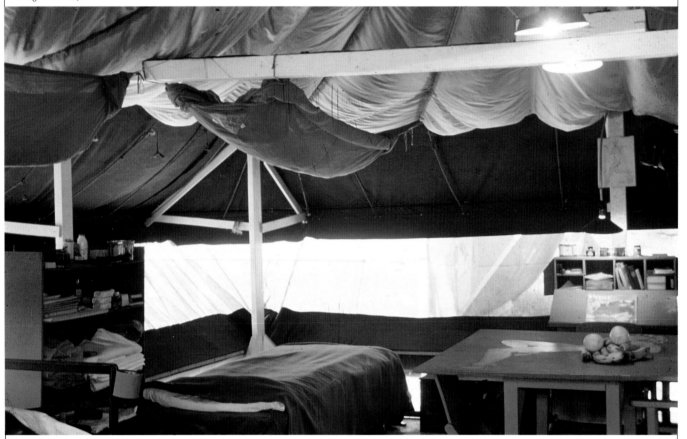

C-46 pilots of the 7th Combat Cargo Squadron called this tent in Leyte, Philippines, home, at least temporarily. As the front line moved closer to Japan, Army Air Forces units would move with it, pulling up stakes and relocating constantly. Transport units like the 7th were called on to keep line units resupplied, carrying everything from bullets to bread.

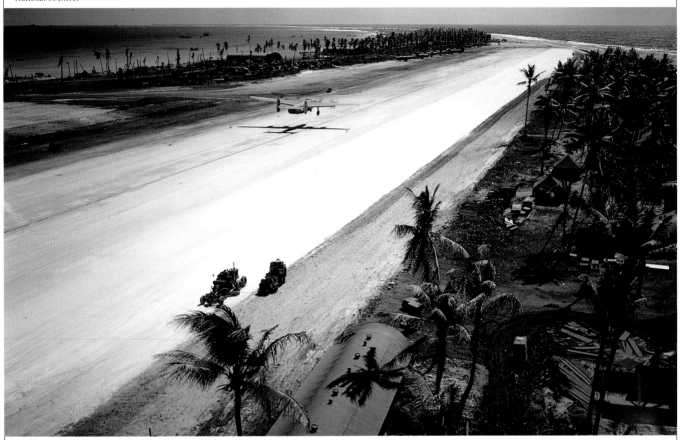

Island airstrips such as this one on Eniwetok in the Marshall Islands were built by the Seabees (CB=Construction Battalion), who participated in every Pacific landing of the war. With bulldozers and earth movers they transformed jungles into small towns with roads, bridges, and airports. Here a B-24 has just become airborne, February 1944.

National Archives

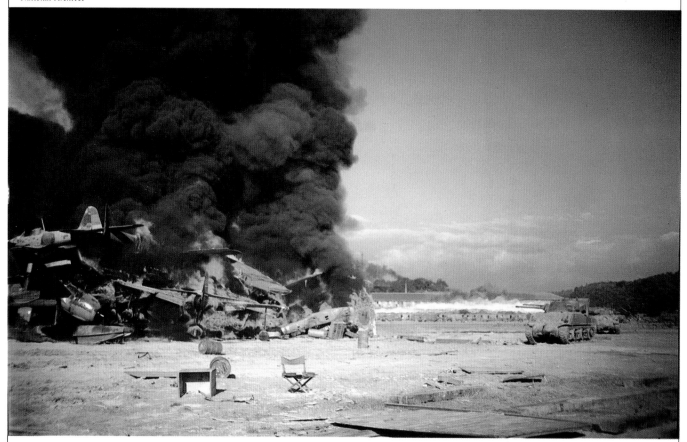

Japanese planes are incinerated by the flame thrower on a Marine Corps tank near Sasebo, Japan, December 1945. Although the war was over, the Allies, ignorant of Japanese culture, were wary of a mass revolt. They destroyed most of Japan's aircraft, leaving very few for vintage-airplane collectors to admire today.

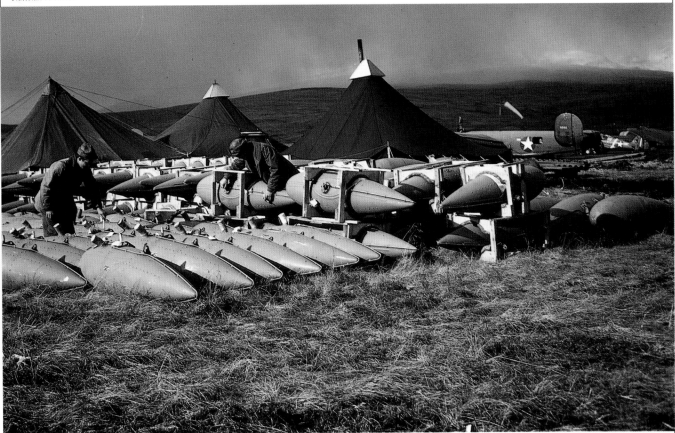

B-24 external drop tanks, Adak, Aleutians. These fuel tanks, which were jettisoned when empty, extended the flying range of fighters and some medium bombers, bringing previously unreachable targets into range. This was especially important in the huge Pacific theater as Allied forces fought island-to-island to control staging areas closer to Japan.

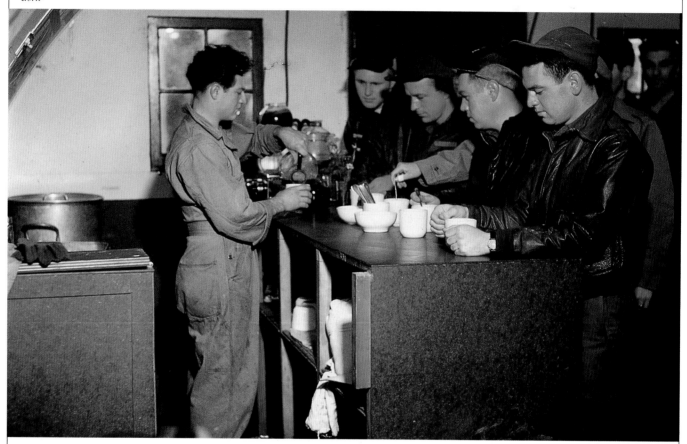

The pilot's crew room was a sequestered relaxation area before and after missions. While the enterprise of air warfare required whole teams of ground crews and technical specialists, not just pilots, the guys in the driver's seat were still the stars, and for that they deserved a few special amenities.

Robert T. Sand

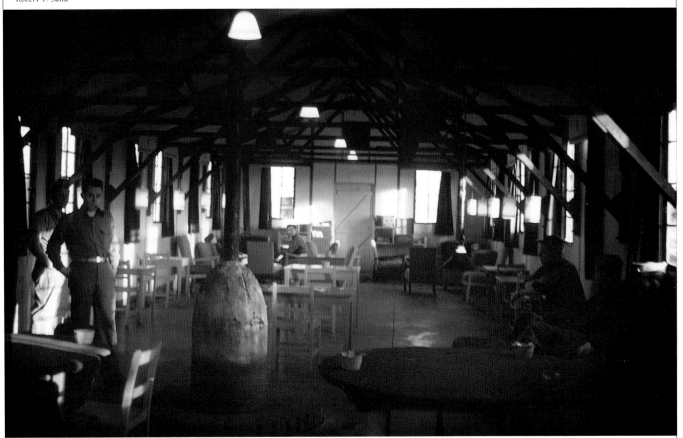

The 55th Fighter Group, stationed at Wormingford, England, appropriated an enlisted man's barracks, and with scrounged paint, furniture, and fixtures, turned a drab, cold building into a comfortable dayroom.

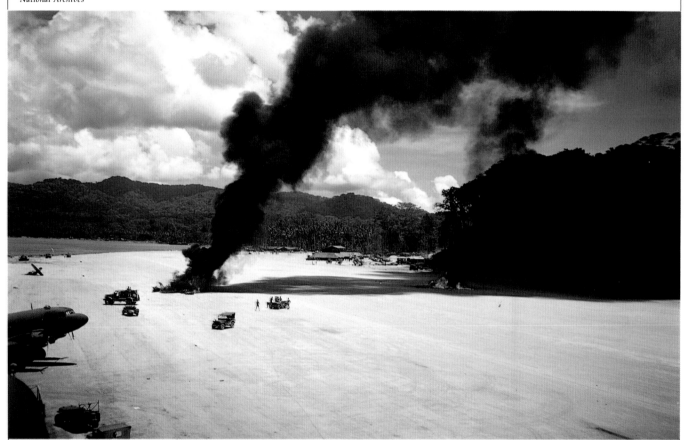

A mid-air collision on the strip at Vella Lavella, Solomon Islands. Both aircraft are burning while others gather around one of the surviving pilots. The fighter pilot reacted quickly enough to jump out at the last second. Ejection seats for fighter aircraft were not to be developed for many years.

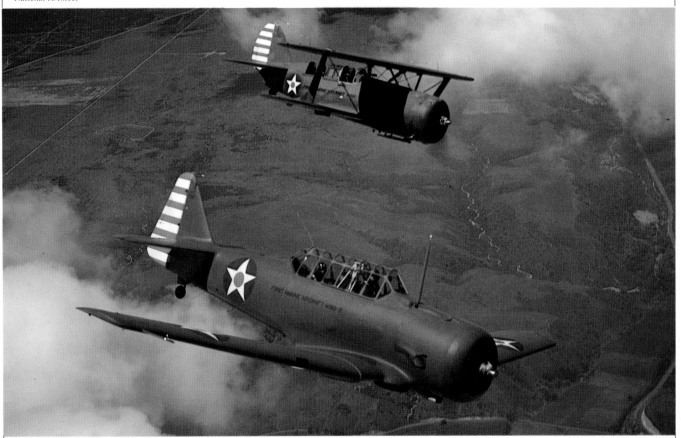

A Curtiss SBC Helldiver, a prewar biplane dive
bomber, follows an SNJ Texan advanced trainer
during a sortie over Florida. Both aircraft were at-
tached to the First Marine Aircraft Wing for advanced
combat training. Even though the SBC was obso-
lete, it still provided new pilots a chance to fly a plane
that fired guns and dropped bombs.

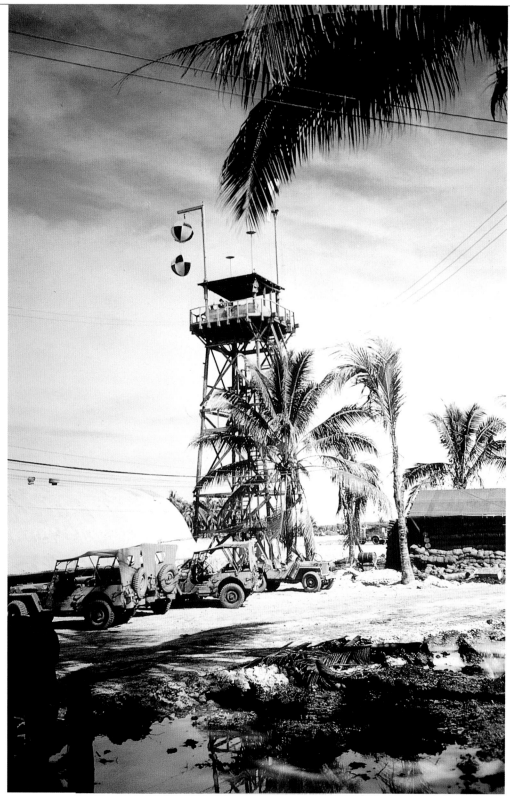

After Green Island was captured from the Japanese, it did not take the Allies long to convert it to a staging harbor and an air base of their own. Strategically this was quite a coup, putting the Allies within striking distance by air of Japanese targets close to their homeland.

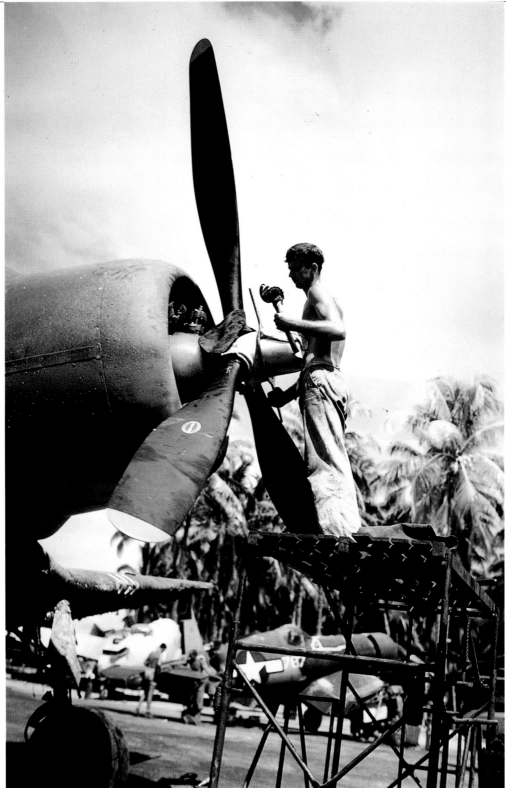

A mechanic from the Marine Air Group 14 works on a Corsair at the air base on Green Island in the southwest Pacific, May 1944. Outdoor maintenance like this was typical of most theaters of the war, making even simple tasks that much harder. The sun would heat metal surfaces so fast that mechanics often were burned if they were not careful.

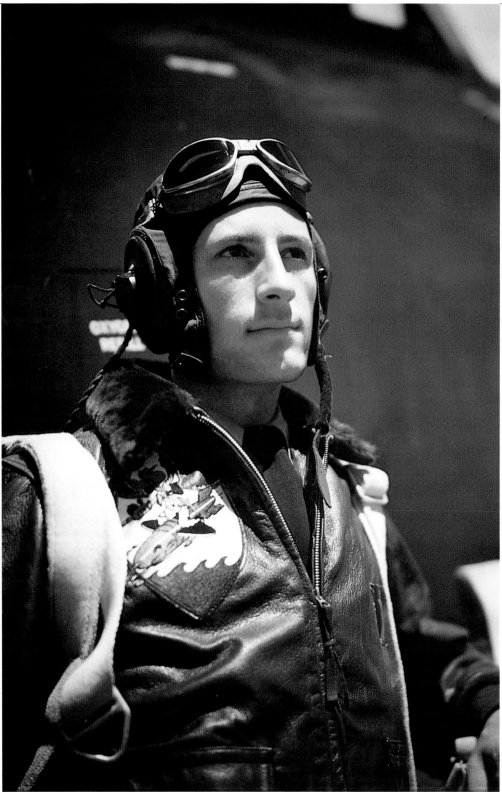

A pilot from VC-65, a composite squadron, gets ready for a mission from the escort carrier Midway. Composite squadrons, so named because they flew different aircraft types, roamed the Atlantic and the Pacific Oceans, performing everything from submarine hunting to close-air support.

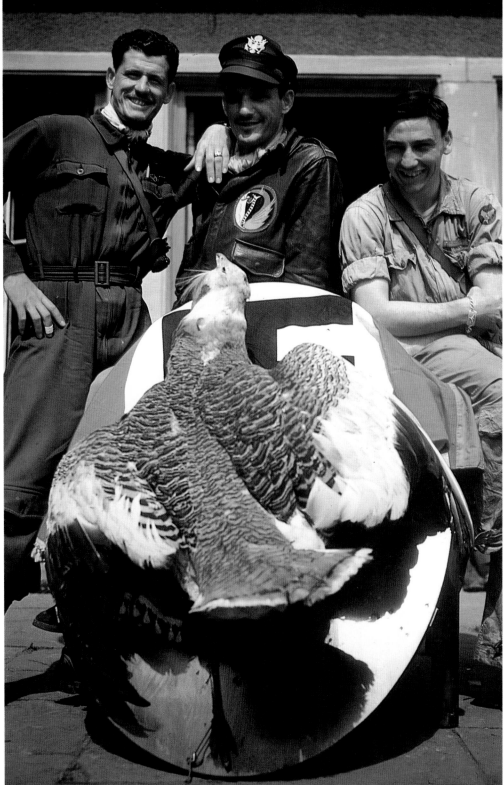

Cooperation planning between Russian and American pilots was necessary at the end of the war. On the combined front, it was not unusual for Russian and U.S. planes to fire on each other, most of the time accidentally. These Mustang pilots of the 354th Fighter Group were among the first to make an air link-up during the last weeks of the war in Europe.

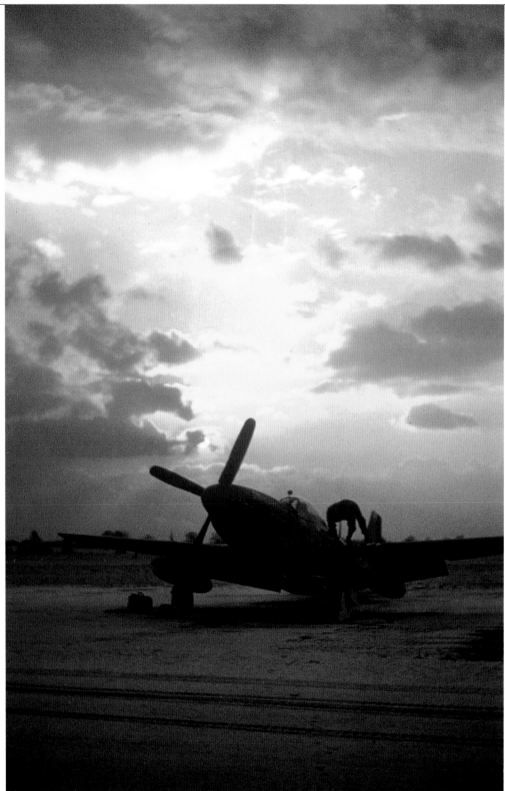

F.M. Grove

A P-51 Mustang at Debden, the 4th Fighter Group's base in England, near Christmas 1944. The P-51, with its long-range capability, turned the tide of the European air war, protecting Allied bombers on their devastating runs to Germany and back, and creating havoc with their strafing tactics on the way back to England.

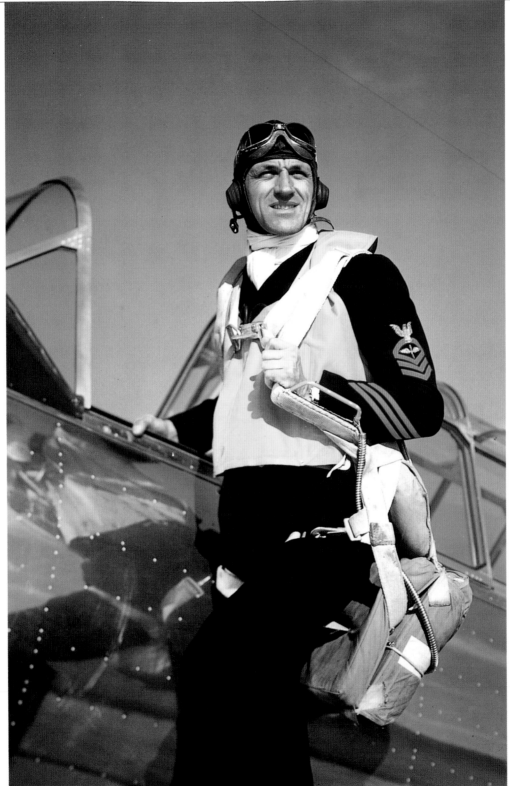

While other air services required pilots to be commissioned officers (with rare exceptions, such as liaison flying), the U.S. Navy allowed enlisted men to fly throughout the war. This Chief Aviation pilot looks delighted to be climbing into his SNJ aircraft somewhere stateside.

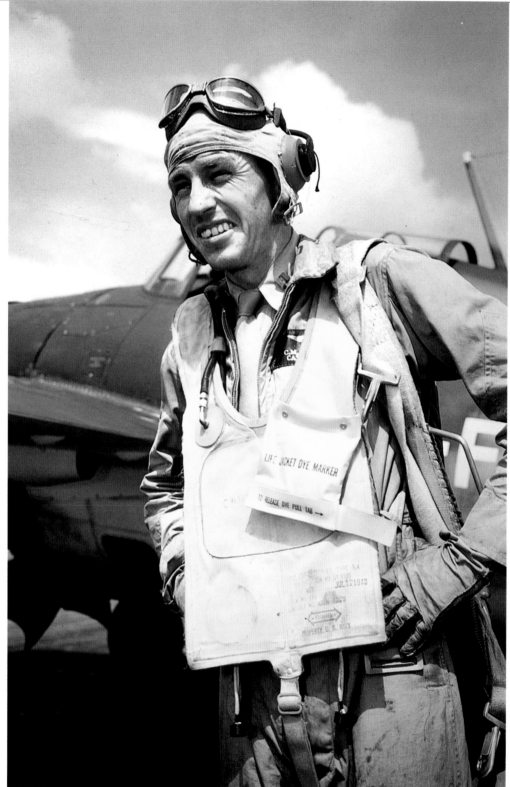

National Archives

This dashing Navy Wildcat pilot has just returned from a mission off a carrier in the South Pacific. Unlike his Army Air Forces counterparts in Europe, he wears a lightweight cotton flight suit, to counter the 100+ degree heat. Life for pilots on ship was far better than for those on the island bases, with hot, fresh meals and air conditioning.

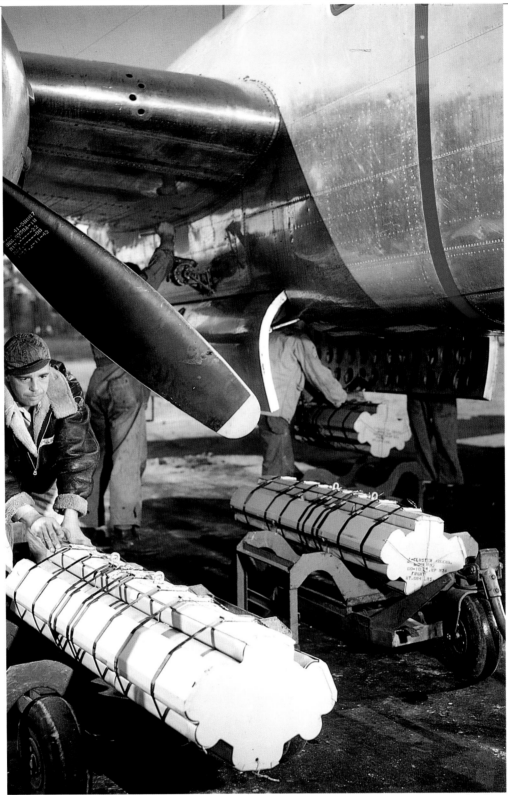

Loading incendiaries on a B-25 Mitchell. This particular armament was used not so much for shock effect, but to start ground fires. When they fell from B-29s on Japanese cities built with wood and paper, the results were horrendous, bringing near-total destruction.

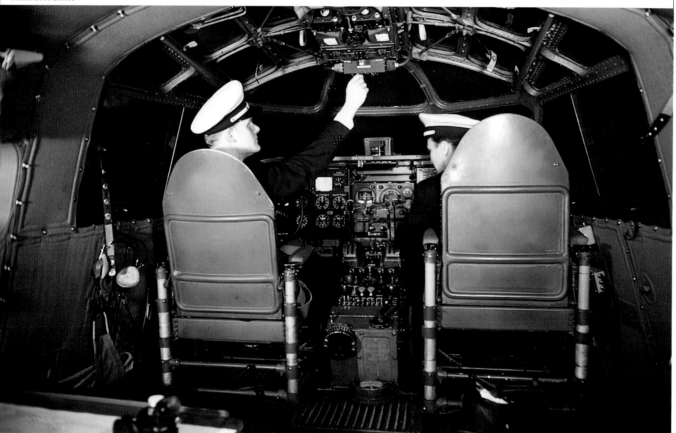

The Navy recruited civilian Pan-Am pilots for service duty. These pilots are flying a PB2Y Coronado from Treasure Island, near Oakland, California, across the Pacific to a U.S. island air base.

Mark Brown/U.S. Air Force Academy

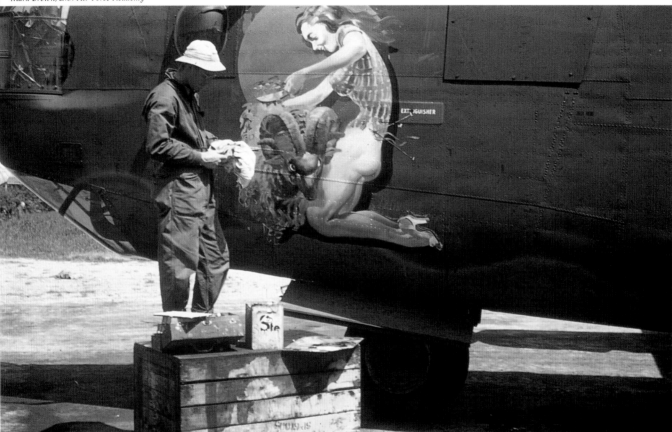

Aviation artist Phil Brinkman paints an Aries zodiac symbol on one of the 486th Bomb Group's B-24s. Brinkman was one of many talented artists who found themselves painting the broad metal canvasses of aircraft for most of their time overseas, even though they were assigned to other duties.

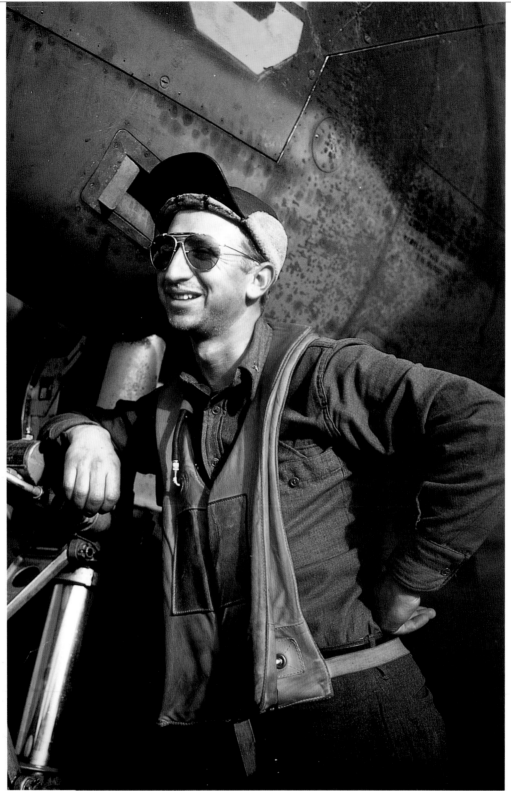

National Archives

A P-38E pilot of the 54th Fighter Squadron, the first Lightning fighter unit in combat. Flying over the Aleutians from late summer 1942, these pilots faced more danger from Arctic weather than from enemy opposition, as was true for the Japanese as well.

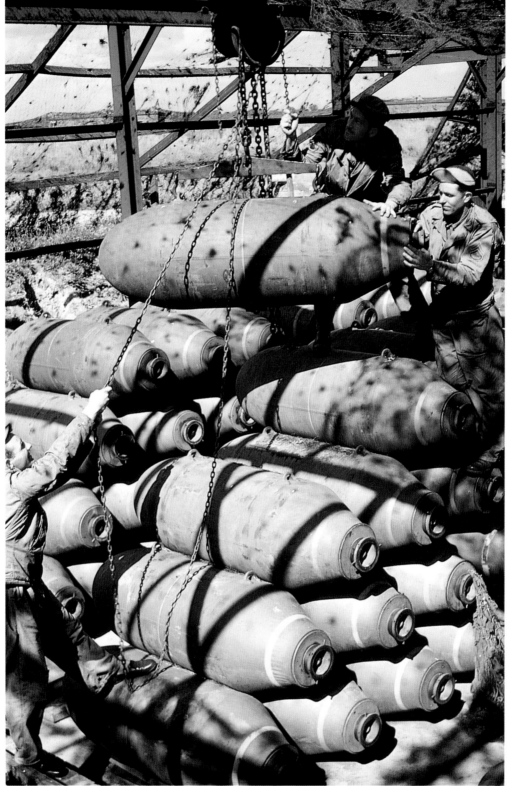

2000 lb. bomb storage. T/Sgt. Charles Walker, S/Sgt. Eugene Martin, and S/Sgt. Edward McDaniel use hoists to get these heavy weapons onto bomb carts and on their way to be loaded into B-24 Liberators.

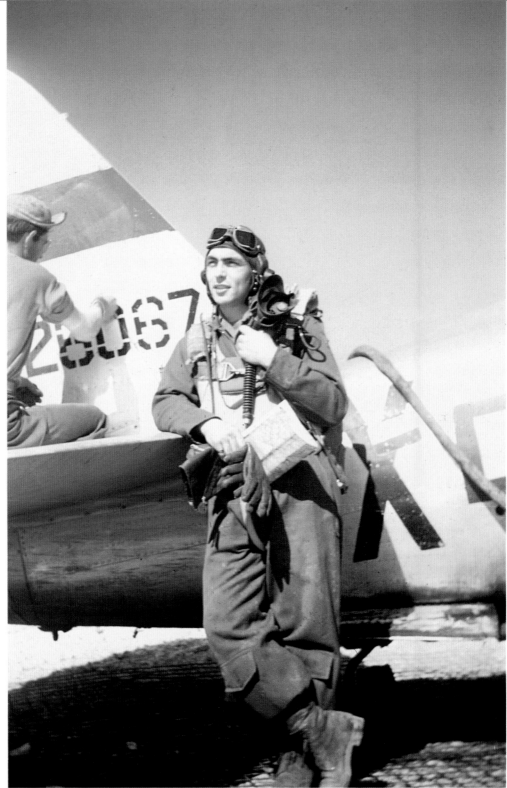

Richard H. Perley

Thunderbolt pilot Phil Savides of the 50th Fighter Group based in Nancy, France. Here in 1944 his group is flying close air support for Gen. Patton's Third Army on the drive to Germany. Like most American fighter pilots, he has managed to get British leather goggles, helmet, and gloves, which fit better than anything the U.S. supplied.

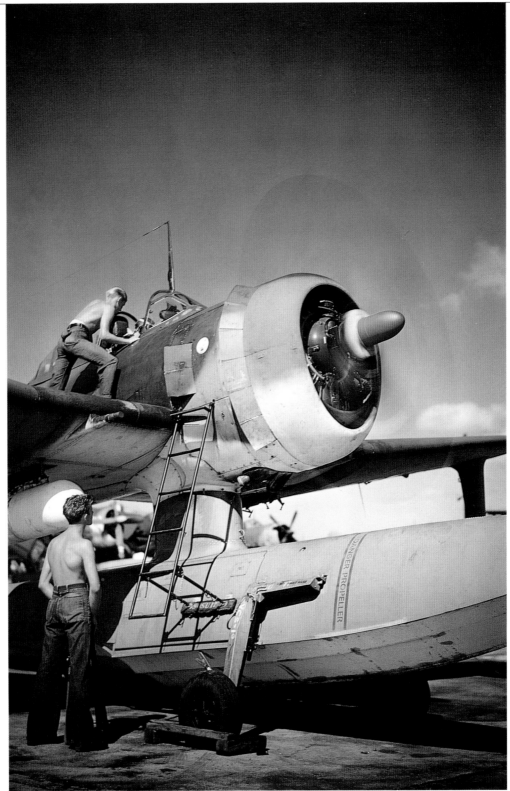

In the Pacific Theatre, an SC-1 Seahawk warms up as the crew chief talks to the pilot. The SC's job was to scout ahead of battle groups. It was launched by catapult, then returned to the ship by water landing. A crane retrieved the plane to the deck.

Joseph S. Kingsbury

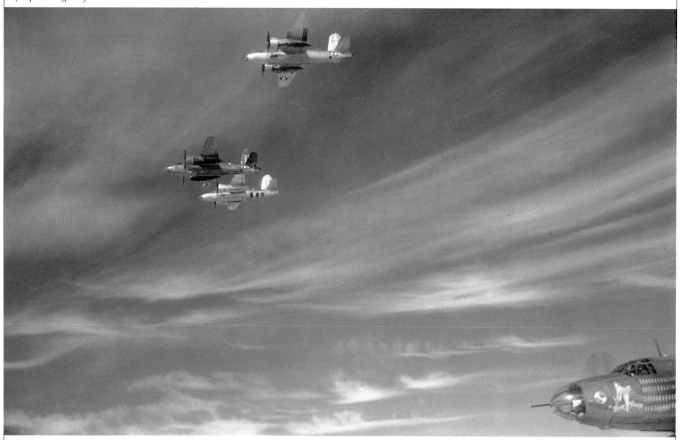

A formation of 320th Bomb Group B-26 Marauders
climbs out of Corsica for targets in German-held Italy
in 1944. The Marauder began the war as one of the
most hated aircraft in the American inventory, with
a bad accident rate. But after pilots learned to fly it
"by the numbers," it had the lowest loss rate of any
American bomber.

Fred Roberts via William Bartsch

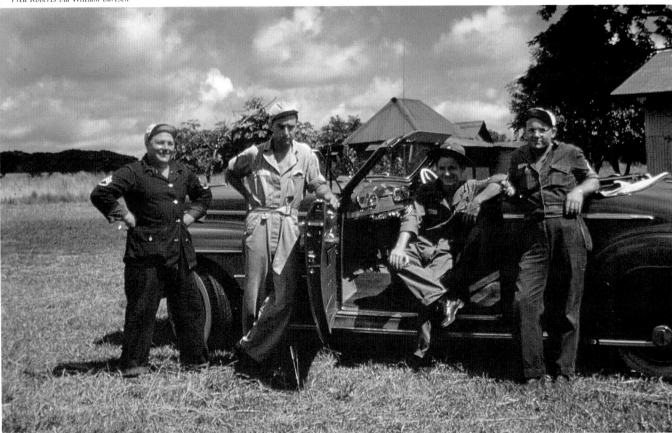

Fighter pilots of the 3rd Pursuit Squadron at Clark Field, Philippines, summer of 1941. Little do they know that the Japanese, just north of their position, are a few months away from attacking their field and Pearl Harbor. As one AAF pilot wrote home, they were "doomed at the start."

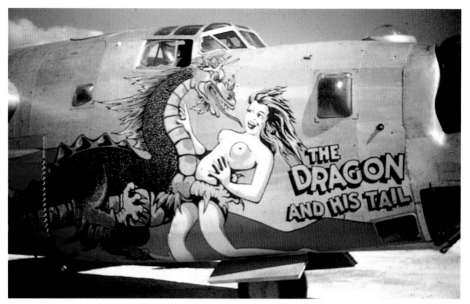

Victor Tatelman

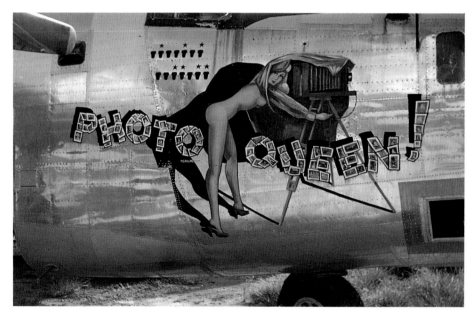

George E. Miltz, Jr.

Aircraft nose art was an uncontrolled phenomenon
of World War II. Top: B-24 of the 43rd Bomb Group
in the South Pacific. Bottom: Nose art for a B-24 of
the 20th Combat Mapping Squadron, New Guinea.

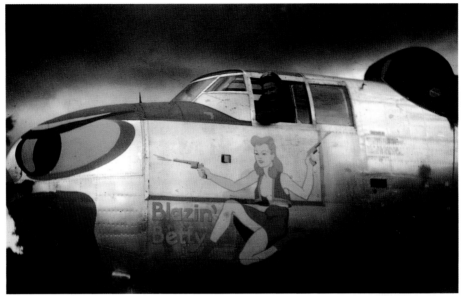

Hank Redmond

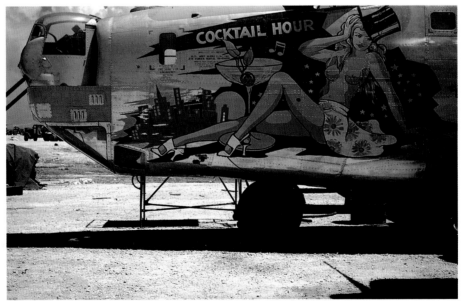

Wilbur Kuhn via Inez Kuhn

Top: Hank Redmond sits in a B-25 of the 12th Bomb
Group, China and India. Bottom: B-24L of the 64th
Bomb Squadron, 43rd Bomb Group, South Pacific.

Stanley Wyglendowski

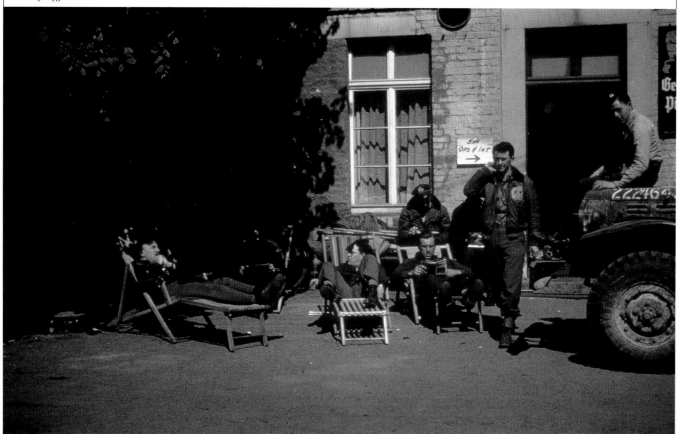

A former German pilot's hostel in Handorf, Germany, is taken over by the men of the 406th Fighter Group in 1945. By the end of March the entire Allied front is east of the Rhine, and the German army is in disarray. By the middle of April the Allies have taken three hundred thousand prisoners.

Richard H. Perley

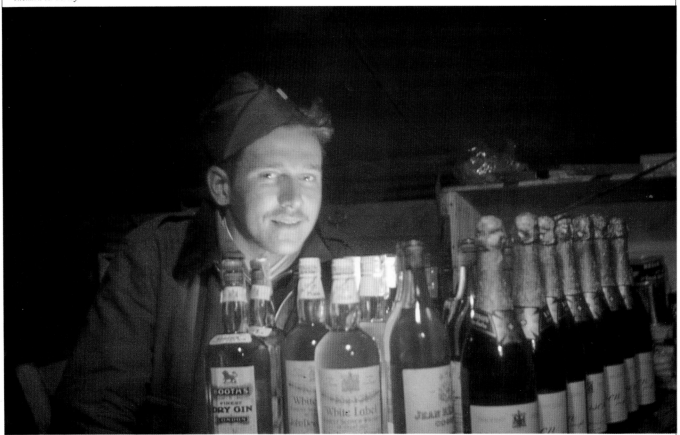

It's New Year's Eve, 1944. There is still some war left to be fought in Europe, but Dick Perley and other pilots need to blow off some steam. They have allocated everyone's liquor ration for a unit party at Toul-Ochey, France. As Dick recalls with understatement, "We had a little whiskey."

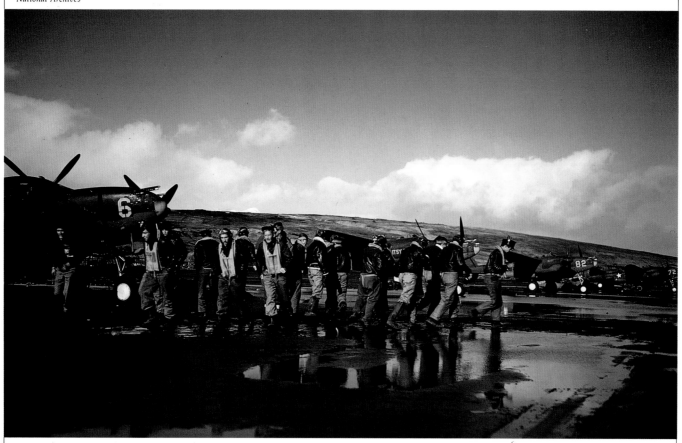

P-38E pilots of the 54th Fighter Squadron have returned from a mission originating in Adak in the Aleutians. This group flew in awful conditions, defending the continental U.S. from potentially fatal Japanese incursion through Alaska.

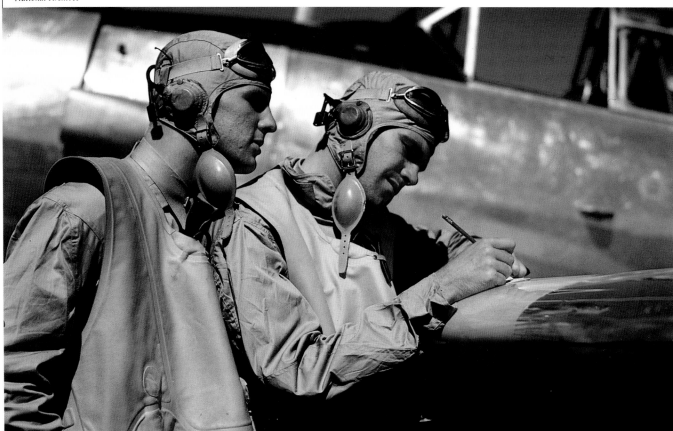

An SNJ instructor and student after a check ride.
The SNJ was the major advanced trainer of World
War II, for both Army (as the AT-6) and Navy pilots.

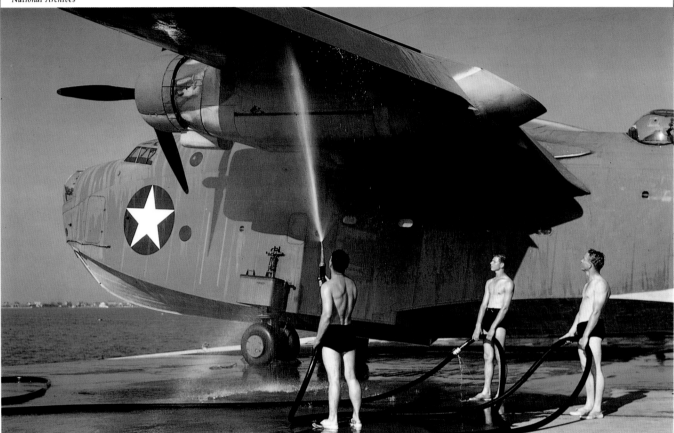

This PBM-3c Flying Boat gets hosed down with fresh water after a training operation out of Naval Air Station Norfolk, Virginia. World War II was the swansong of the Navy's flying-boat era. Even though these massive patrol bombers did an excellent job in combat, the jet era left them behind.

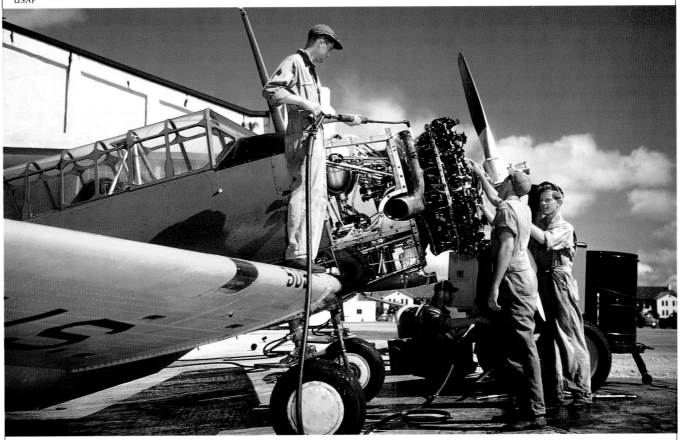

Mechanics work on a BT-14 trainer at Randolph Field, Texas, 1942. Although the public heard very little about the mechanics and enlisted men who worked on non-combat stateside training planes, the job was crucial to winning the war. In fact, pilot training and aircraft production, which the enemy did not consider very important, may have won the war.

Ben Marcilonis via Roger Freeman

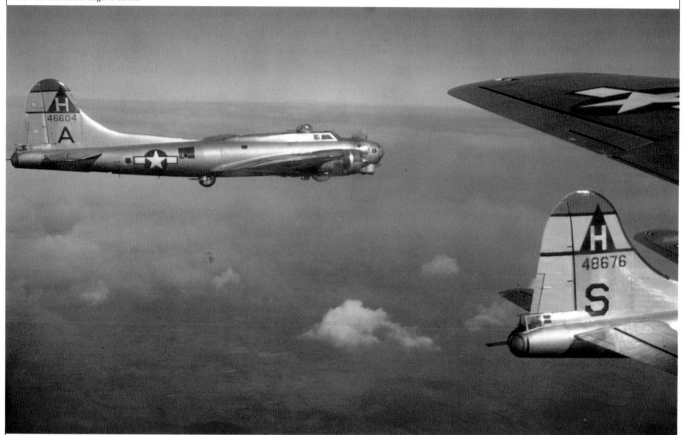

A formation of B-17s from the 306th Bomb Group climbs out of England for a bombing mission over Germany. The 306th had a long and distinguished career, made public by the novel and film *Twelve O'Clock High*. The 306th was the first American bomber outfit to hit Germany itself.

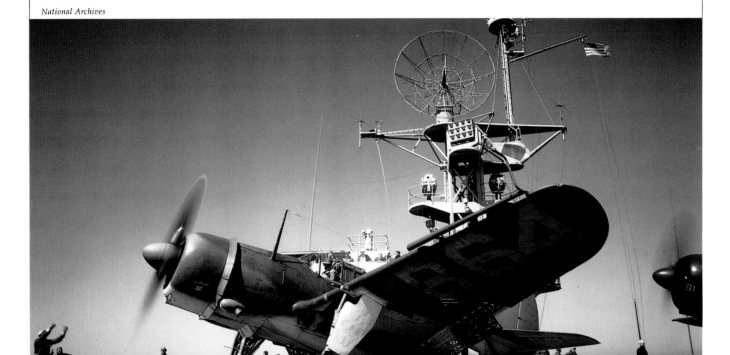

An SB2-C Helldiver during a training sortie on an escort carrier in U.S. waters. These training exercises were very dangerous; in fact, more planes were lost in training than in combat during the entire war.

George Armstrong

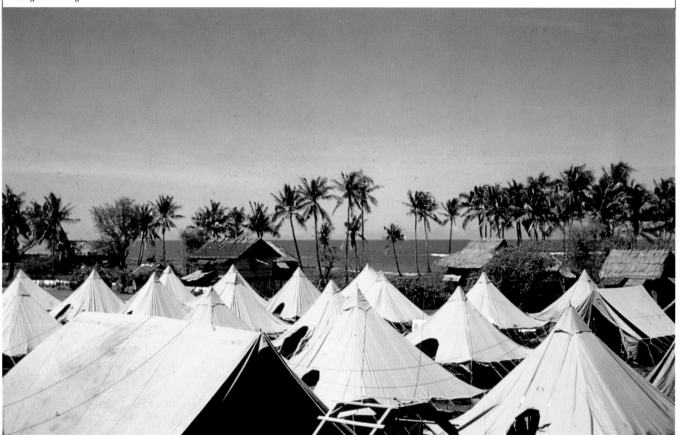

Field tents of the 17th Pursuit Squadron in early 1941 at Nichols Field, Philippines. This calm scene would be shattered a few months later with the near-simultaneous attacks on the Philippines and Pearl Harbor.

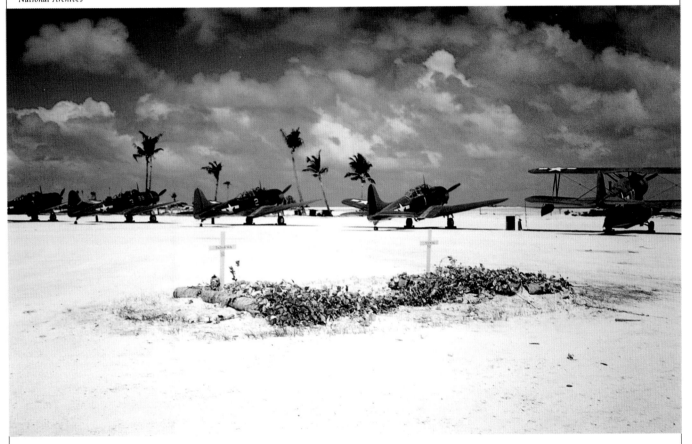

SBD dive bombers and J2F Duck amphibians await
their pilots at the dusty airstrip on Tarawa in the Gil-
bert Islands, 1944. The graves in the foreground
are of Marines killed in the fierce fighting for control
of the airfield.

Robert T. Sand

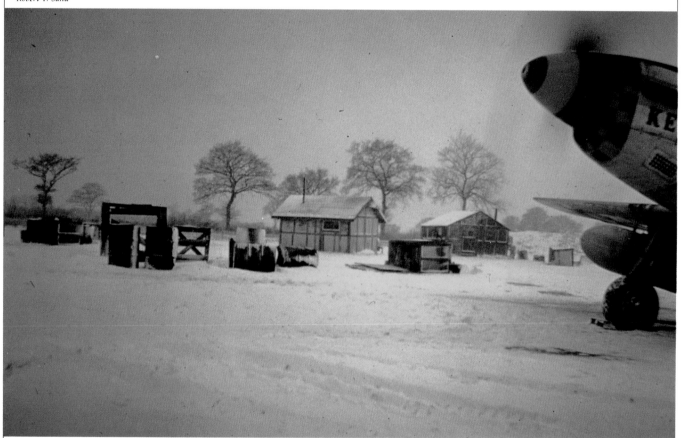

There was hardly any hangar space on U.S. air bases in England. Nearly all mechanical operations took place outdoors in weather such as this at Wormingford, England, home of the 55th Fighter Group in the winter of 1944.

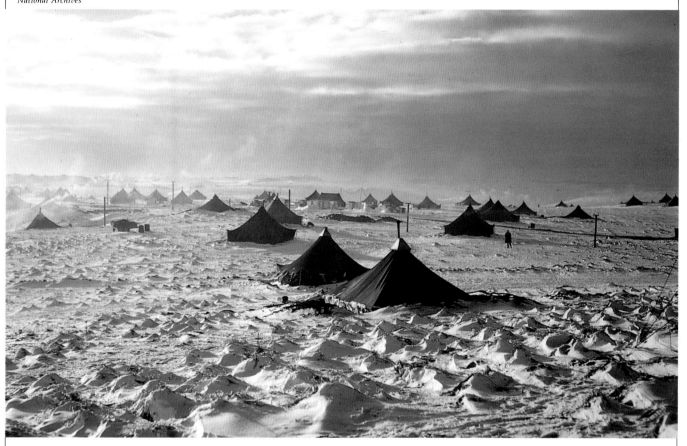

The Japanese invasion route to America was over
the Aleutians, and our pilots had to deal both with
the enemy and the cold, damp weather of the
Arctic. Both sides said that the weather was their
worst enemy.

Frederick Hill

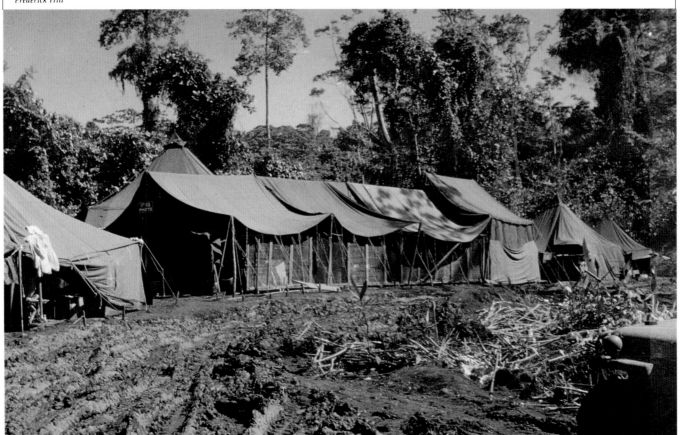

This is the photo lab of the 17th Reconnaissance (Bomb) Squadron on New Guinea during the rainy season. The 17th developed reconnaissance photographs taken during B-25 flyovers.

Fred Roberts via William Bartsch

In the maintenance area at Clark Field, Philippines, summer 1941. The tractor was used by the 3rd Pursuit Squadron as an aircraft tug and general towing device around the base.

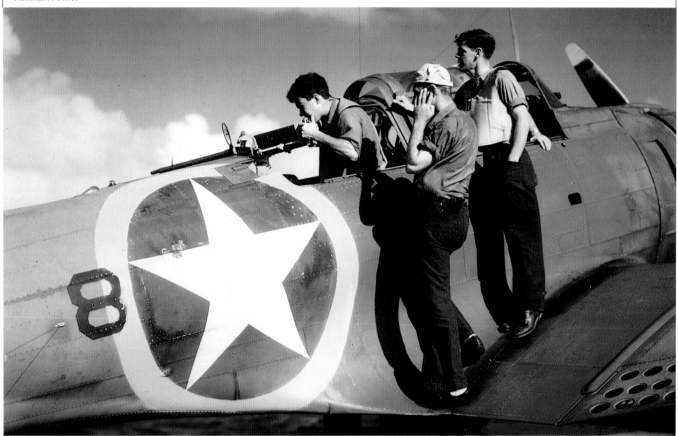

Gunners-in-training get the feel of the machine gun from the aft seat of an SBD trainer on an escort carrier during the invasion of North Africa, November 1942. These men had a high casualty rate; Japanese pilots knew how vulnerable these planes were with no rear gunner, and they tended to target them.

Ole C. Griffith

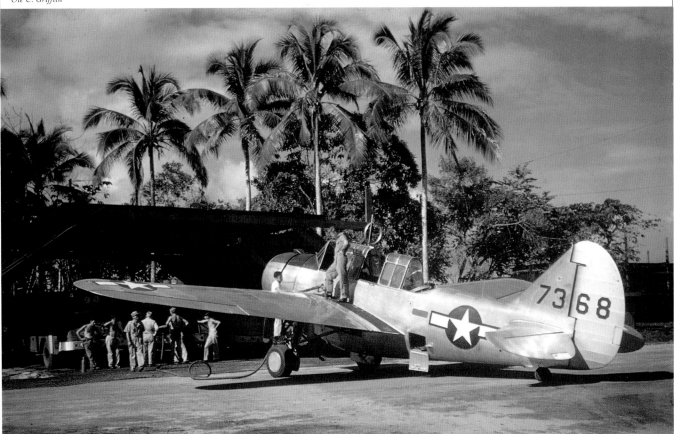

An obsolete prewar O-47 observation aircraft gets
refueled on a ramp in South America. Surpassed
by fighters converted to carry cameras, the slow,
trusty O-bird was used instead for aerial mapping
by the 91st Photo Mapping Squadron, which usu-
ally flew F-10s, the camera-carrying versions of
the B-25 bomber.

James M. Stitt, Jr.

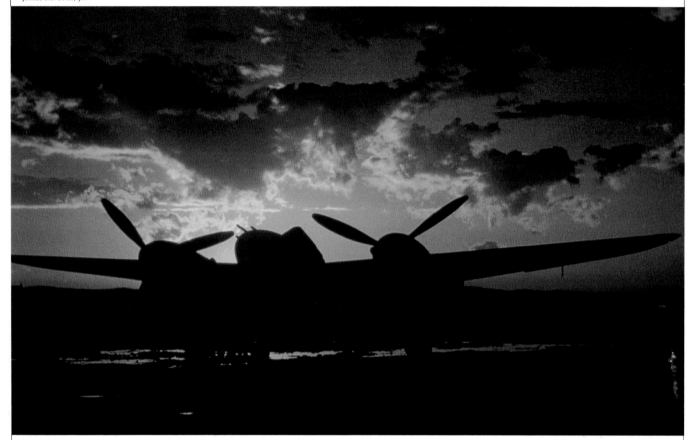

Late 1944 at Triolo, Italy. The sun sets on a P-38 Lightning of the 37th Fighter Squadron, 14th Fighter Group, one of three Lightning units assigned to the Fifteenth Air Force in the Mediterranean. The 38 was one of the most successful Army fighters of the war. The Lockheed product was the first modern American fighter to equal the opposition.

Richard H. Perley

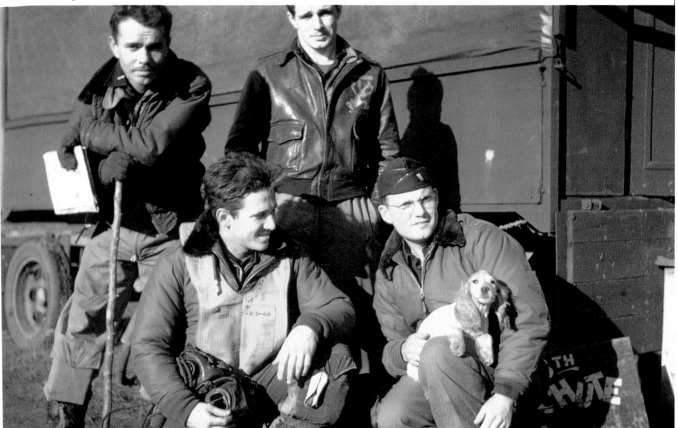

50th Fighter Group Thunderbolt pilots Hamilton, Holt (rear), Perley, and Walters with their new mascot, "Propwash," at Toul-Ochey, France. Pets of all kinds were an enormous boost to morale, particularly for men like these living on the forward lines in tents. They would go to great lengths to keep their animals healthy and protected from snooping brass.

J.P. Crowder via Dorothy Helen Crowder

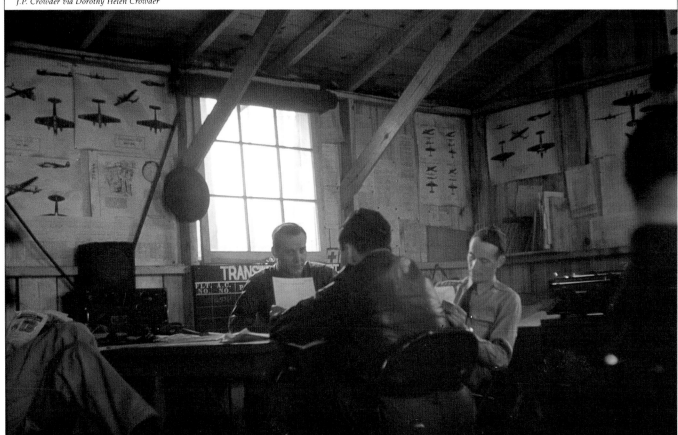

Operations at Martin Field, Baltimore, Maryland, March 1942. The 33rd Fighter Group is about to be shipped to North Africa, where they will continue to fly P-40s, the fighter in which they are training.

Morris Davidson via Richard Davidson

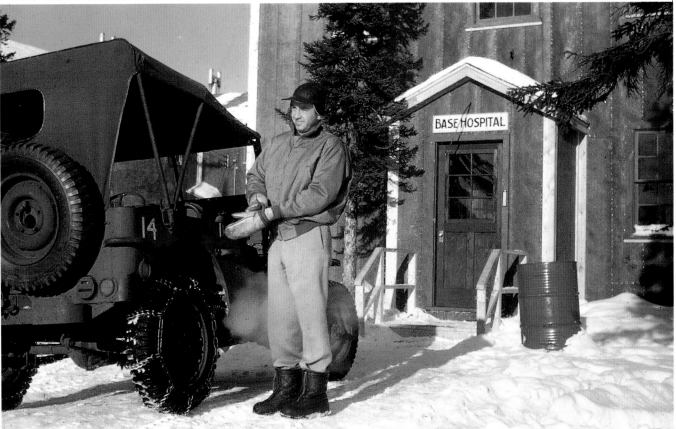

Flight Surgeon Morris Davidson at the U.S. air base in Goose Bay, Labrador. The flight surgeons performed a critical function in air operations, determining by medical exam who would continue to fly missions and who got to rest.

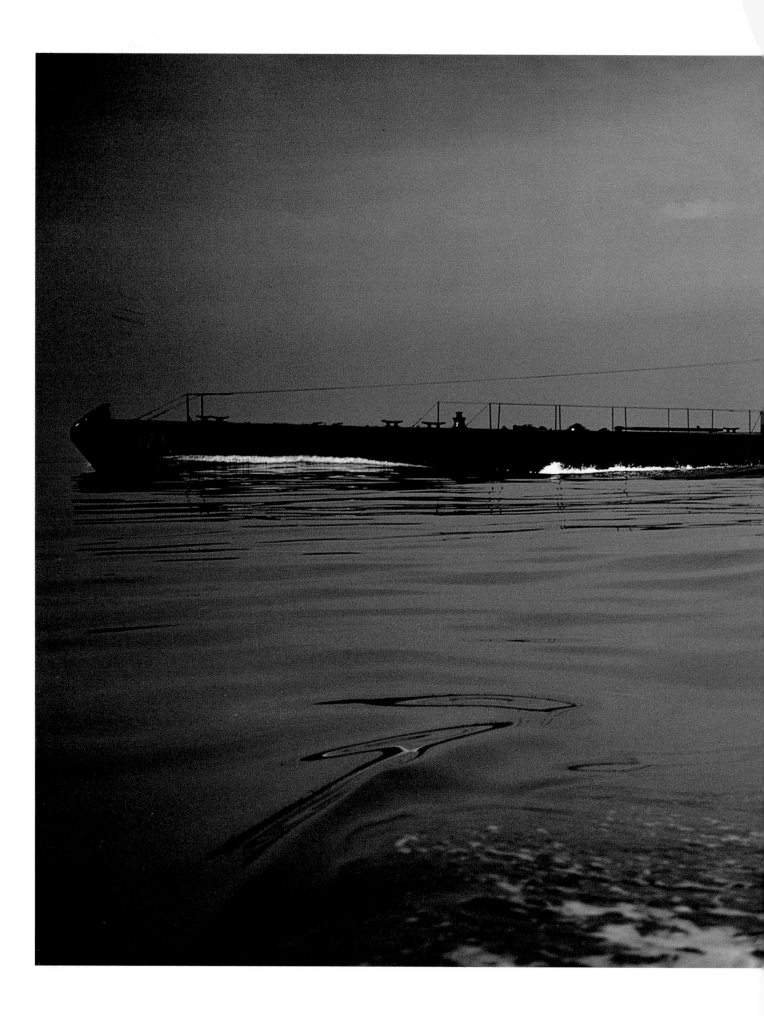

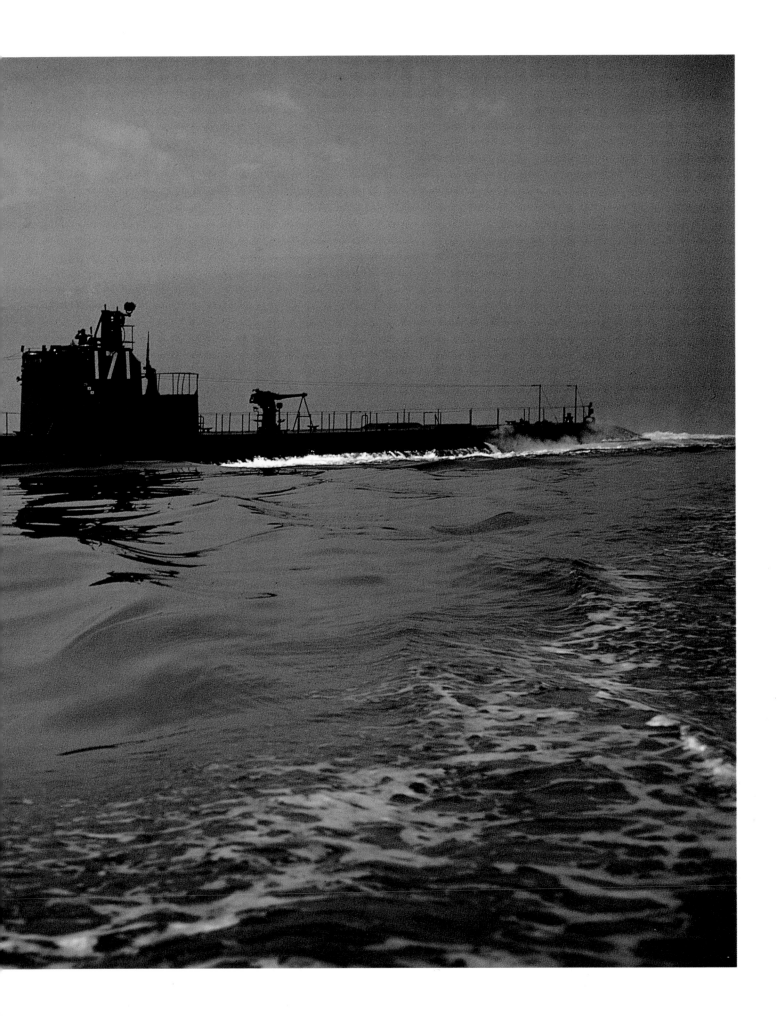

SAILORS

The War At Sea

The cramped, often wet, often below-decks life of a combat sailor was not especially conducive to picture-taking with Kodachrome film. In fact, while exterior shots are abundant, it is difficult to find more than a handful of color photographs of life inside the steel walls of battleships, submarines, or aircraft carriers from this period.

In addition to the lighting and moisture problems, Navy regulations also played a part in the scarcity of color. Enlisted men were forbidden to use a camera at all, although some, thankfully, ignored the rule. Many officers thought they were tied to the same sanctions, but on the whole those who shot color knew they were allowed to do so.

The Pacific Theater itself prevented Navy personnel from using much color. Being at sea for long periods of time prevented photographers from sending their Kodachrome off for processing. As a result the film sat in a hot, humid environment, which often ruined the sensitive emulsion. Black-and-white film was much more durable, and could be developed aboard ship. As a result few shutterbug sailors were willing to take chances with the new film.

As in the other services, Navy combat action shots are very rare in color. What you will find are outside shots from one ship to another, training shots, and many pictures of naval aviation taken from the carrier fleet.

Previous page: The USS *Cuttlefish*, SS-171, New London, 1942. Built in 1933-34, this Electric Boat submarine was the first fitted with air conditioning, an enormous improvement. Although successful, the boat's limited speed and endurance kept it from wartime operations in the Pacific. It was relegated to training duties. (National Archives)

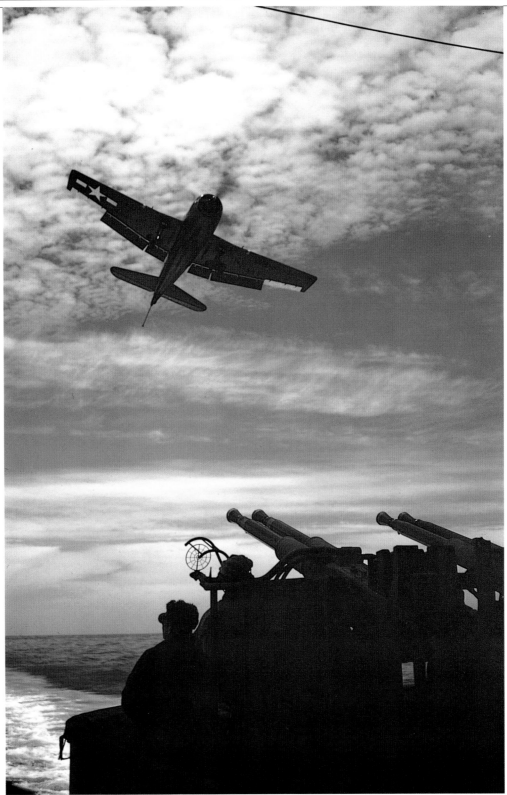

National Archives

Sunset in the Pacific, 1945. On the aircraft carrier USS *Randolph* an F6F is trying to get on the carrier deck before dark, but he gets waved off. Naval aviation, an inherently more dangerous enterprise than flying off land, was crucial to the conduct of the war in the Pacific.

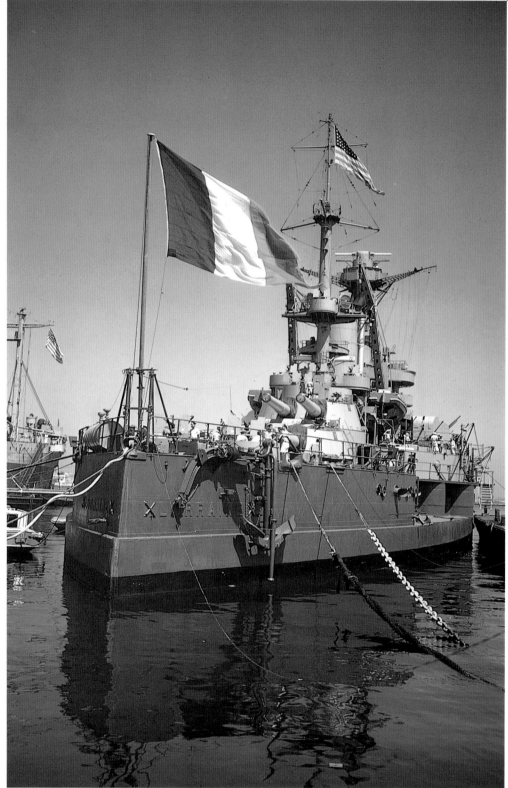

The French battleship SS *Lorraine* photographed on the fourth of July, 1943 in New York harbor. The ship carries an American flag as well, since it sailed without a home port as a Free French vessel attached to the U.S. fleet. Most Free French ships sailed in the Pacific to fight the Japanese, then returned to Europe as home ports were liberated.

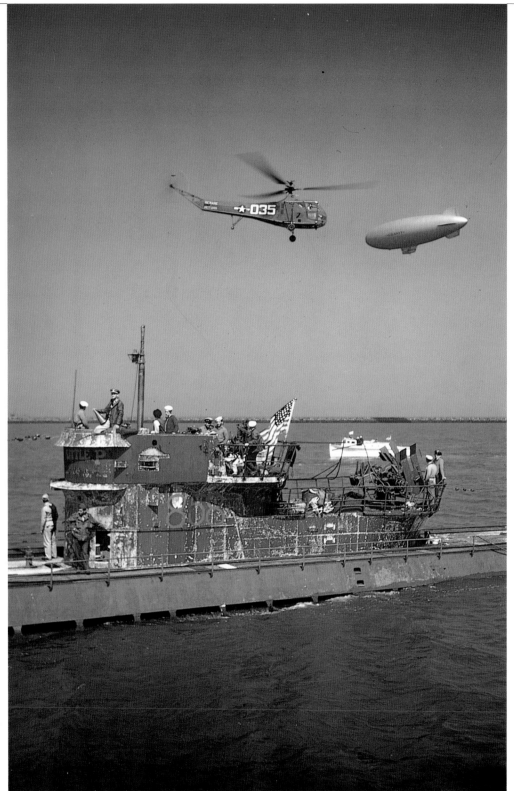

National Archives

A helicopter has just delivered American sub skip-
per Lt. Cdr. Willard to the conning tower of surren-
dered German submarine U-858 off Cape Henlopen,
Delaware, in April 1945. Above them all is a K-Type
Navy blimp, one of the unheralded antisubmarine
aircraft of the war. Blimps had more loiter time than
other aircraft to find and track German U-boats.

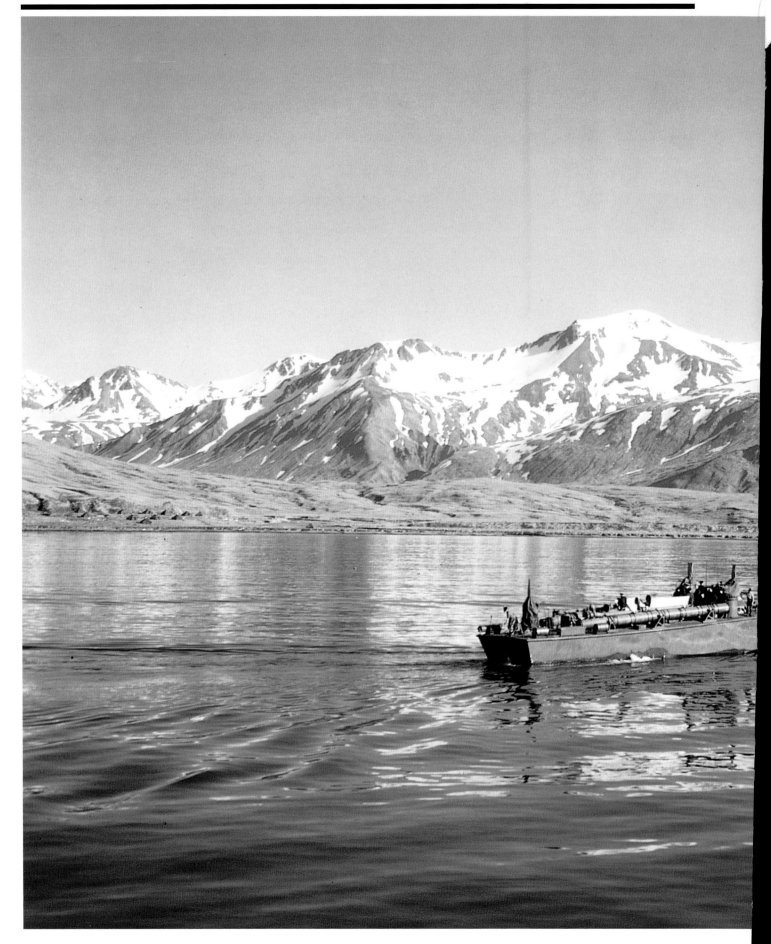

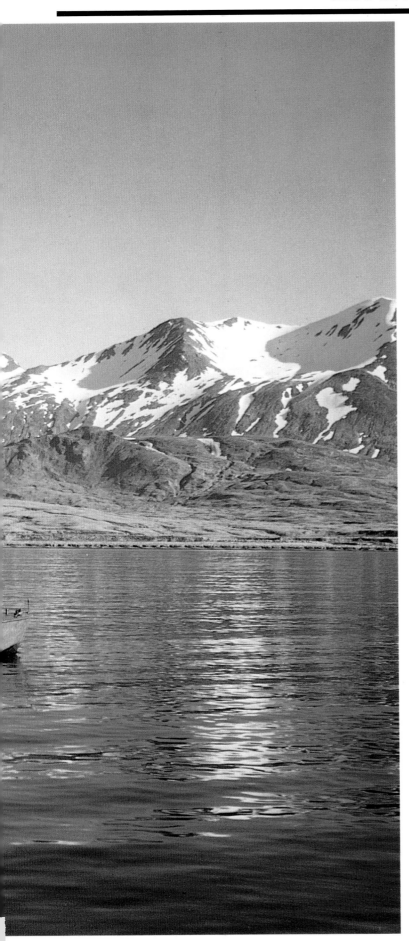

November 1943 in the Aleutians. An MTB PT boat patrols the chilly waters of the North Pacific. Six months earlier, American and Canadian forces completed the ejection of Japanese troops from the islands of Attu and Kiska, lessening the threat of invasion from the northeast, and at the same time creating an Allied invasion route to Japan. (National Archives)

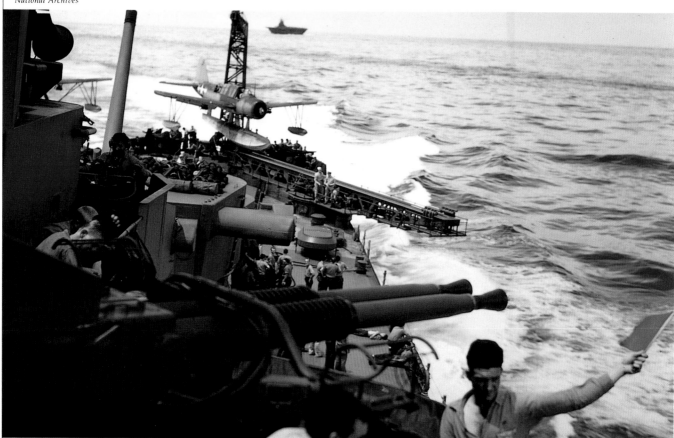

An OS2U Kingfisher scout plane is about to be launched by catapult from the aft end of a battleship. Because these planes were very slow compared to fighter aircraft, they were used for forward observation only.

Navy brass makes last-minute preparations as an
OS2U on its beaching gear is ready to be craned
onto its battleship catapult before another cruise.

National Archives

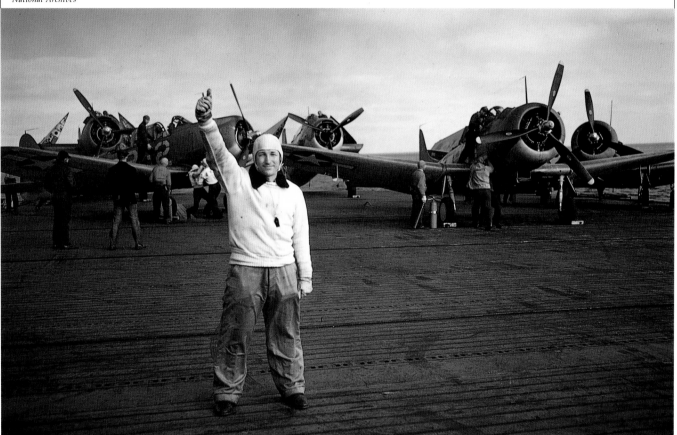

A yellow-jersied plane director on an aircraft carrier gives a thumbs-up to Fly Control that he has received a signal from the squadron-leading chief that operations can begin. A carrier was divided into three Fly Areas—forward, amidships, and aft—which were directed by deck crews in different colored jerseys. These men ruled the deck regardless of rank.

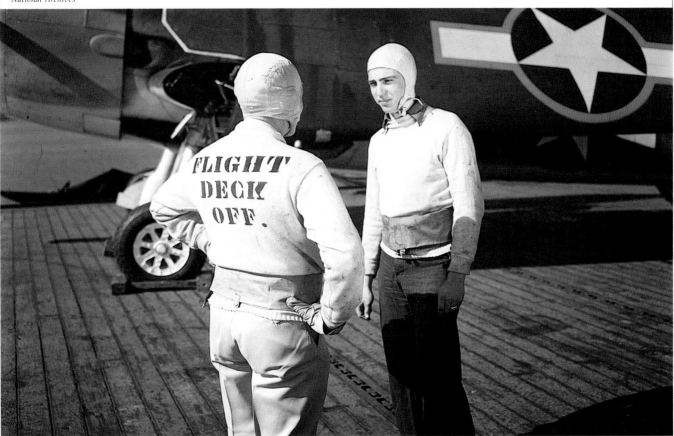

A flight-deck officer confers with one of his plane handlers about flight operations. The decks of aircraft carriers were extremely dangerous, not just from enemy fire and kamikazes, but also from dozens of normal shipboard hazards. Extreme vigilance was needed to avoid fatal mistakes, and the flight-deck officers tried to keep it all under control.

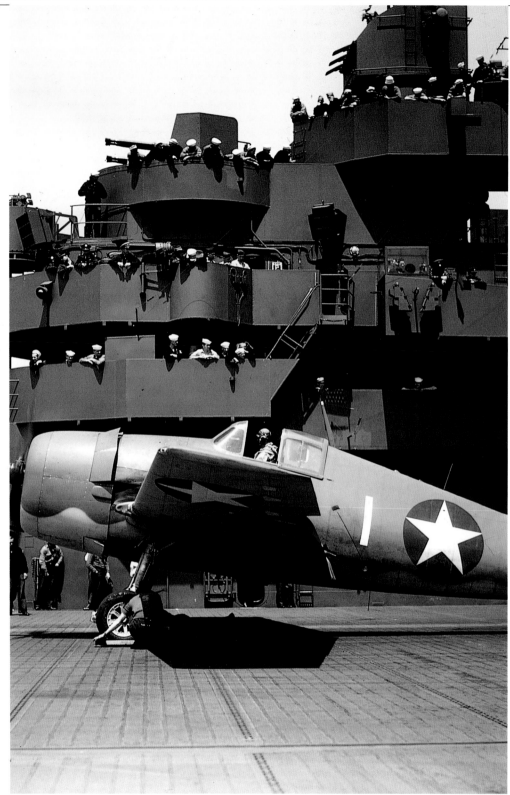

A Grumman F6F Hellcat runs up before launch from the second USS *Yorktown* (CV-10) during the carrier's shakedown phase in early 1943. These training missions were dangerous and costly in terms of men and equipment, since carrier operations were still in their infancy, and pressure was on to turn out as many trained squadrons as possible.

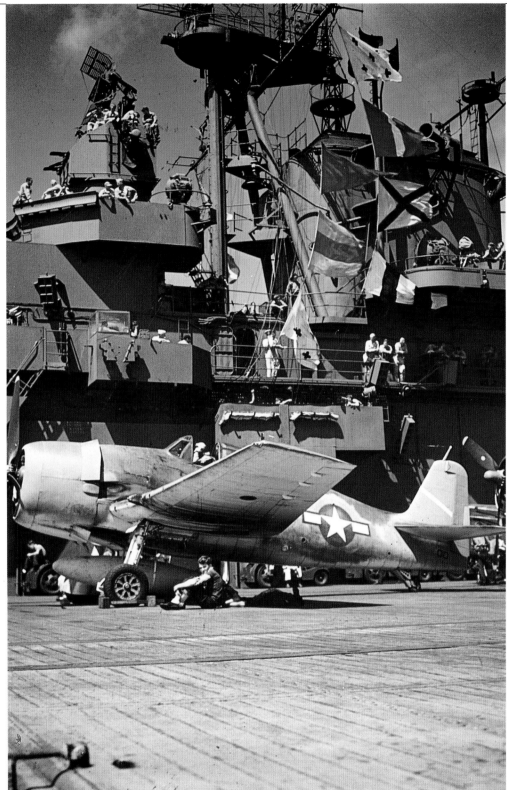

National Archives

Aboard The Fighting Lady, USS *Yorktown*, August 1943 during the first combat operations for the Navy's new Hellcat fighter. The carrier is heading into the wind while this F6F sits ready to start in the chocks. After drawing first blood in the Marshalls-Gilberts campaign, the Hellcat went on to master the Pacific skies.

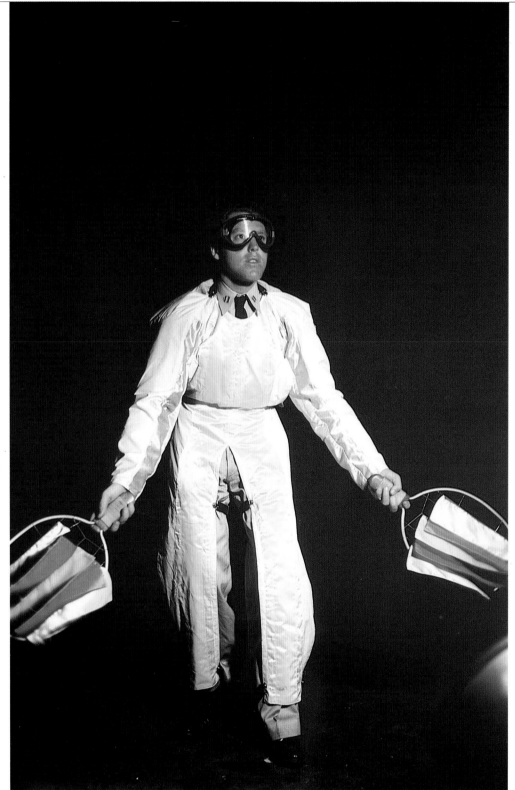

The landing-signal officer was responsible for guiding pilots to safe landings on the carrier deck, using brightly-colored paddles to communicate his instructions. The reflective strips on his clothing made him visible to pilots during night landings.

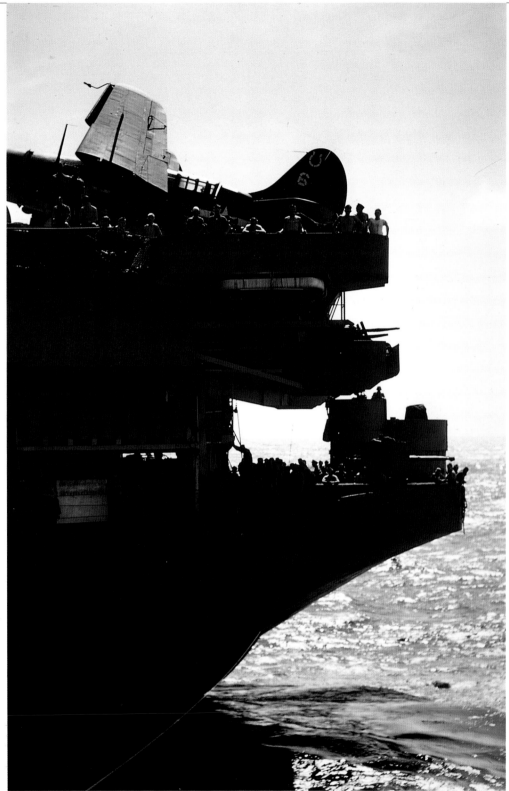

The fantail of the USS *Hancock* (CV-19) gives some idea of the massive size of these floating airfields. The SB2C Helldiver, five stories above the water, and the rear-facing antiaircraft guns are dwarfed by the sheer bulk of the ship. It did not look so big, however, to pilots trying to get back aboard in bad weather or with combat damage.

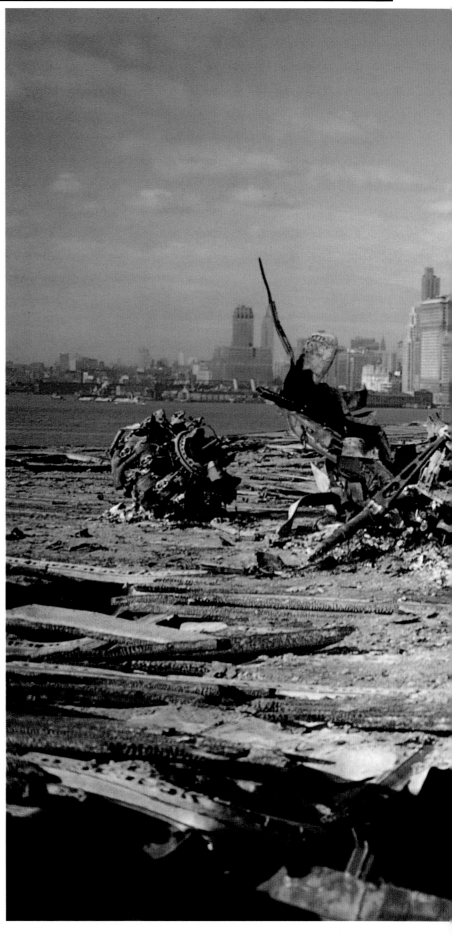

The aircraft carrier USS *Franklin*, heavily damaged by Japanese kamikaze attacks in the Inland Sea, nonetheless sailed all the way home despite losing over 700 men. Here, the courageous lady is within sight of New York on March 19, 1945.
(National Archives)

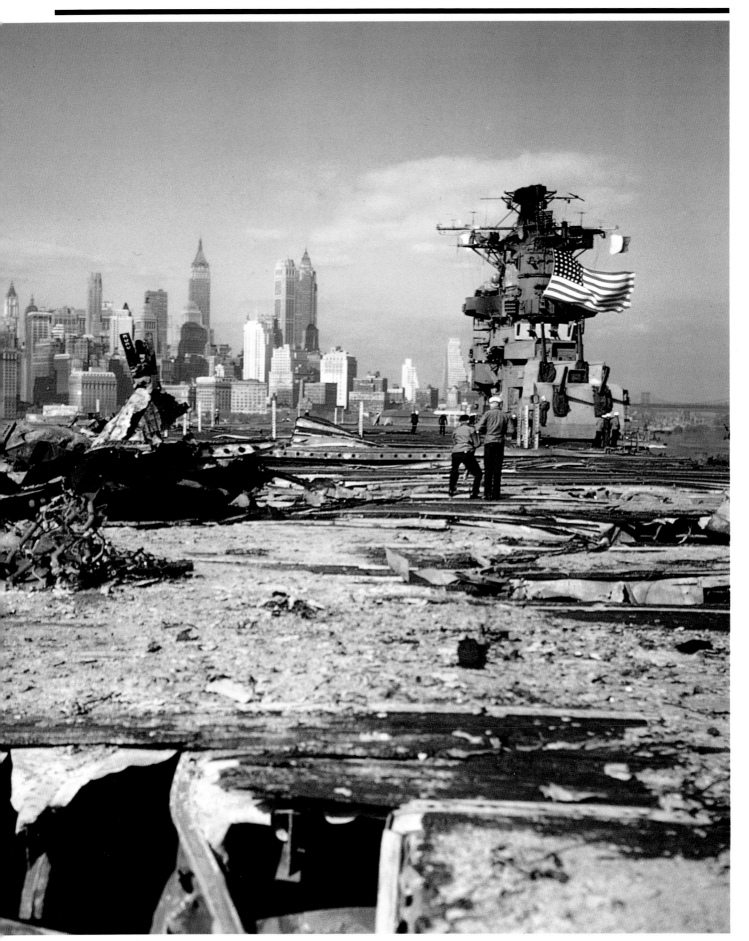

National Archives

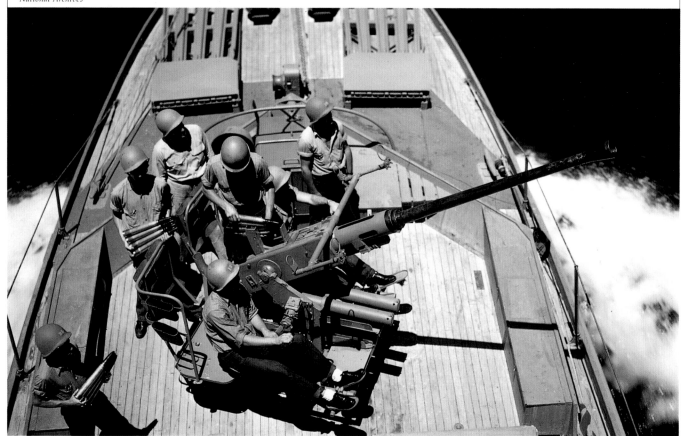

Shakedown exercise for a 40mm gun crew on a sub chaser out of Miami, Florida. After the United States entered the war, German U-boats moved into American waters, sinking over 80 merchant ships off the Atlantic coast in the first four months of 1942. German subs also moved into the Gulf of Mexico, where over 40 ships were sunk in May 1942 alone.

National Archives

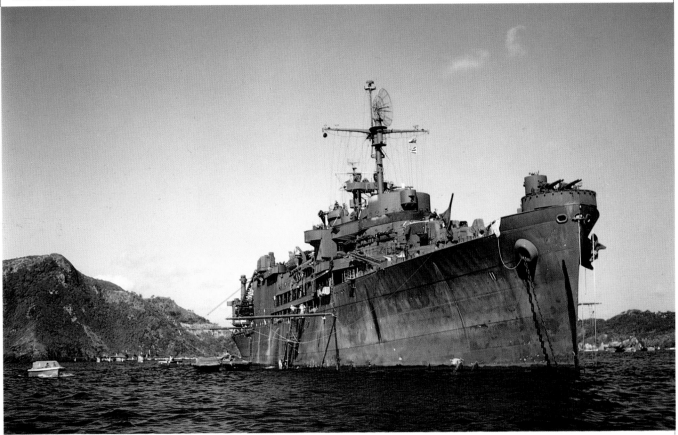

The seaplane tender USS *Norton Sound* (AV-11) at anchor in Tanapag Harbor, Saipan. Ships like this one, carrying everything from high-octane aviation fuel to cigarettes and candy, were necessary to support the Navy's far-flung seaplane squadrons which roamed the oceans as bombers and transports.

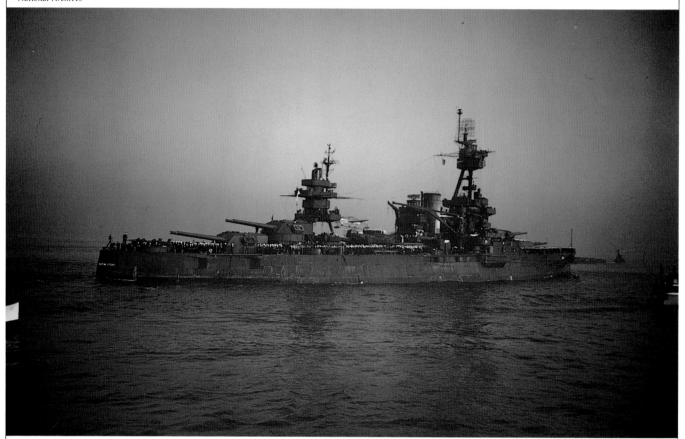

The battleship USS *New York* (BB-34) shows her form on Nimitz Day, October 19, 1945. The crew is on deck for the occasion. Although older battle wagons like this one had been surpassed by the aircraft carrier as the Navy's primary capital ship, they could lay down a murderous barrage prior to island invasions, often more effectively than aircraft.

National Archives

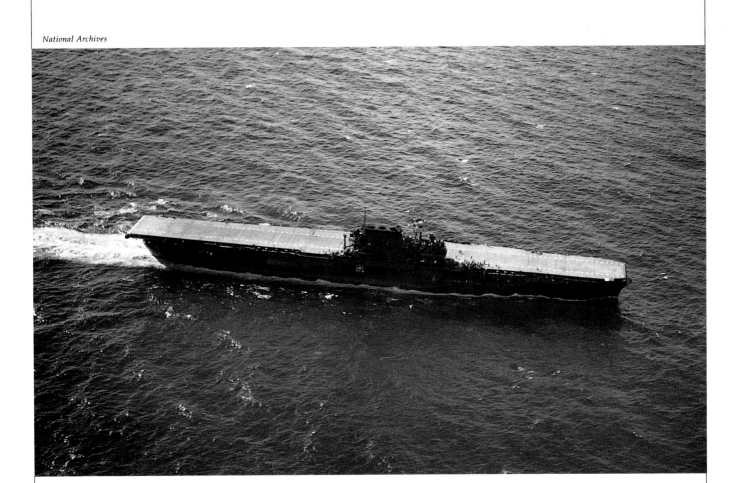

The USS *Enterprise* (CV-6) in October 1941 featured the long, straight plank design of early carriers. She was damaged near Guadalcanal in August 1942 and again in the Battle of Santa Cruz the following October. Both times she was returned to duty in the Pacific after repairs. She was finally put out of commission by kamikaze attacks in 1945.

via Stan Piet

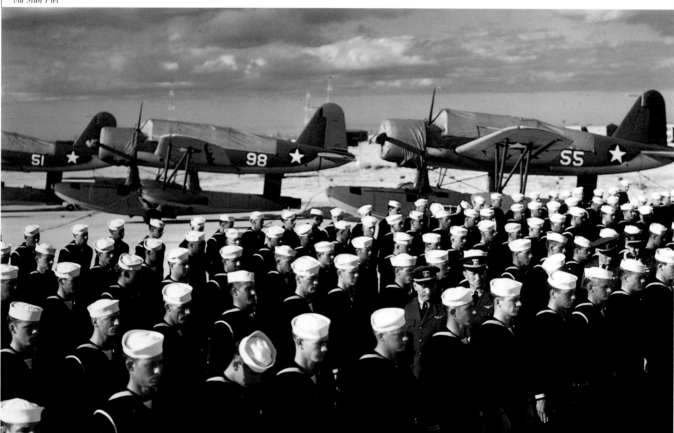

A formation of Navy enlisted men at Naval Air Station Pensacola, Florida, 1944. Those are OS2U King-fishers in the background. At the peak of its enlisted strength, the Navy had over 3,500,000 men and women serving the nation. Of those, the Navy suffered total battle casualties of 83,550, including 46,469 battle deaths.

National Archives

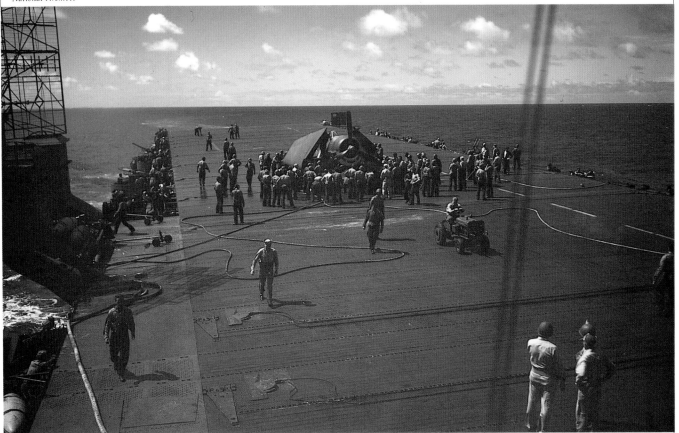

Deck crews gather around a TBF Avenger with its wings folded on the USS *Monterey* (CVL-26) during the Marshalls-Gilberts campaign of November-December 1943. This light carrier was one of over 100 aircraft carriers in service by mid-war, a testimony to American productivity.

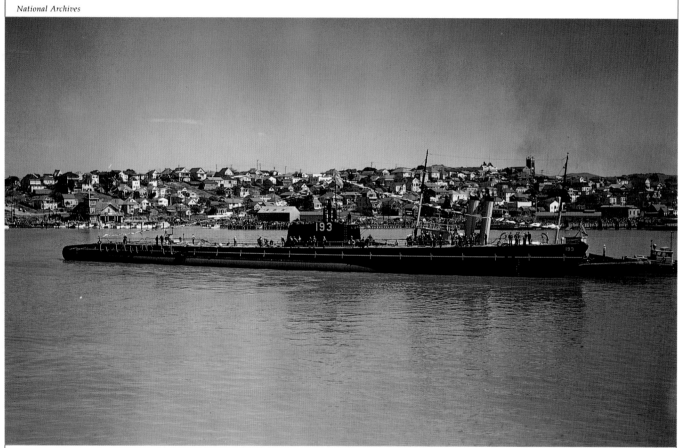

The launch of the USS *Swordfish*, Mare Island, California, April 3, 1939. America is not in the war at this point, but President Roosevelt is anticipating U.S. involvement by building a bigger navy. The Swordfish sank the first enemy ship of the war with a torpedo that struck a Japanese freighter on December 16, 1941.

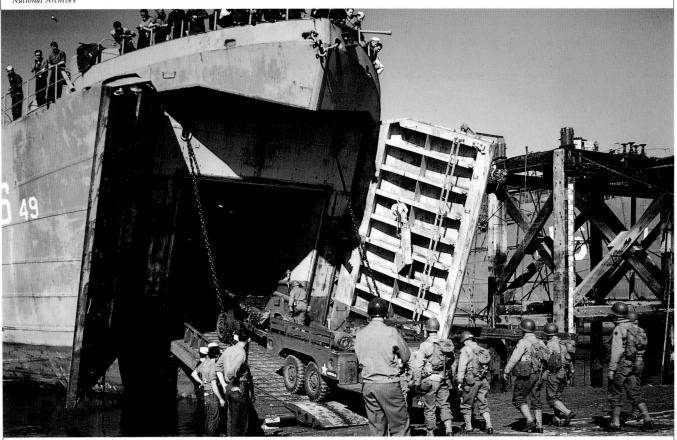

An LST is loaded and unloaded in a port rehearsal prior to the beginning of Operation Overlord, the Allied invasion of Europe. Preparations like this for the assault on Fortress Europe were exhaustive, but the bad weather and rough seas encountered on D-Day (June 6, 1944) were conditions that could not have been duplicated in practice.

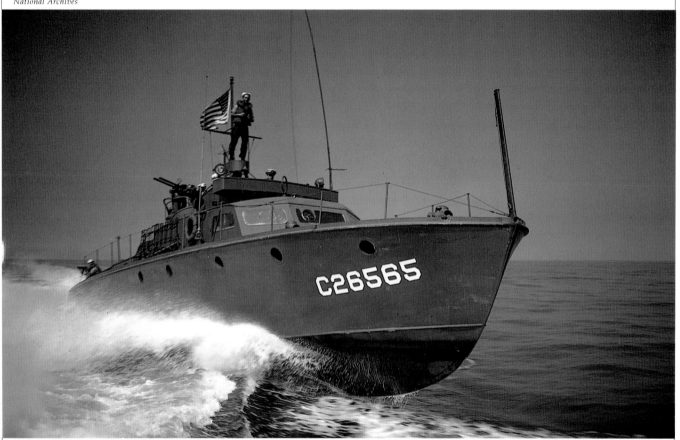

An ARB-Aviation Rescue Boat races across the
water at high speed. Harbor-based not far from Navy
airfields, this fast motor launch was used primarily
to rescue downed pilots.

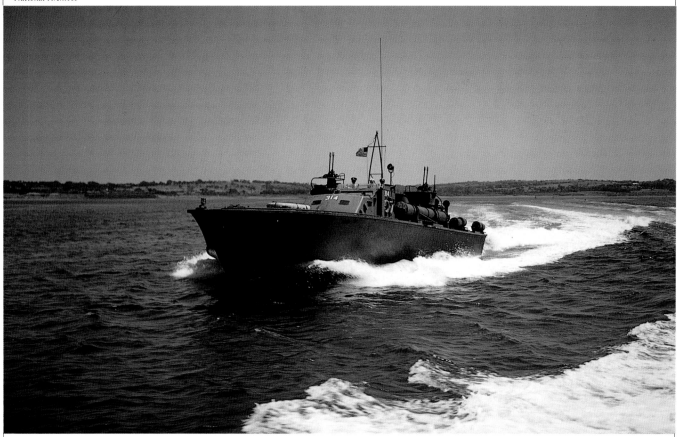

A PT (Patrol Torpedo) boat on a training exercise off Rhode Island in July 1943. Designed as torpedo attack vessels, PT boats would sneak up on enemy fleets at speed under the cover of darkness, launch their torpedoes, then make a fast escape. These fighter pilots of the sea had one of the most dangerous jobs in the Navy.

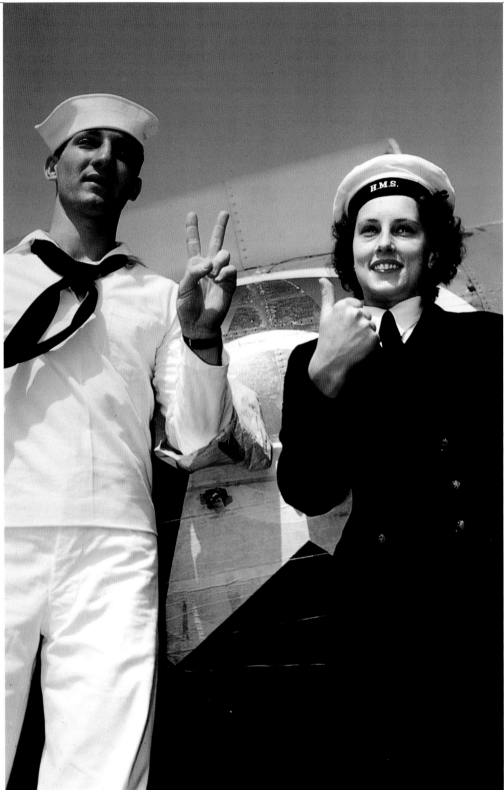

National Archives

A British WREN and a U.S. sailor pose for a public-
ity shot in 1943 at Quonset Point, Rhode Island.
The American plane in the background, with a tem-
porary white star glued over the British roundel, was
given to the Royal Navy as a part of the Lend-Lease
Program to help England.

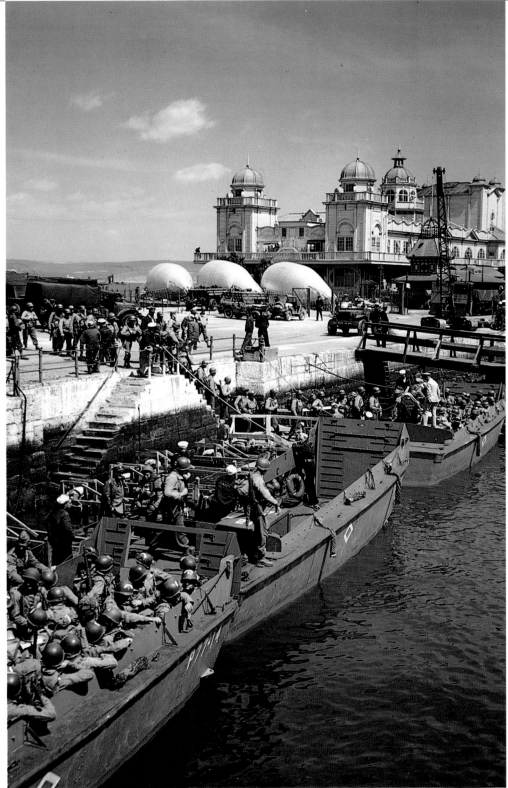

National Archives

U.S. troops in England finally get the call; the training is over and Operation Overlord is under way. Despite the danger ahead, most of these troops are glad to end the wait and get on with the show. These landing craft will take them to troop ships for the passage to France.

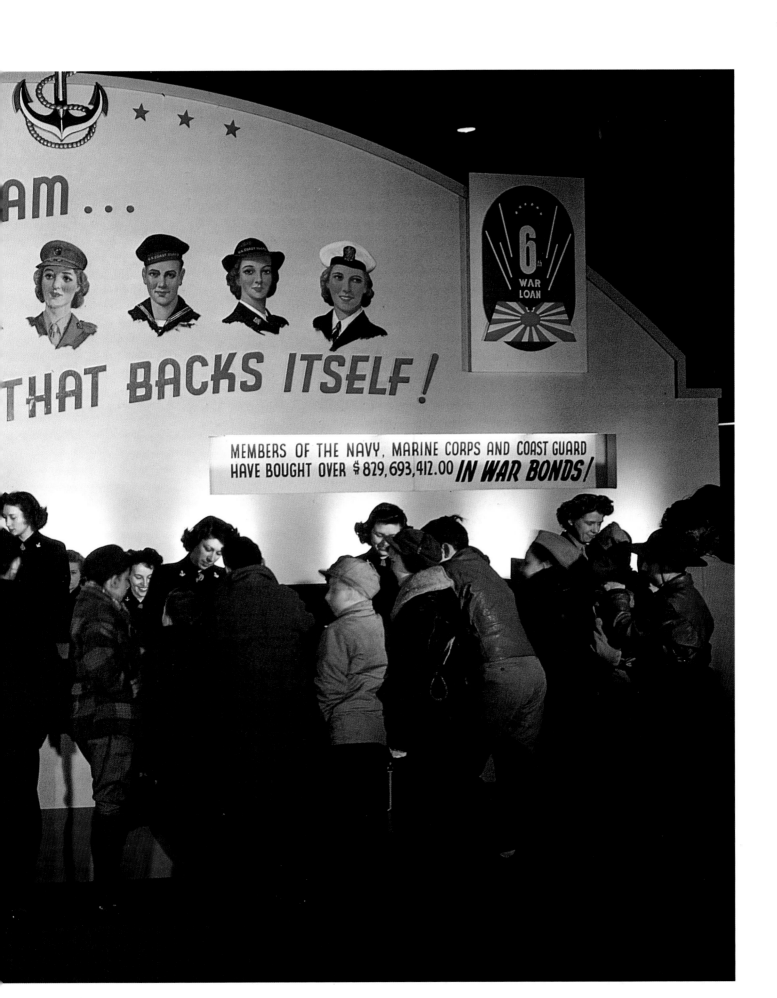

BEHIND THE LINES

People, Places, and Events

Back at home, the climate was right for the emergence of color pictures as the new illustration medium of choice. Magazines were screaming for color images—for clarity, depth, and impact, this was an easy call to make, but difficult to fulfill. While the technical side of Kodachrome processing was much easier and faster in the States than on the battlefields of Europe and the Pacific, most people did not realize it was readily available on their local drugstore shelf. And professional news photographers could not be hampered by the speed limitations and fragility of this color film.

But the defense establishment saw the value of color film early on, especially in the motion picture area, and avidly pursued the production of color stills, movies, and training films. Not only were these color films more valuable as training aids, imparting a broader range of information to the eyes, but also more effective as image builders and morale builders. More than once did generals and admirals feel competitive pressure to create prestigious color images and identities for their services.

The pictures produced in out-of-combat situations are uniformly better in quality than those taken near the front lines, as is to be expected. Even from the color-jaded perspective of the 1990s we can appreciate the beauty of these images, and imagine what a jolt to the eyes they must have been to a citizenry raised on black-and-white. Only now can we trace our sensory progress back to the development of color film, and realize that the first practitioners of the medium were ordinary men, undergoing one of the most extraordinary events of the 20th century.

Previous page: The Navy shipyard near the Chicago docks on Lake Michigan was the site of a War Bond exhibit in November 1944. Bond drives and bond-selling events, some featuring movie stars and famous singers and entertainers, were an important part of the domestic war effort, raising both money and morale. (National Archives)

National Archives

This Kodachrome portrait of President Franklin Delano Roosevelt was taken in 1944 and distributed by the Office of War Information.

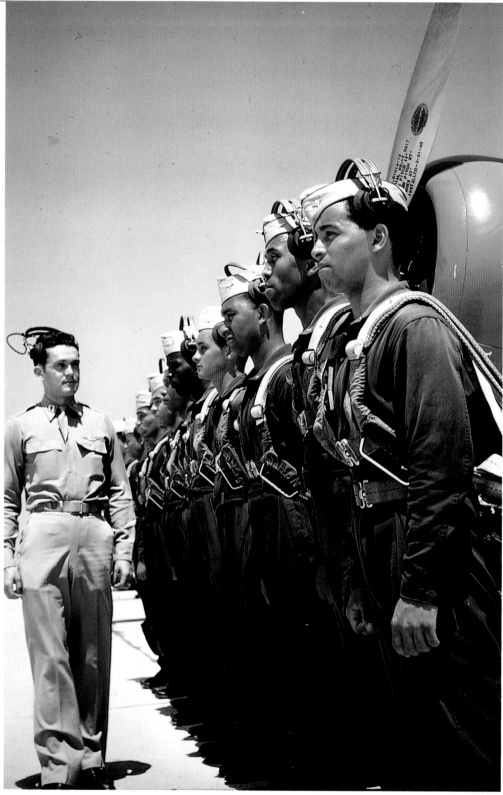

USAF

The 99th Pursuit Squadron was established in March 1941 and later transferred to the training field adjacent to Alabama's all-black college, Tuskegee Institute. African-American fighter pilots trained there became known as the "Tuskegee Airmen." Pilots of the 99th entered combat over North Africa in June 1943, and ran up an outstanding combat record.

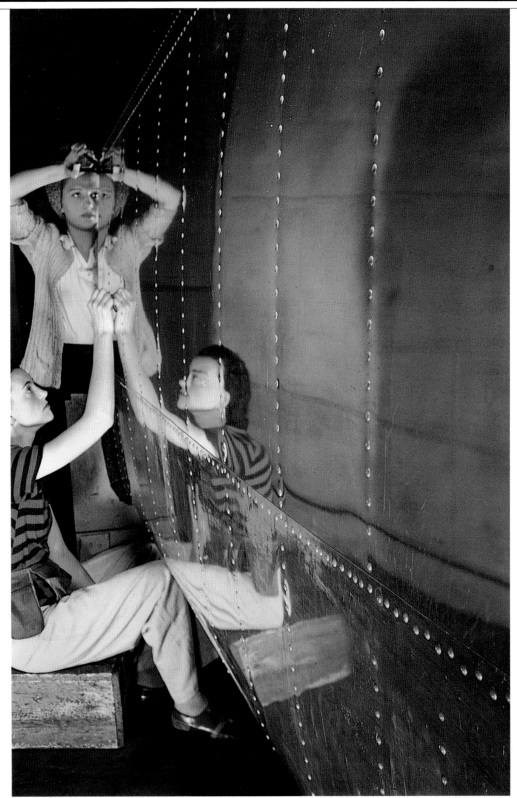

Women riveting PB2Y Coronado flying-boat wingsets at the Consolidated-Vultee plant, Downey, California, July 1943. It didn't take long before male plant supervisors came to appreciate the qualities American women brought to the job—efficiency, attention to detail, and punctuality.

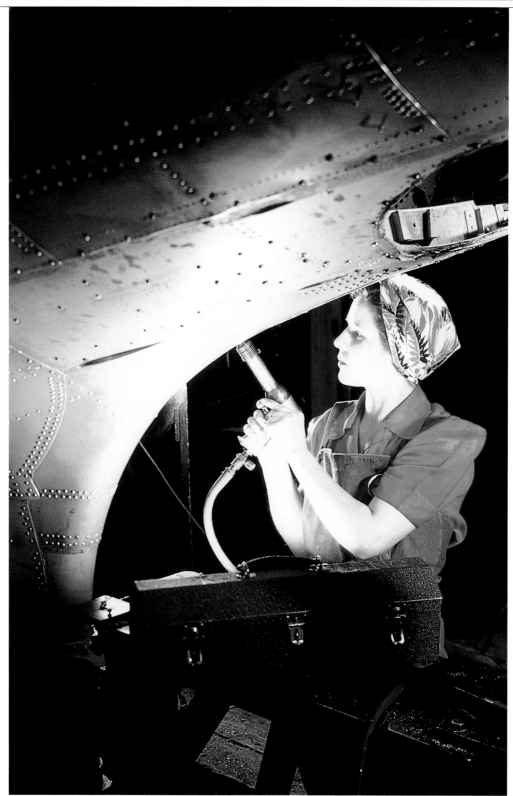

National Archives

A very real Rosie the Riveter does her job in April 1943 at the Baltimore manufacturing plant for Martin PBM Mariners. American women made the production miracle of World War II possible. By the end of 1943 American workers had produced 160,000 airplanes compared to Japan's 30,500.

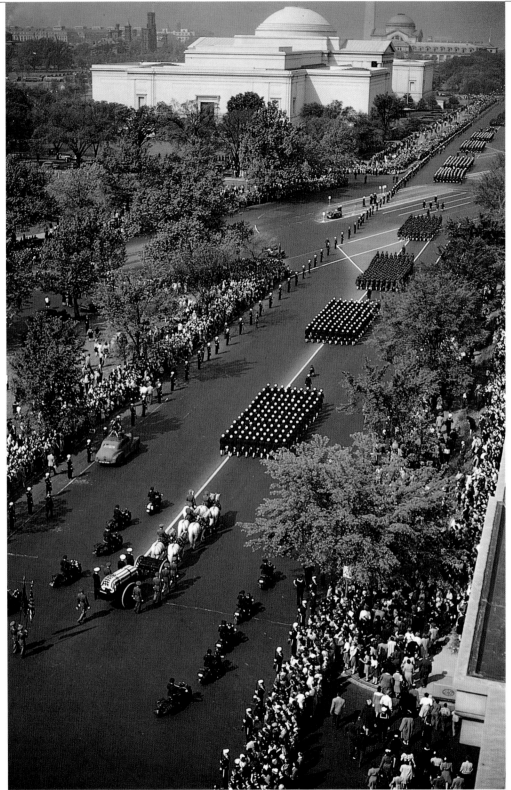

At the same time American troops dispatched the Japanese from Okinawa and advanced to the Elbe River 50 miles from Berlin, President Franklin D. Roosevelt died on April 12, 1945. His funeral cortege moved through Washington, D.C., as the nation wondered, as did the German High Command, what the consequences of his death might be.

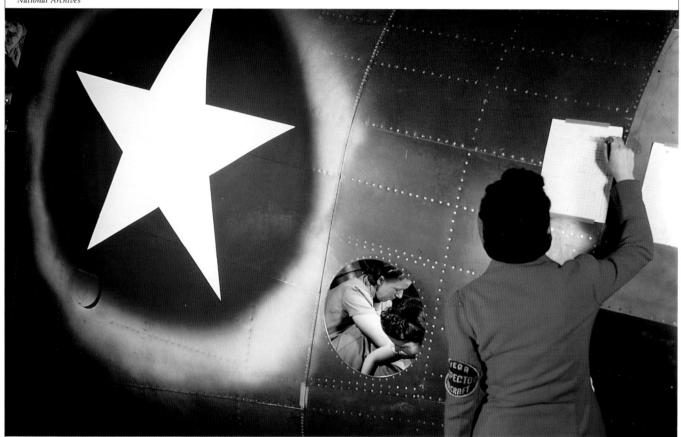

A female inspector checks PV-1 Ventura progress at the Lockheed-Vega plant, Burbank, California. The need for wartime productivity amid a male-labor shortage brought women into the labor force like never before, and the societal changes were felt long after the war was over.

USAF

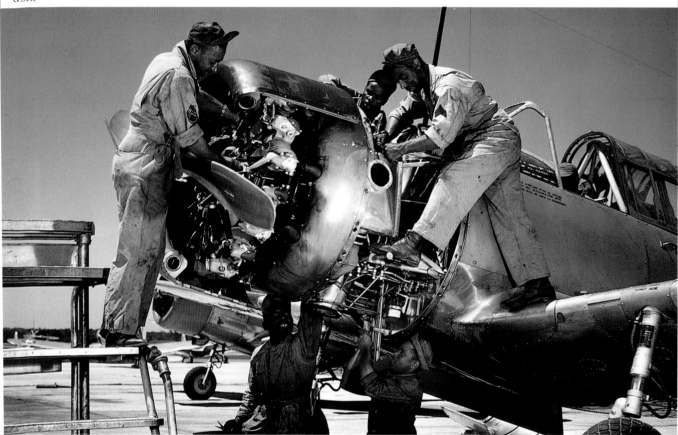

Mechanics work on a Vultee BT-13 at Tuskegee, Alabama. The men who had the moxie to make the Tuskegee experiment successful, both the black crews and pilots and their white commanders, changed American society by leading to the integration of the military services, a harbinger of things to come for the whole nation.

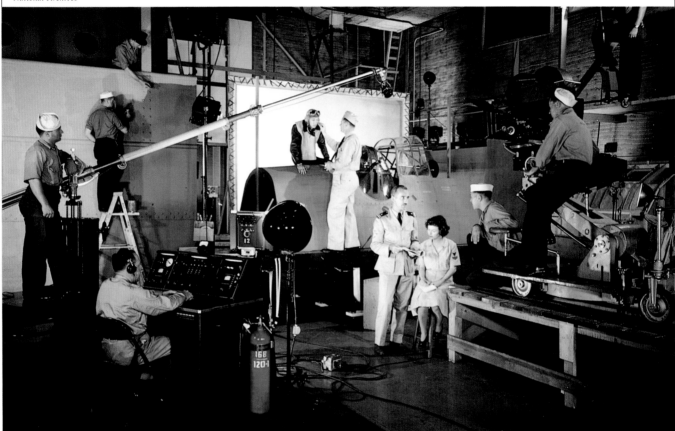

Naval Air Station Anacostia near Washington, D.C., was equipped with a motion picture studio for a unit called the Photographic Science Lab. It was clear to the Navy that training films, both in color and in black-and-white, could accomplish training tasks efficiently. Here they are shooting a scene from a film on the TBF Avenger aircraft.

Frederick Hill

A war-bond sales-promotion event in Portland, Oregon. The financing of the war was accomplished in large measure by the constant sale of Series "E" bonds. By war's end, some $36 billion of these bonds had been sold.

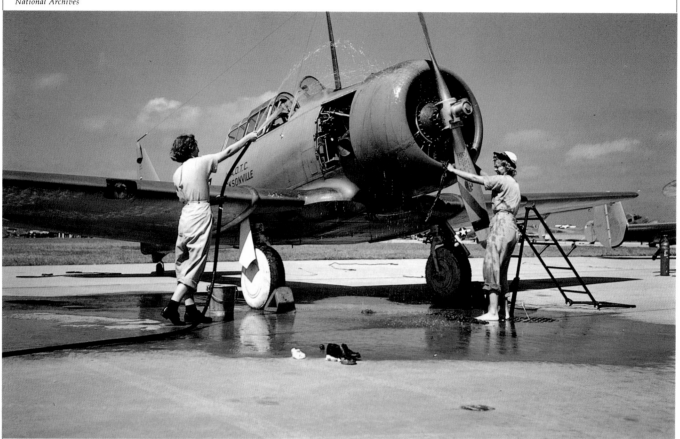

Not all female contributions to the U.S. work force
were limited to civilian factory work. Many women
joined the Armed Services as WAVES, WACS,
SPARS, or Women Marines. Here, two WAVES have
clean-up duty on an SNJ trainer at Naval Air Station
Jacksonville, Florida.

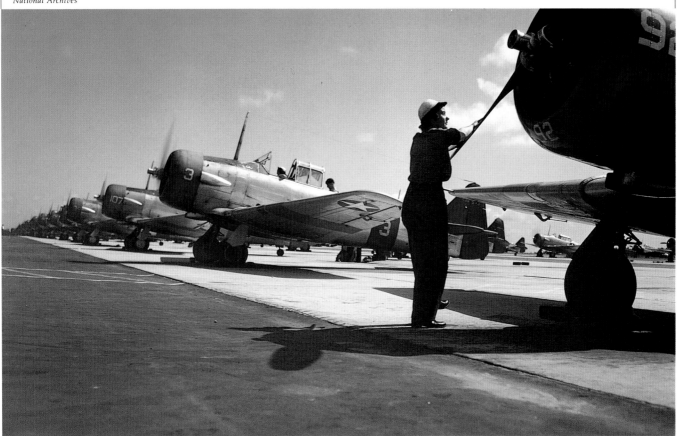

A WAVE attends a propeller SNJ trainer. Auxiliary duties such as this were commonly performed by WAVES, but women also had flying duties during the war. The Women's Auxiliary Ferrying Squadron (WAFS) was begun in mid-1942, followed by the Women's Airforce Service Pilots (WASPS) in the same year.

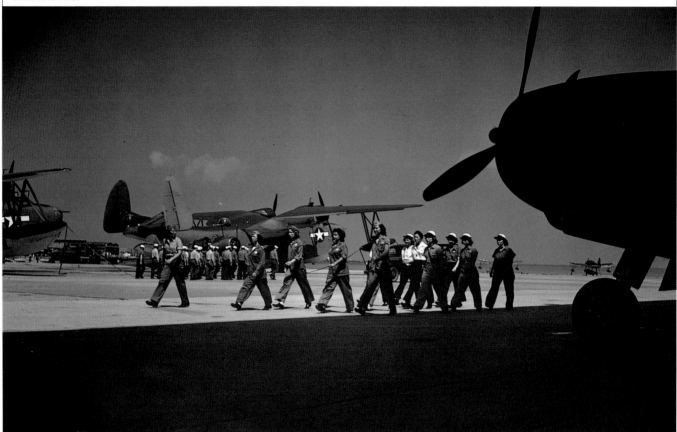

WAVES at Naval Air Station Norfolk, Virginia, March 1945. Each of the four main services had its women's component, and over 200,000 women enlisted for duty between 1942 and 1945.

Wartime shortages of nearly all consumer goods and foods were common. A Coca-Cola delivery man pauses on his route at the WAVES indoctrination center, U.S. Navy Reserve Midshipman's School at Massachusetts State College in Northampton. After this stop he may have no more soft drinks to sell.

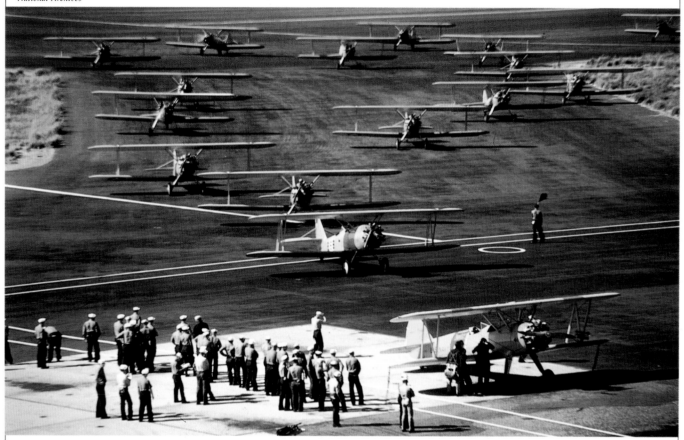

A flight line full of "Yellow Perils," N2S and N3N primary training biplanes at Naval Air Station Corpus Christi, Texas. The nickname came easily as these yellow aircraft were usually flown by new students trying to learn the rudiments of piloting. The color was fair warning for everyone, in the air or on the ground, to give these planes a wide berth.

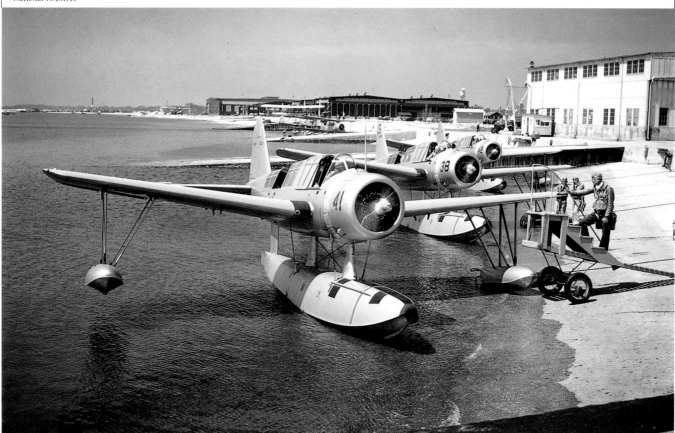

In October 1940 three OS2U Kingfishers warm up for new students on the seaplane ramp at Naval Air Station Pensacola, Florida, the home of naval flight training. Even though Pearl Harbor is more than a year away, military analysts in America are watching Britain and Germany fight in the skies over Europe, and want U.S. pilots to be prepared.

Plant production is in full swing at the Consolidated-Vultee plant in San Diego, California, July 1943. The first shift leaves for the day, and the PB2Ys under the camouflage netting await the next wave of factory workers.

A bombardier gets his wings from a beautiful ad-
mirer during graduation. By the time the war ended
the Army had trained 47,354 bombardiers. The train-
ing mill changed from not enough graduates in 1942
to far too many in 1944, so much so that thousands
of men were put on hold, waiting at colleges and
airfields for orders that never came.

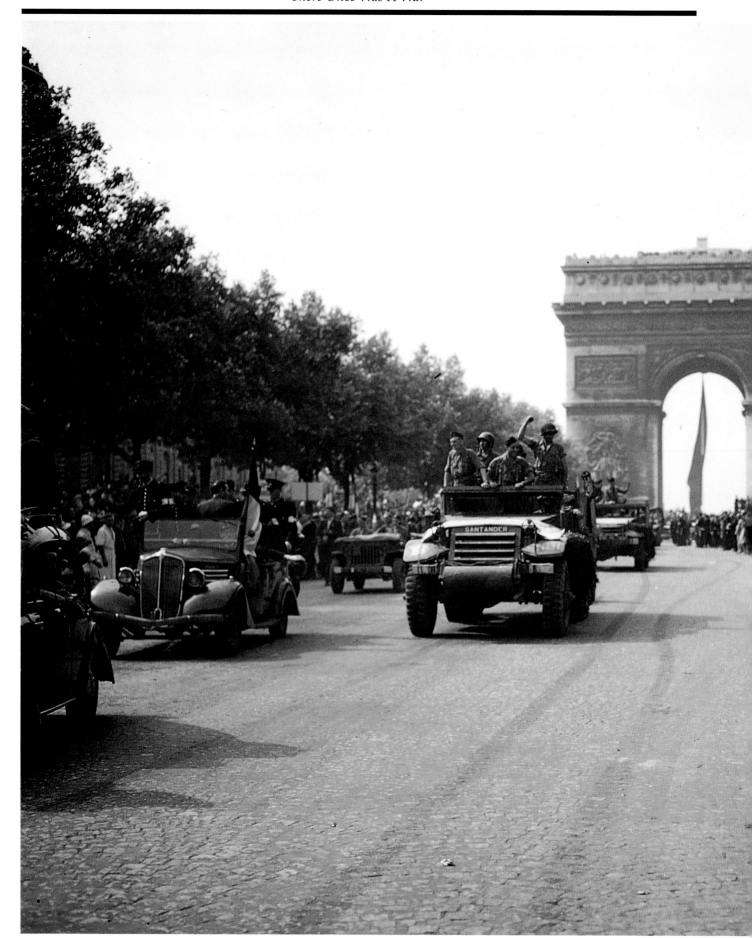

The liberation of Paris wasn't exactly in Supreme Commander Gen. Dwight D. Eisenhower's plans in August of 1944. He and Gen. Omar Bradley wanted to bypass it and devote their fuel, food, and troops to the continuing chase of the German army. But the French forces couldn't resist the chance to throw the Germans out of their beautiful city, and Eisenhower was forced to allow Gen. Jacques Leclerc's 2nd Armored Division, followed by the U.S. 4th Infantry Division, to liberate the city. Here American troops parade under the Arc de Triomphe.
(National Archives)

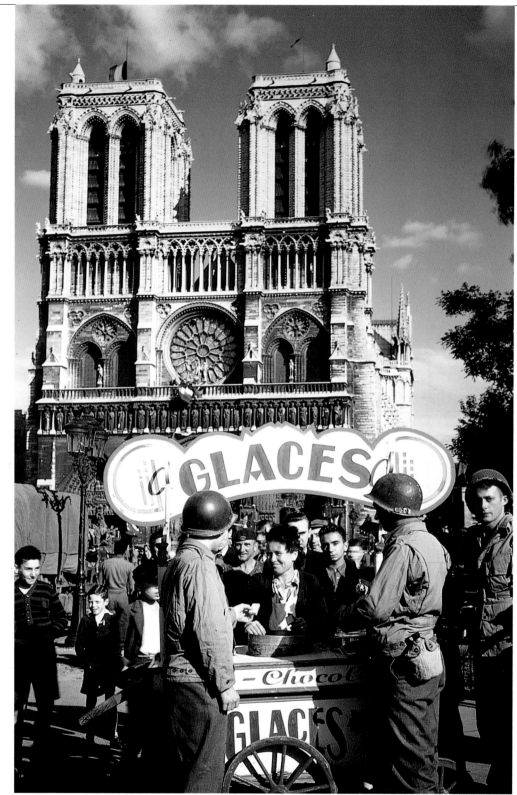

For many American soldiers being in Paris was the dream of a lifetime, even if it was wartime. They might never have gotten to Europe any other way. Here GI's enjoy some ice cream in front of the Cathedral of Notre Dame, a favorite stopping point, as the vitality of the city seems to be reviving around them.

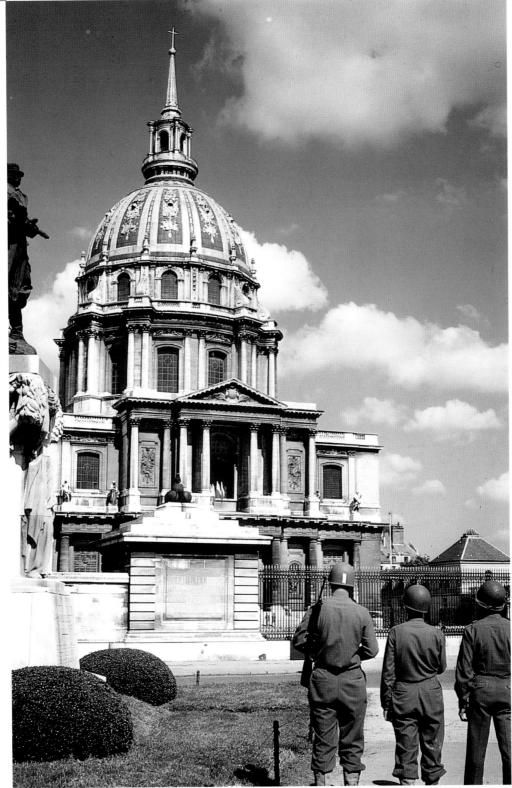

National Archives

Here is another of Paris's famous monuments, Sacre Coeur in Montmartre. Buildings and churches such as Sacre Coeur were lucky to have been spared the destruction that Hitler ordered on August 20, 1944. General von Choltitz instead negotiated a surrender-and-withdrawal plan that left the world's most beautiful city intact.

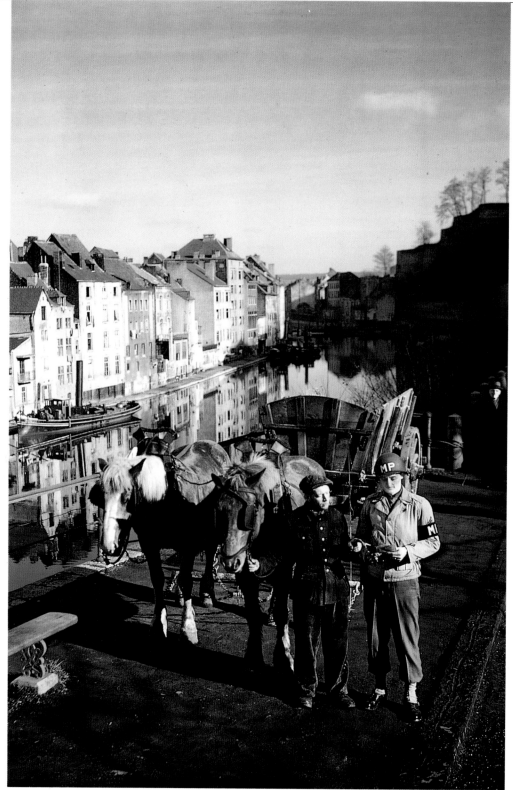

MP Sgt. Andrew Para checks the credentials of a Belgian farmer near the canals of Namur, Belgium. Checking papers had all the overtones of the German occupation, so American military police were ordered to treat liberated nationals as friends. Nevertheless, German operatives were still around and precautions had to be taken.

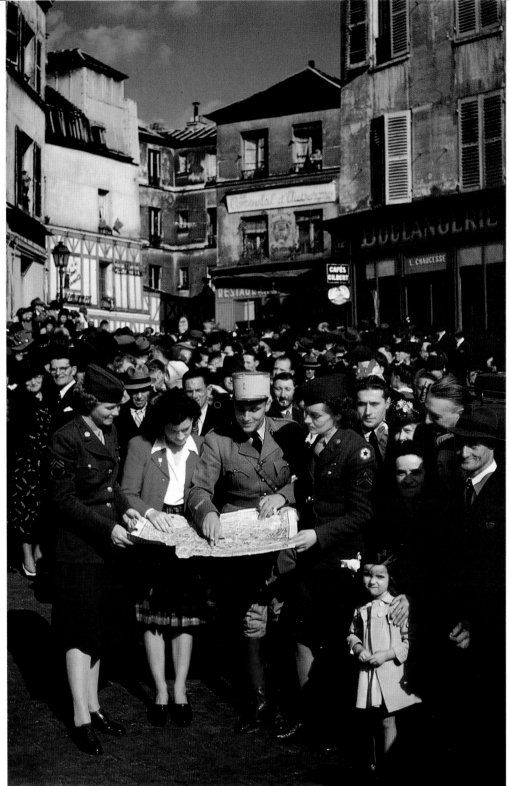

On May 7, 1945, the Germans surrendered uncon-
ditionally. In Allied countries the news brought a joy-
ous outpouring of emotion. Here in a French village,
the news brings everyone together in a heartfelt
celebration. In America there was relief, but the war
with Japan was not yet over. The big celebration
would have to wait until then.

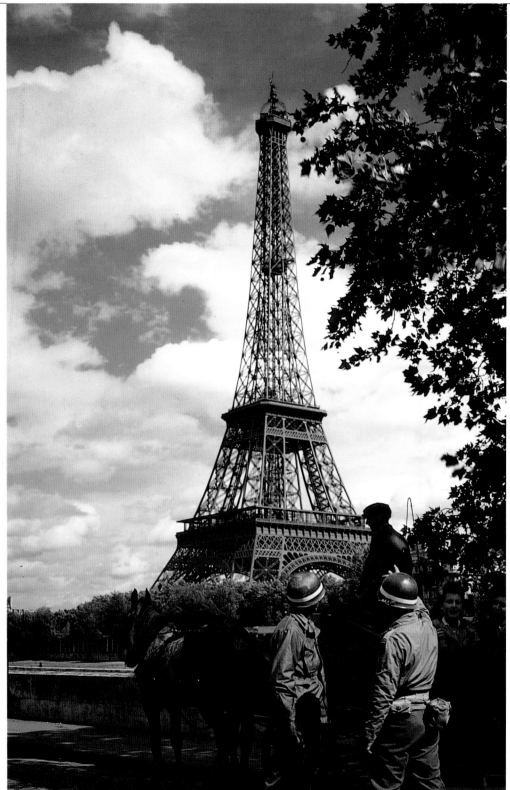

National Archives

September 9, 1944. Two American MPs stand in the shadow of the Eiffel Tower barely two weeks after the city was liberated. Parisians welcomed the Americans warmly, opening their city without hesitation, which led to some overexuberant celebrating by the liberators. MPs were stationed all over the city to keep things under control.

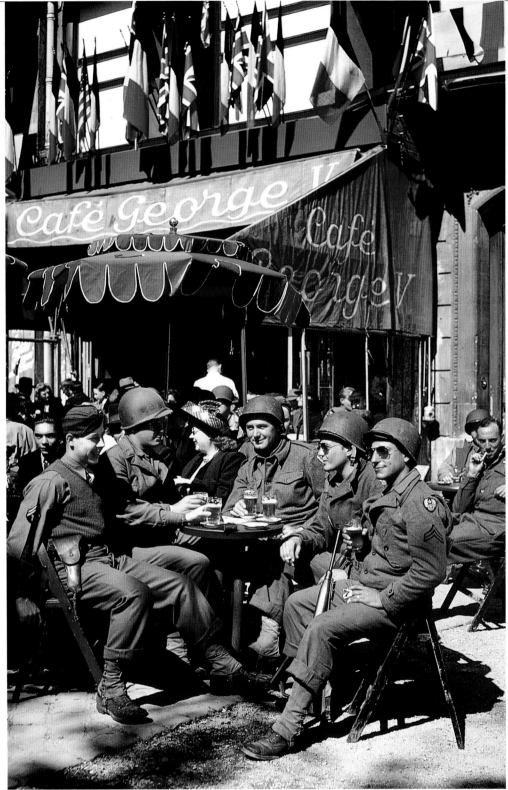

Ah, Parisian café society! Sitting in the Café George
V is quite a contrast to a thousand days of mud,
blood, chowline food, and constant danger.

National Archives

The war is over, and an American MP is lucky
enough to be stationed at a French villa on the coast.
Mansions like this were opened to soldiers as rest
camps after the war, providing a huge contrast to
the hardships just endured.

National Archives

A French nun and two children stand amid the ruins of the St. Malo Catholic Church in Valogne, Normandy, in the summer of 1945. Scenes like this were common across the European continent after the war, providing a constant reminder of the terrible cost of war.

American, British, and Free French forces broke down the walls of Nazi might with staggering speed in the late spring of 1945. As they entered the towns of Germany, it was not rancor they met, but gifts of flowers and brandy. Here an American ambulance moves down a German boulevard.

Ralph M. Powers, Jr.

P-38 pilot Monty Powers of the 82nd Fighter Group enjoys the bar at the famous Eden Roc Hotel, Cannes, France, in 1945. The availability of such fancy establishments did a great deal toward restoring the combat capabilities of American fighting men. It was hard to endure a drafty tent and bad food, but one could hold on for the Eden Roc.

Hank Redmond

The pilots who flew in the China-Burma-India Theater had quite a different war experience than those who fought in Europe. Here 12th Bomb Group navigator Hank Redmond sports with two young friends near the rest camp at Darjeeling, India, before flying back to his B-25 base at Fenny, India.

Fred Poats

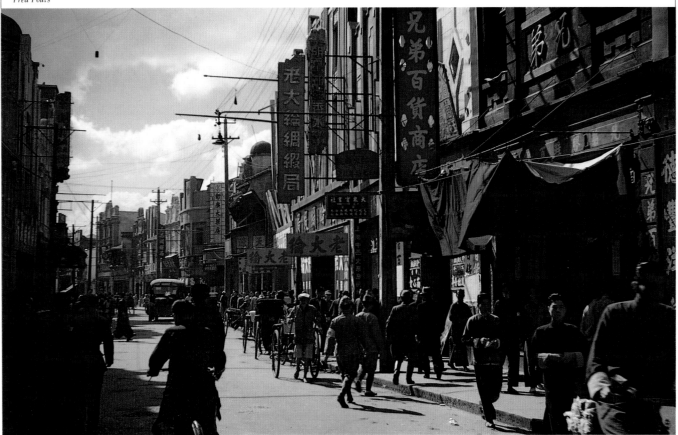

A street scene in Shanghai, August 1945. The Potsdam Conference demanding Japanese surrender was under way as these Chinese went about their day.

Fred Poats

American GI's used their cameras to document the exotic life of the Orient. Here an opium seller plies his trade openly on the streets of Kwei Yang.

Harold Cohen

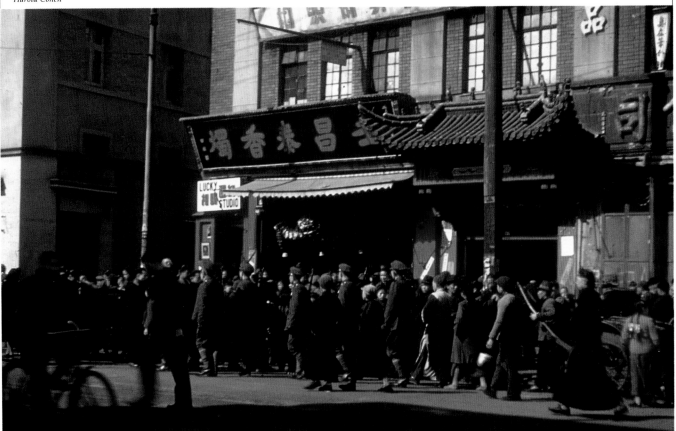

"Silk Street" in Shanghai, August 1945. Armed Chinese soldiers can be seen walking at the edge of the crowd.

Edward Richie

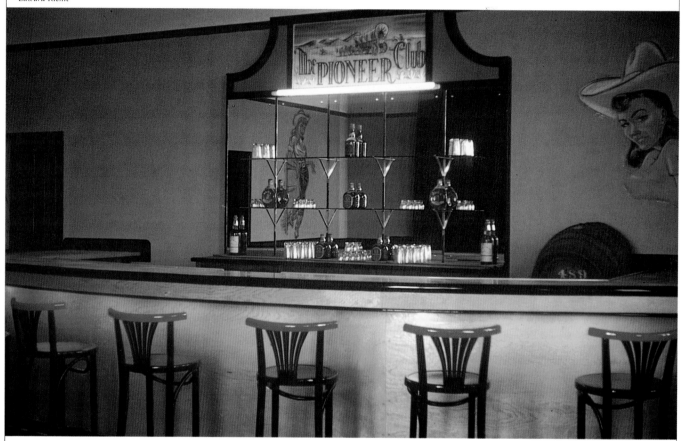

The 4th Fighter Group held forth at the Pioneer Club, a pub built by the men themselves on their airbase at Debden, England. Pubs like these were frequented by American servicemen all over Great Britain, and their unit patches, plaques, and insignia can still be spotted in many of them today.

Joseph S. Kingsbury

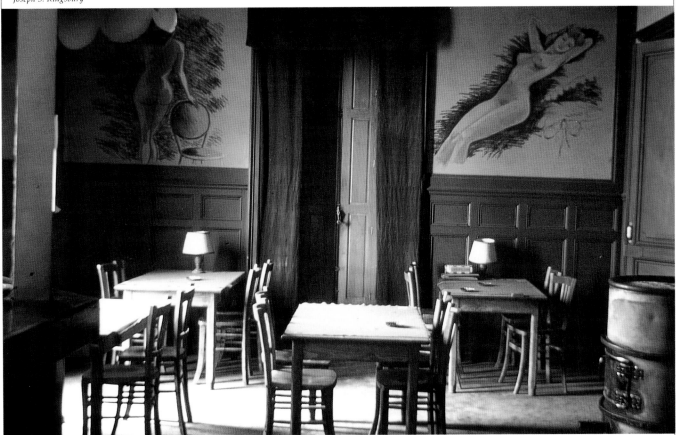

After moving north from their original staging area in the Mediterranean, the 320th Bomb Group set up this comfortable Officer's Club in Longecourt, France, in early 1945.

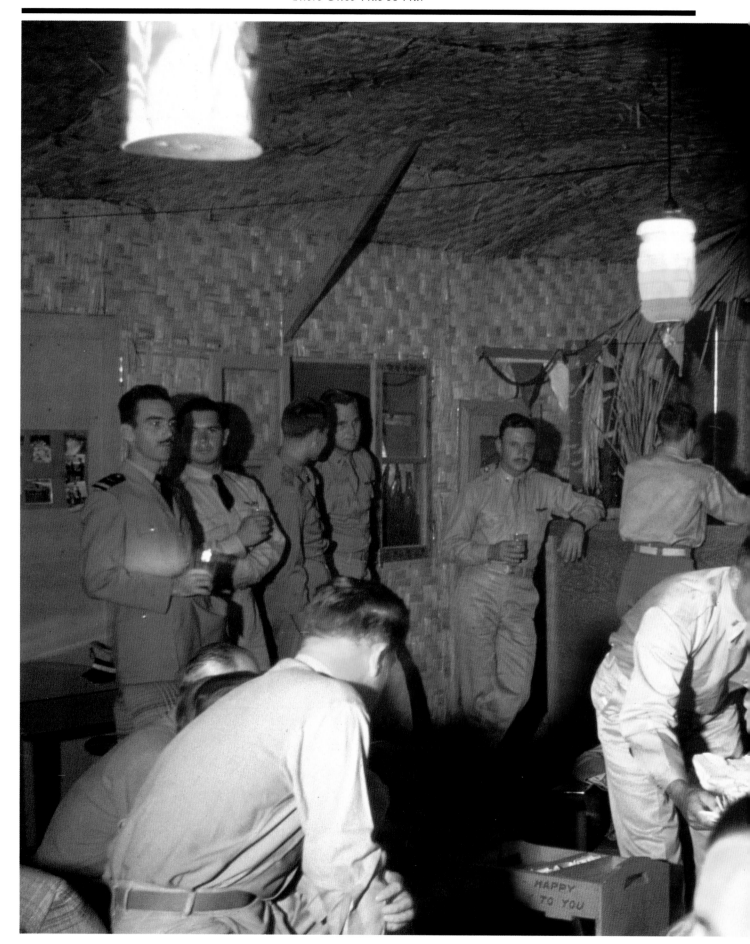

An unusual assignment of the war was that
given to the 91st Photo Mapping Squad-
ron to provide aerial mapping of Peru from
their F-10s. This was their Officers' Club.
(Ole C. Griffith)

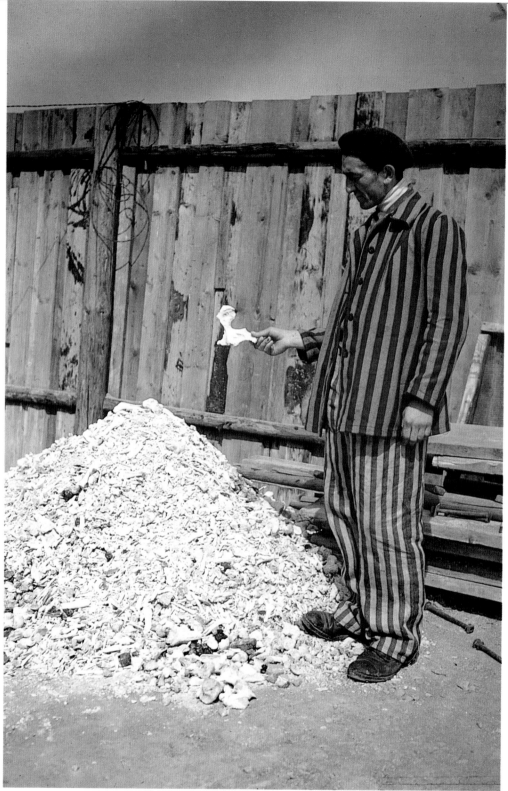

National Archives

A Buchenwald survivor looks at the grim remains of his comrades. As U.S. and Russian forces swept through the remnants of Hitler's Germany, they liberated the concentration camps and discovered the horrible truth of Third Reich atrocities. Weimar residents were forced to go through the camps, and most said they had no idea what had gone on there.

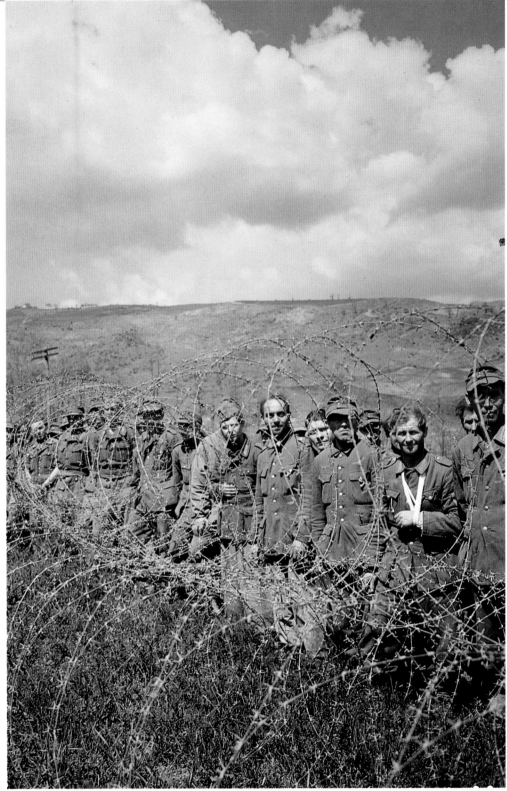

The 5th Army captured these German and Italian soldiers in the first few days of the May 1944 offensive across the Rapido River. Although the Allies' record in prisoner-of-war treatment was not spotless, the overall view was that the American military treated its prisoners honorably and ethically.

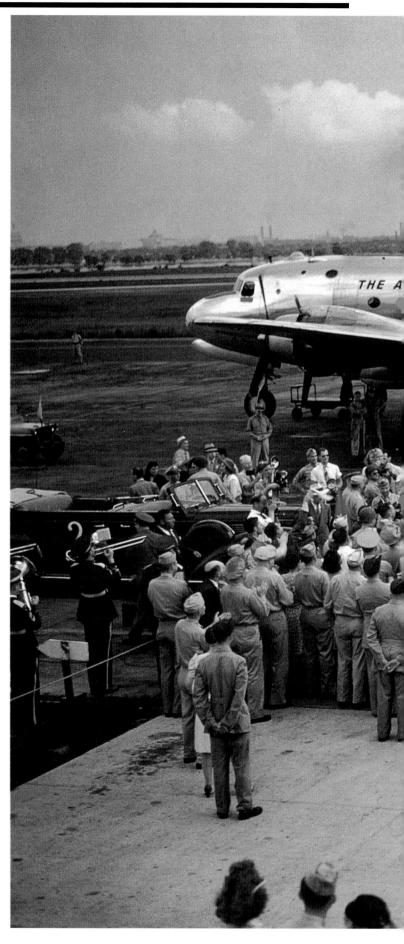

Adm. Chester Nimitz was honored by his fellow Texans for his outstanding contributions to the Allied victory in ceremonies in November 1945. Here the admiral and his wife are surrounded by the press on "Nimitz Day." (National Archives)

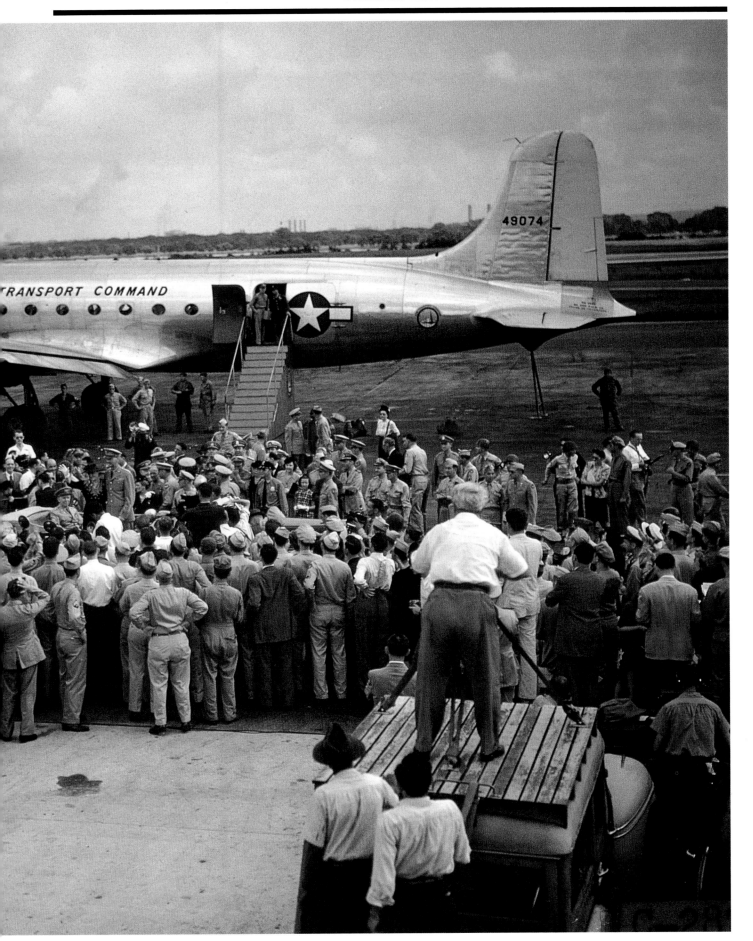

Fred Poats

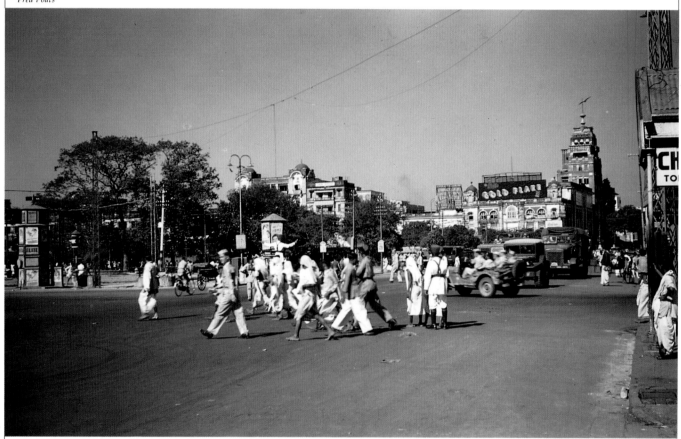

Karachi, India, 1945. Allied supply and air bases in India were crucial to the Pacific air war, especially as Allied bombers and fighters were stretching themselves across China and the Pacific and hitting Japan itself. Air Transport Command was "flying the hump" over the Himalayas delivering food, supplies, and war materiel from India to China.

George J. Fleury

Darlinghurst Road, Melbourne, Australia, a great rest
and relaxation city for Allied fighting men. Gen. Dou-
glas MacArthur withdrew to Australia after the de-
bacle in the Philippines, found not much defensive
capability, and chose to defend Australia by taking
on the Japanese further north in New Guinea.

James G. Weir

American sailors walk the streets of Honolulu in 1944 when it was still very much a sleepy tropical city with a slow pace of life. The temperate climate and wonderful beaches gave Americans fighting the rough Pacific war a great place for rest and recuperation.

Frederick H. Hill

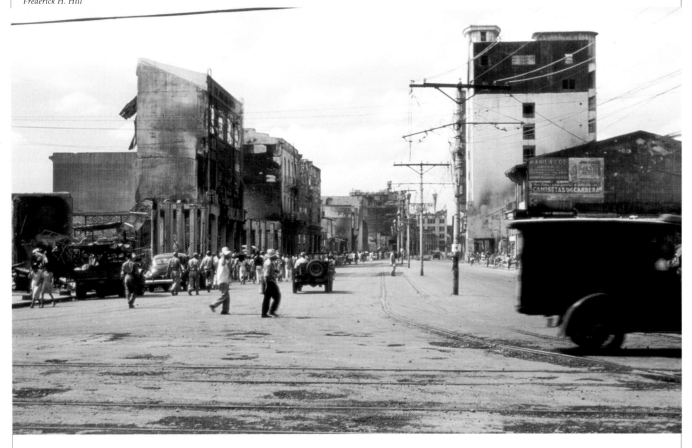

By early March 1945 American forces had subdued the Japanese in the Philippines enough to allow Gen. Douglas MacArthur to make good on his promise to return. By March 4 Manila had been cleared of enemy resistance, but not before the Japanese tried to bomb and burn the city to the ground. Amid the ruins on Rizal Avenue, life returns to normal.

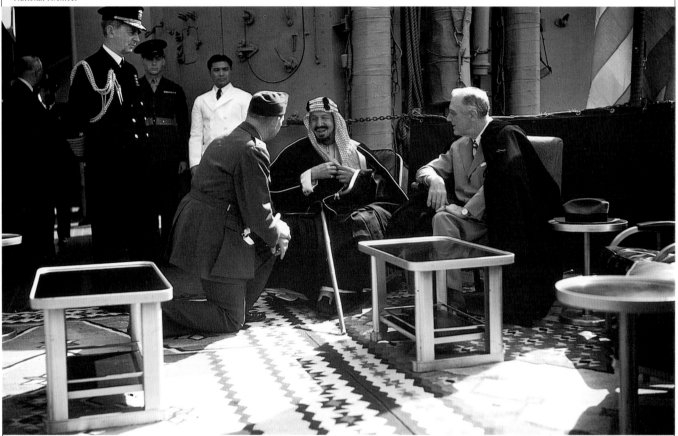

President Franklin Delano Roosevelt (at right) and King Saud of Saudia Arabia meet in Cairo, November 1943. To ensure adequate oil supplies for fuel-hungry ships, tanks, and airplanes, the U.S. needed an oil ally, and King Saud needed a commitment for protection from German expansionism.

National Archives

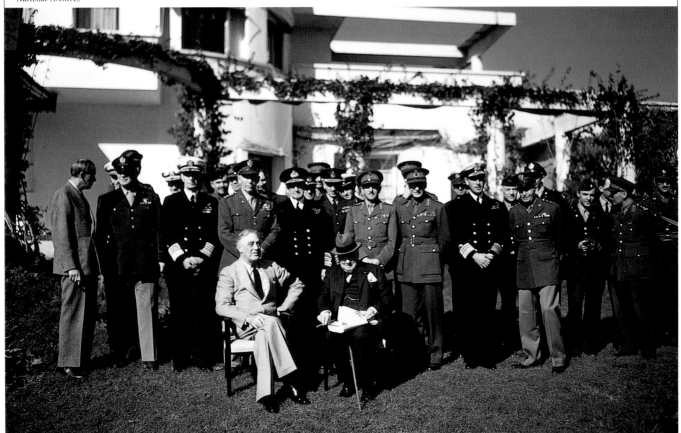

President Roosevelt and Prime Minister Churchill meet at the Cairo Conference. They participated in eight other conferences during the war years: Washington (December 1941), Washington (June 1942), Casablanca (January 1943), Washington (May 1943), Quebec (August 1943), Teheran (November 1943), Quebec (September 1944), and Yalta (February, 1945).

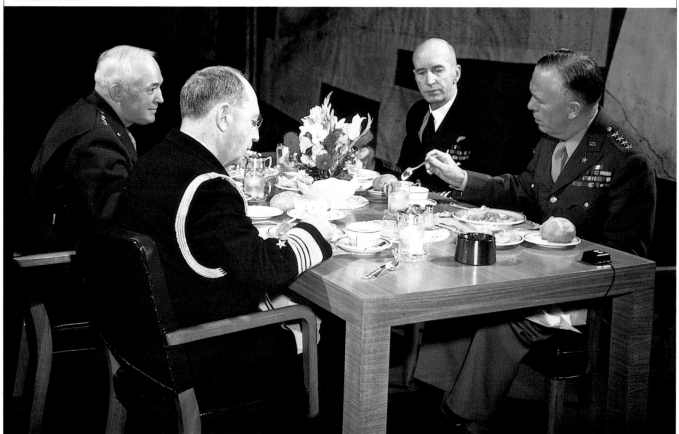

The Joint Chiefs meet for one of their many working lunches. Counterclockwise from right are Gen. George C. Marshall, Adm. Ernest J. King, Lt. Gen. H.H. Arnold, and Fleet Adm. William D. Leahy.

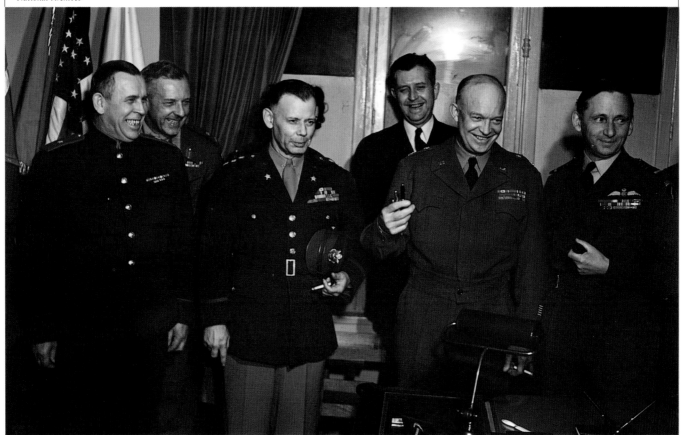

The Germans have surrendered unconditionally, and Gen. Eisenhower (second from right) has given his victory speech. With him are, from left, Gen. Suslaparoff, Lt. Gen. Holland Smith, and Air Chief Marshal Sir Arthur Tedder.

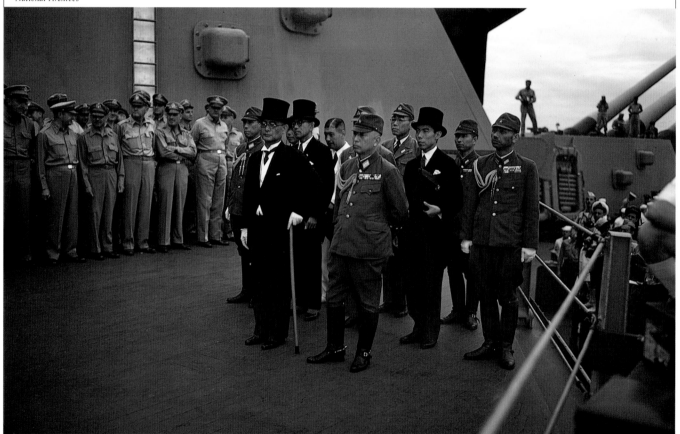

September 2, 1945. Japanese officials arrive on the
USS *Missouri* to sign the terms of surrender. Among
them are Minister Mamoru Shigemitsu (signing for
the Emperor) with his two formally dressed depu-
ties, Ketsuo Okayoki and Toshikaya Kose, and Gen.
Yoshijiro Umezu (signing for the Imperial Japanese
Army High Command).

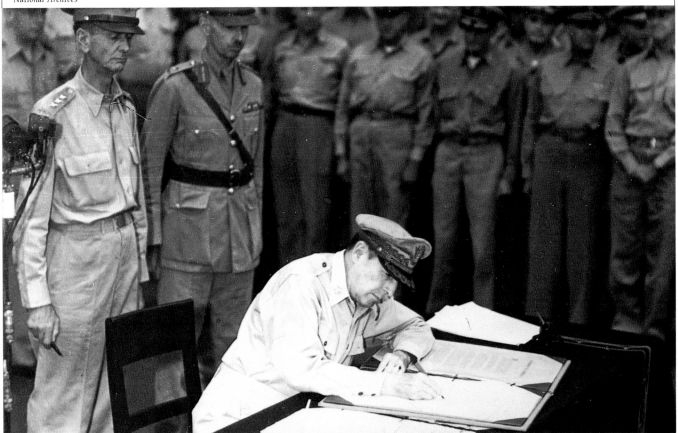

Gen. Douglas MacArthur signs the Japanese sur-
render documents. Behind him is Lt. Gen. Jonathan
Wainwright, whom MacArthur had regrettably been
forced to leave behind on Corregidor three years
earlier.

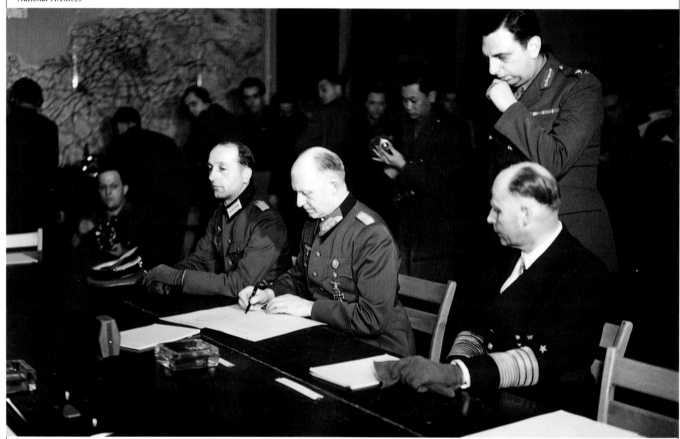

Gen. Alfred Jodl, German Chief of Staff, signs the terms of surrender at Supreme Allied Headquarters in Rheims, France, on May 7, 1945. To his left is Adm. Hans Georg Friedeburg, Commander in Chief of the German Navy. Friedeburg would kill himself a few days later; Jodl was hanged after being found guilty of war crimes at the Nuremburg Trials.

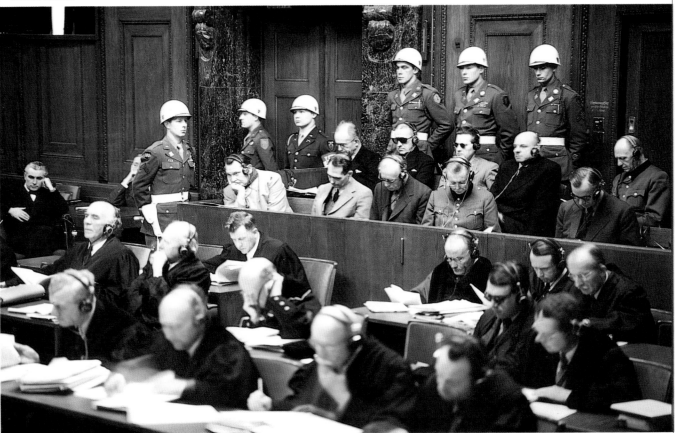

The Nuremburg Trials, August 1946. Among the accused are Hermann Goering, Rudolph Hess, Joachim von Ribbentrop, Wilhelm Keitel, Alfred Rosenberg, Karl Donitz, Erich Raeder, Bolden von Shirack, Fritz Sauckel, and Alfred Jodl. On October 16, 1946, eleven of the prisoners were hanged; Goering escaped his fate by committing suicide.

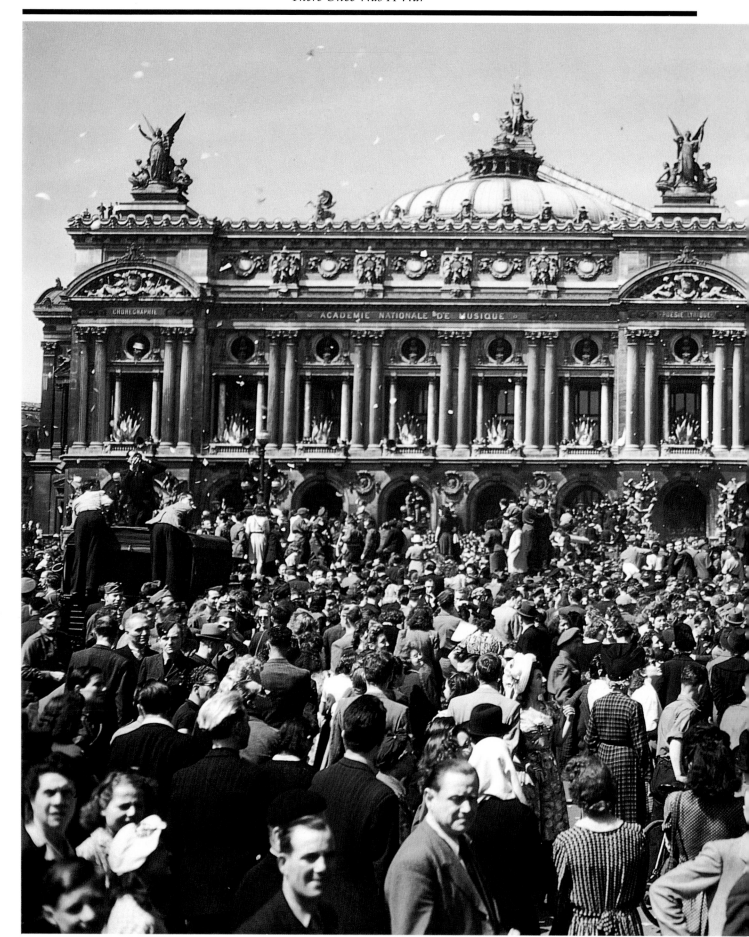

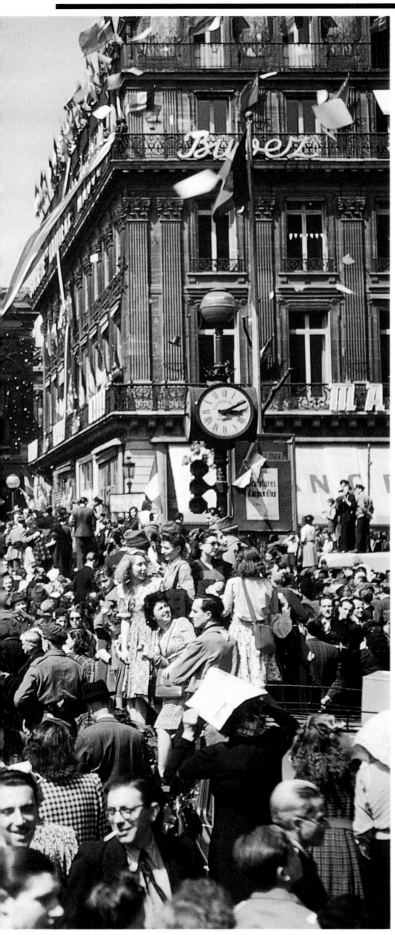

May 8, 1945. Around the Place de l'Opéra, thousands of Parisians celebrate after the announcement of the German surrender, ending five years of occupation.
(National Archives)

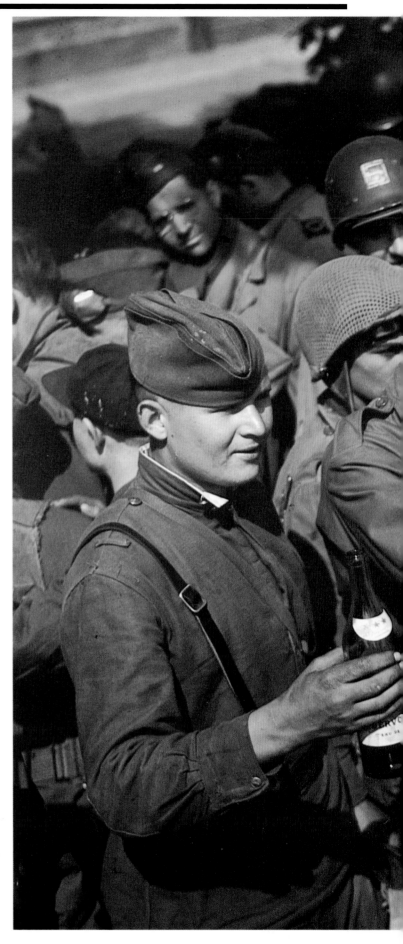

Advance patrols of Russian and American forces meet at the Elbe River near Torgau, Germany, on April 25, 1945. With this joining of forces, Germany was well and truly broken. The end was only two weeks away.
(National Archives)

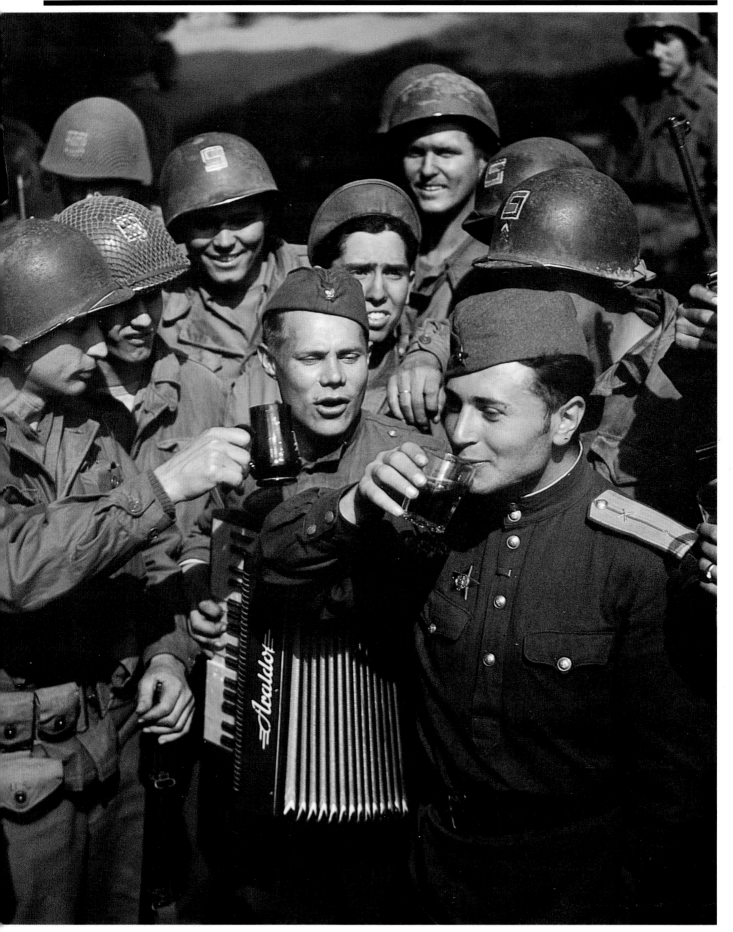

GLOSSARY OF TERMS AND ABBREVIATIONS

AA	Anti-aircraft
AAF	Army Air Force
Adm.	Admiral
AF	Air Force
ARB	Aviation Rescue Boat
B	Bomber
Bn.	Battalion
Brass	A slang term for all officer ranks
Brig.	Brigade
Brig. Gen.	Brigadier General
BT	Basic Trainer
C	Cargo
CB	Construction Battalion
CG	Cargo Glider
Capt.	Captain
CBI	China-Burma-India (Theater)
Cdr.	Commander
CO	Commanding Officer
Col.	Colonel
Cpl.	Corporal
CV	Aircraft Carrier
Div.	Division
F	Photo
Gen.	General
GI	Government Issue, a slang term for draftees
Inf.	Infantry
JCS	Joint Chiefs of Staff
LC	Landing Craft
LST	Landing Ship, Tank
Lt.	Lieutenant
Lt. Cdr.	Lieutenant Commander
Lt. Col.	Lieutenant Colonel
Lt. Gen.	Lieutenant General
Luftwaffe	German Air Force (Literally "Air Weapon")
Maj. Gen.	Major General
mm	Millimeter
M.P.	Military Police
MTB	Motor Torpedo Boat
O	Observation
P	Pursuit
PBJ	Patrol Bomber, North American (Land-based, Navy)
PBM	Patrol Bomber, Martin (Navy)
PBY	Patrol Bomber, Consolidated (Navy)
Pfc.	Private First Class
PoW	Prisoner of War
PT	Patrol Torpedo Boat
PV	Patrol Bomber, Lockheed (Land-based, Navy)
RAF	Royal Air Force
Rear Adm.	Rear Admiral
Regt.	Regiment
SBC	Scout Bomber, Curtiss (Navy)
SC	Scout Plane, Curtiss
Sgt.	Sergeant
SNJ	Advanced Trainer (Navy)
SS	Submarine
S/Sgt.	Staff Sergeant
TBM	Torpedo Bomber, General Motors (Navy)
T/Sgt.	Tech Sergeant
USS	United States Ship
WACS	Women's Army Corps
WAVES	Navy Women's Reserve